THE PUBLISHER GRATEFULLY ACKNOWLEDGES THE GENEROUS SUPPORT
OF THE ART ENDOWMENT FUND OF THE UNIVERSITY OF CALIFORNIA PRESS
FOUNDATION, WHICH WAS ESTABLISHED BY A MAJOR GIFT
FROM THE AHMANSON FOUNDATION

TASTES AND TEMPTATIONS

CALIFORNIA STUDIES IN FOOD AND CULTURE

DARRA GOLDSTEIN, EDITOR

Tastes and Temptations

FOOD AND ART IN RENAISSANCE ITALY

John Varriano

UNIVERSITY OF CALIFORNIA PRESS *Berkeley Los Angeles London*

University of California Press, one of the most distinguished university presses in the United States, enriches lives around the world by advancing scholarship in the humanities, social sciences, and natural sciences. Its activities are supported by the UC Press Foundation and by philanthropic contributions from individuals and institutions. For more information, visit www.ucpress.edu.

University of California Press
Berkeley and Los Angeles, California

University of California Press, Ltd.
London, England

Library of Congress Cataloging-in-Publication Data

Varriano, John L.
 Tastes and temptations : food and art in Renaissance Italy / John Varriano.
 p. cm. — (California studies in food and culture ; 27)
 Includes bibliographical references and index.
 ISBN 978-0-520-25904-1 (cloth : alk. paper)
 1. Gastronomy—History. 2. Food habits—Italy—History. 3. Cookery, Italian—History. 4. Art, Renaissance—Italy. 5. Food in art. I. Title.
 TX641.V375 2009
 641'.013—dc22 2009010541

Designer: Janet Wood
Compositors: Janet Wood, Integrated Composition Systems
Text: 11.5/13.5 Vendetta Medium
Display: Dalliance, Vendetta
Indexer: Joan Davis
Printer and binder: Sheridan Books, Inc.

Manufactured in the United States of America

18 17 16 15 14 13 12 11 10 09
10 9 8 7 6 5 4 3 2 1

For Elisabeth de Bièvre and John Onians

CONTENTS

ACKNOWLEDGMENTS

Like a *bollito* simmering on low heat, the thought of writing a book about the art and cuisine of Renaissance Italy warmed in the back of my mind for some time before I first began to put words on paper. Over the years that followed, countless friends and colleagues stirred my ideas with their own enthusiasm, sometimes adding a spice or two to what eventually became *Tastes and Temptations*.

The late Phyllis Pray Bober has perhaps been my greatest inspiration, both for the example she set in her 1999 monograph, *Art, Culture, and Cuisine: Ancient and Medieval Gastronomy*, and for the words of wisdom she shared when, late in her life, she was a visiting lecturer at a nearby college. I first met Phyllis at a memorable dinner party in Conway, Massachusetts, at which Gillian Riley, another luminary in the world of gastronomy, was also present. My friendship with Gillian, author of *The Oxford Companion to Italian Food* as well as a medley of publications on the congenial nature of food and art, began that same evening. I am most grateful to her for the time she spent reading an earlier version of this manuscript and for the many wise queries and comments she had to offer.

In equal measure, I thank Ken Albala for all I learned from his two books, *Eating Right in the Renaissance* and *The Banquet: Dining in the Great Courts of Late Renaissance Europe*, as well as for his own thoughtful reading of my original manuscript. I am especially grateful for the extraordinarily generous spirit with which he shared his wealth of culinary knowledge. Whatever shortcomings may remain, *Tastes and Temptations* is a better book for the many insights I owe to Ken and Gillian.

Darra Goldstein deserves special thanks on two accounts: as editor of *Gastronomica: The Journal of Food and Culture*, she oversaw the publication of fragments from two of my chapters, and as acquisitions editor of the series California Studies in Food and Culture, she prompted the acceptance of the final work by the University of California Press.

The staff and freelancers of the University of California Press could not have been more helpful in turning these meditations into print. Dore Brown, Adrienne Harris, Katherine Marshall, and especially Sheila Levine guided me through each step of the editorial and production processes with exemplary efficiency and good humor. No publisher in my experience has ever responded faster or more helpfully to e-mails or phone messages.

Here in the hills of western Massachusetts, my editor, Mary Bagg, worked tirelessly to polish and format the manuscript. Her thoughtful questions about content, no less than her keen eye for expository infelicities and factual inconsistencies, occasionally made me groan, but I shall be forever in her debt. Laura Weston, with customary proficiency and grace, transformed a mess of footnotes into an acceptable bibliography.

Humberto di Luigi at Art Resource and Wendy Zieger at the Bridgeman Art Library cheerfully tracked down most of the photographs and permissions I needed, while staff members at several museums went out of their way to facilitate my orders or to lower reproduction fees. Silvia Inwood deserves special mention in this regard, as do Maurizio Buora, Ila Furman, John Overholt, and Eva Karlson. I am most grateful as well to those private collectors—the Antonius Group, Howard Stein, and one gentleman who wishes to remain anonymous—who granted me permission to reproduce their treasures at no cost. But I also cannot resist naming the Kunsthistorisches Museum in Vienna as the only institution whose exorbitant reproduction fees actually led me to exclude one of their works from my discussion and seek a substitute from another museum.

Once again, Mount Holyoke College has helped with publication expenses. For this, I am most grateful to the Faculty Grants Committee and to Donal O'Shea, Dean of Faculty, who supplemented his spiritual

support of my work with funds tapped from his discretionary account. As a faculty advocate, Don is deserving of beatification, at the very least.

Among those who enriched this study in so many other ways, I should like to single out Martin Antonetti, Claudia Chierichini, Joe Ellis, David Ellison, Barry Fifield, Ombretta Frau, Robert Herbert, Tamra Hjermstad, Tony Kaufmann, David Levine, Michael Marlais, Maureen Maynés, Ulrich Meyer, Véronique Plesch, Pierre Rosenberg, John and Michelle Spike, Carole Straw, Geoffrey Sumi, and Vasco Tacconi.

My wife, Wendy Watson, was as unstinting in her support as she was unflinching in her questioning of some of my rougher prose and glibber suppositions. For this, I remain most humbly grateful. Chapter 7, moreover, could not have been written without her extensive knowledge of Italian Renaissance maiolica. Two briards, first Cyrano and later Cennino, have been my constant companions in the *studiolo*, each with the gift for sensing when I needed to be nudged from my desk and taken for a restorative walk in the woods.

Finally, the dedication of this book to Elisabeth de Bièvre and John Onians is an expression of gratitude for twenty-five years of stimulating friendship. I've learned much from them both, but nothing more important than the joy of the free play of ideas.

Introduction

This book is about the interplay of the eye and the palate at a time when the luxuries of life were considered necessities, at least among those who left a record of their desires. Like most Renaissance appetites, the cravings for art and cuisine grew out of the culture of humanism, a worldly approach to existence that sought inspiration in the classical past as it celebrated individual creative genius and searched for new insights into man's physical and spiritual nature. Humanistic study, *studia humanitatis*, began in the fifteenth century with verbal inquiry—grammar, rhetoric, poetry, history, and moral philosophy in particular—but quickly spread to all aspects of civilized behavior.[1]

The culinary world of the Renaissance was shaped by humanistic influences as much as any cultural expression of the period, but few modern studies have examined this dependence in any depth.[2] The interplay of food and art proves to be rich territory for exploration in Renaissance Italy. Though the break with medieval traditions was less decisive in culinary practice than it was in the visual arts, both disciplines began with straightforward professional ideals that then involved into more elaborate late styles. Beyond being the products of a shared cultural context, the parallel evolutionary developments of art and cuisine can also be viewed as immanent processes of development, with the accomplishments of one generation preparing the way for those of its successor.[3]

In departing from classical models, Renaissance cooks and artists relied on their own imaginations and had little hesitation in drawing from one another. Both produced offerings for public consumption,

and both had an affinity for ritual. The dominance of sacred subjects in painting—by one estimate, constituting 87 percent of all the pictures produced between 1420 and 1539[4]—and the prevalence of feasts devoted to weddings, religious observances, and diplomatic gatherings suggest the symbolic value these forms assumed in Renaissance Italy. The output of artists and cooks served the spiritual or psychological needs of those who experienced their creations: artistic works aided devotion as they delighted the eye; culinary delights fostered bonds among family and friends while nourishing the body. Each, in its way, played a key role in the cultural anthropology of the time.

Unlike the thinking of the later Middle Ages, which relied on rigid categories inherited from Aristotle, Renaissance thought took its cues from the observation of nature, with the senses playing a crucial role in the apprehension of matter and meaning.[5] Of the five senses, sight and taste were the primary cultural receptors—more than touch, hearing, or smell—attuning people to the colors and flavors of the age. Strolling past a Renaissance palazzo or a produce market, praying before a newly installed altarpiece, dining with one's family and friends—all were occasions that tantalized one's senses.

Historically, taste has ranked below sight in the hierarchy of the senses.[6] Whereas vision keeps the observer at a judicious distance from the object, taste, along with touch and smell, is subject to baser bodily involvement. Nevertheless, artists had a lowly status, and those who looked to gastronomic themes for their inspiration frequently infused their still lifes or scenes of butcher shops and kitchens with allegorical meanings, as if to impress those who would otherwise dismiss their work as mere imitation. This hierarchical system may well explain why ambitious painters like Caravaggio and Annibale Carracci turned away from these subjects as they grew older and more concerned about their reputations.

When allegory was not a priority, artists and cooks of the later Renaissance shared a penchant for unrestrained virtuosity and mordant wit. A libidinous still-life painting, a famous building re-created using edible

materials, a recipe for fish molded in the shape of a goat, or the discovery of an Ovidian scene at the bottom of one's soup bowl were primarily visual, not gustatory, experiences, artful treats for the eye that stimulated viewers' expectations of delectable tastes. These exercises in artifice and illusion promised a fanciful retreat from the vicissitudes of the age and from the unrelenting pressures on the peninsula's sovereignty and spiritual hegemony brought about by the Reformation and numerous foreign invasions.

Any investigation of how developments in premodern art and cuisine came to intersect must depend on both textual and visual evidence. Because food perishes while art endures, we rely on books of cookery—beneficiaries of the invention of the printing press and rapid dissemination of ideas[7]—for most period recipes and menus, and then garner what we can from painted depictions of meals and markets that embellish a narrative or carry an allegorical message. The reverse, of course, is true for the study of art—at least as practiced by most art historians—where the image is primary and the text supplementary. Of necessity, but with certain exceptions, the study of both art and cuisine tends to privilege the better-preserved records of courtly and aristocratic patrons over the scant material evidence of middle- and lower-class culture. Such evidence naturally reveals a higher level of "process," or artifice, than one finds when simple spiritual or nutritional sustenance was the only goal. The structural metaphor I use here derives from Claude Lévi-Strauss, whose binary opposition of the "raw" and the "cooked" (the natural versus the man-made) in cultural anthropology fully encompasses the transformation of, say, pigments into painting, eggs into *zabaglione*, or grapes into wine.[8]

We may be amused to learn that Andrea del Sarto fashioned a tabletop version of the Florentine Baptistery out of sausages and cheese, or that the architect Bernardo Buontalenti was the supposed inventor of *gelato*, but the indirect and immaterial ties between Renaissance art and cuisine are equally intriguing.[9] The immateriality I have in mind is the kind Albert North Whitehead speaks of in his *Adventures of Ideas*:

In each age of the world distinguished by high activity…there is a general form of the forms of thought; and, like the air we breathe, each form is so translucent, and so pervading, and so seemingly necessary, that only by extreme effort can we become aware of it.[10]

As we shall see, the sensibility underlying the menus of Messisbugo and the table decorations of Cellini, the recipes of Bartolomeo Scappi and the painted narratives of Veronese, or the treatises of Alberti and Platina, are virtually one and the same.

The offerings in this book are diverse, but they never stray far from my primary subjects, art and cuisine. In the Renaissance spirit, my method is mostly empirical, taking images and primary texts as the essential sources. I have organized the chapters topically rather than chronologically or regionally, because this approach seems best for exploring the most compelling intersections, unities, and "plays of sympathy," as Michel Foucault would put it.

The first two chapters highlight some of the aesthetic, social, and political influences of the period by focusing on two areas in which cooking and the arts developed in parallel. In chapter 1, "Artists and Cooks," I examine, first through written treatises and then through graphic portrayals, the changes that occurred in the social and professional positions of both vocations, including unexpected inversions between ideas of "high" and "low" status. Chapter 2, "Regional Tastes," then explores the shared geography of art and cuisine in Italy that grew out of political divisions and alliances as well as the dictates of *terroir*.

The next three chapters investigate the types of food and cuisine that appeared in the art of the era. Chapter 3, "Significant Still Lifes," examines two popular genres for presenting such images: *xenia*, which aimed to rival the realism of still-life painting from classical antiquity, and *bodegónes*, which presented kitchen and tavern scenes featuring both the ingredients of a simple meal and a sympathetic portrayal of those who prepared or devoured it. Chapter 4, "Sacred Suppers," focuses on depictions of meals

in biblical scenes like the Last Supper and the Supper at Emmaus. Because scripture consistently overlooks specific details, artists were free to invent them, sometimes in accordance with iconographical traditions but more often in response to personal or regional preferences such as those I discuss in chapter 2. Chapter 5, "Erotic Appetites," introduces the reader to images reflecting the Renaissance enjoyment of wit and sexual double entendres. Turning to literary puns, visual allusions, and pseudoscientific genetic theories of the era, I describe two forms of humor: the use of fruits and vegetables as erotic metaphors, and satiric portrayals of people who purveyed or consumed foods that were thought to enhance sexual performance and reproductive outcomes.

Renaissance cuisine was often as much a feast for the eye as for the palate, as the final three chapters illustrate. In chapter 6, "Eggs, Butter, Lard, and Oil," I look at the unexpected parallels between ingredients used in studios and kitchens—from the time, early in the Renaissance, when the binding agents in paint and food were mainly eggs and lard, respectively, to the later fifteenth century, when vegetable oils largely supplanted them.

Once the kitchen prepared a Renaissance feast, the serviceware in which the courses were served became a key part of the overall presentation. Just as ancient Greeks used decorated vessels in their postbanquet wine fests (*symposia*), so sixteenth-century Italians embellished relatively inexpensive terra cotta crockery with colorful stories they often appropriated from classical sources. In chapter 7, "Eating and Erudition," I explain how maiolica embellished with narrative scenes became popular conversation pieces of the period, sparking learned exchange within the tightly prescribed rituals of Renaissance dining.

Equally tantalizing to guests were the elaborate centerpieces that completed the table settings. In chapter 8, "Edible Art," I investigate the popular practice of decorating banquet tables with sculptures fashioned from foodstuffs like sausages or sugar. These ephemeral decorations—whether figural or architectural—frequently borrowed designs by major artists like Giambologna or Bernini and on occasion served either

as *bozzetti* (preparatory models) or replicas of more permanent works of art.

I have conceived *Tastes and Temptations* as a tasting menu for the eye and palate. Although each of my discretely themed chapters may be taken à la carte, I hope that together they will satisfy the reader's appetite for a fusion of Renaissance art and cuisine.

Parallels in Food and Art

Artists and Cooks

The culture of humanism raised the aspirations of artists and cooks during the Renaissance just as it did for the emerging middle class of bankers and businessmen whose enlightened patronage stood behind them. For those who toiled in studios and over stoves, the quest for higher social and intellectual status prompted attempts to display their individual genius, and as class distinctions of every kind began to dissolve, some cooks and painters inevitably became celebrities. The concomitant blurring of sacred and secular values only heightened the appreciation of earthly achievements. As a consequence, the greatest respect went to those who could transform basic ingredients like pigeons or panels into artful creations for the palate or the eye.

Renaissance aesthetics typically attached greater value to the skill with which an item was made than to the intrinsic value of its raw materials.[1] The most notable example in art occurred in the fifteenth century when gold-ground devotional painting lost favor to pictures that rendered blue skies and compositions in accurate perspective. Although this change obviously paralleled broader shifts in religious attitude during the postmedieval period, it was generally believed that only through the skill of the artist could the humanist vision of bringing heaven to earth be realized.

Early Writings on Art and Cookery

Even before the invention of the printing press, manuscript copies of books on art and cookery circulated throughout Renaissance Italy. The subsequent developments within each genre were remarkably similar, as

we can see by examining three books from each category, paired by date of composition.

The earliest texts are from the fourteenth century: the anonymous *Libro di cucina*[2] and Cennino Cennini's *Il libro dell'arte*. Both are small, slim volumes of just 74 and 130 printed pages, respectively. The anonymity of the author of the cookbook is typical of the unsung efforts of medieval artisans, just as the generic titles of both books reflect their largely impersonal contents. *Cucina* could hardly be less revelatory. The text consists of 135 short recipes unaccompanied by either a preface or an introduction. Given the occasional notation that a dish is intended "per XII [or far less often, XX] persone," we can infer that the meals were designed for family or friends rather than for courtly feasts. One copy of the manuscript describes the guest list as "XII gentili homini giotissimi," or twelve gluttonous men.[3]

Cennini's book, which he probably wrote later in the century, is only a little more informative. Its intention, the author discloses, "is for the use and good and profit of anyone who wants to enter the profession," but his advice is almost exclusively technical. Of the book's 189 chapters (a number of which are less than a page long), all but the three introductory ones describe workshop practices such as how to gild a panel or apply a coat of varnish. Moreover, the logic of the introductory chapters is not always cogent. Frustrated by Cennini's "occasional attempts at rhetoric," one modern translator laments, "He is apt to lose himself in complications." The book's most sensible advice is in chapter 3, where the author exhorts would-be artists "to begin by decking yourselves with this attire: Enthusiasm, Reverence, Obedience, and Constancy." Genius and imagination go unmentioned.[4]

The next generation of texts—Bartolomeo Sacchi's *De honesta voluptate et valetudine* (*On Right Pleasure and Good Health*), from the 1460s, and Leon Battista Alberti's *Della pittura* (*On Painting*), dated 1436—are more concerned with ideas. Both authors were men of learning and letters. Sacchi (1421–81)—better known as Platina—began his career as a Latinist in the Gonzaga court in Mantua, spent five years in Florence studying Greek, and eventually settled in Rome, where he served first in the papal chancery and

later, under Sixtus IV, as Vatican librarian.[5] A fresco in the Vatican Palace by Melozzo da Forli commemorates the appointment that was to be the capstone of his career. Platina, then, was not a man of the kitchen but a scholar. Among his many literary accomplishments were a commentary on the works of Pliny the Elder, a history of the Gonzaga family, a history of the papacy, and a treatise on love.

Alberti (1404–72) was no less of an intellect. Born to a Florentine family, he studied classics in Padua and took a degree in canon law at the University of Bologna. As an artist, he focused his creative energies primarily on architecture, but his books and essays proved to be the mainstay of his legacy. A prolific author, he wrote nearly two dozen treatises on subjects ranging from cryptography to family life to Italian grammar. His trio of books on painting, sculpture, and architecture—none of which were printed during his lifetime—represent the most progressive ideals of the fine arts in the Renaissance.

Platina's text comprises nearly two hundred pages organized into ten more or less discrete books. At the end of his dedicatory preface to Cardinal Roverella of Ravenna, the author claims that he composed the work in emulation of ancient treatises by Cato, Varro, Columella, C. Matius, and Caelius Apicius. The work by Apicius to which he refers is the *De re coquinaria*, the earliest recipe collection to survive.[6] Platina's acknowledgment of the classical texts may indicate a few of his sources, but in citing these works, he also assures the reader of his devotion to the antiquarian ideals of his age. In truth, he borrowed little more than the ten-book format from Apicius and failed to cite Pliny, his principal antique source. More surprising, still, is the discovery that many of the recipes in *De honesta voluptate* derive not from antiquity but from the recently assembled recipe collection of the so-called Maestro Martino of Como.[7] Only in book 6, chapter 41, does Platina admit to this source: "What a cook you bestowed, oh immortal gods, in my friend Martino of Como, from whom I have received in great part the things which I am writing!" A parallel reading of Martino's *Libro de arte coquinaria* with Platina's text confirms Luigi Ballerini's observation that *De honesta voluptate et valetudine*

was, in fact, little more than an "outright cannibalization" of the earlier manuscript.[8]

Platina's title *On Right Pleasure and Good Health* promises more than just savory meals to delight the palate. Yet the "good health" (*valetudine*) and nutritional values of which he speaks all derive from humoral theory, the notion that ill health resulted from an imbalance of the four cardinal fluids, or humors: blood, yellow bile, black bile, and phlegm. This theory stemmed from ancient dietary beliefs (most notably recorded by Hippocrates and Galen), which, in turn, were adopted by Arabic and medieval savants.[9] Platina followed the dictates of the *regimen sanitatis*, the Arabic "rules of health," and in his introductory chapters, he recounts the bewildering linkages thought to exist between the organs of the body, body temperature, the seasons, and moisture.[10] The dietary implications of this view are equally perplexing. Various recipes claim beneficial or detrimental health effects for everything from fig fritters to roasted peacock. For example, the author explains that cabbage is "of a warm dry nature and for this reason increases black bile, generates bad dreams, is not very nourishing, harms the stomach a little and the head and eyes very much, on account of its gas, and dims the vision."[11] Because Maestro Martino made no such medical claims for any of the recipes that Platina so freely borrowed from him, the most original aspect of *On Right Pleasure and Good Health* is the author's concern for the salutary benefits of the items his readers might eat and drink.

On Painting was the product of almost the same cultural moment. Like Platina, Alberti was a humanist who looked to antiquity for inspiration as he sought insights into the mysteries of nature. With no ancient texts to use as a model (as that of Vitruvius would later provide when Alberti composed his treatise on architecture) but possessed of greater intellectual ambition than the workmanlike Cennini, Alberti produced the first modern treatise on the theory of painting. The audience for his manuscript—the book's first printing appeared only in 1540—was also broader than Cennini's. He extends the discussion of art beyond the painter's craft, introducing readers to many of the underlying principles of Renaissance art.

In the first of the treatise's three books, Alberti speaks of linear

perspective, the most fundamental of those principles. Although he was by no means its inventor—credit for that innovation usually goes to Filippo Brunelleschi—Alberti was the first to explicate the mathematical concept of spatial illusionism, doing so with a crisp Ciceronian logic honed by his years of legal study.

Alberti's second and third books are even more deeply grounded in humanistic thinking. With more than the cachet of classicism in mind, he writes in book 2, "The first care of one who seeks to obtain eminence in painting is to acquire the fame and renown of the ancients."[12] The key, in his view, lies in choosing elevated subject matter. The term he uses is *istoria*, a word suggestive of history painting but one that has no modern English equivalent. For him, *istoria* embraces both subject matter and style, with the subject drawn from ancient literature and the style providing a clear and reasoned expression of human emotion in a formally unified setting. Linear perspective was, of course, central to the illusion along with an accurate interplay of color and light. Though the work of art itself was of paramount importance to Alberti, the renown that accrued to the artist was never far from his mind. His interest in the modern painter's "search for eminence" led him to praise the "fame and renown of the ancients," and elsewhere he proclaims, "The greatest work of the painter is not a colossus, but an *istoria. Istoria* gives greater renown to the intellect than any colossus."[13] The pride taken in that accomplishment would presumably be shared by patron and painter.

Although Platina and Alberti set out to address different issues and advance different arguments, the authors conclude their respective texts with encomiums to free will, perhaps the central tenet of early Renaissance humanism. For Platina, one must exercise free will to overcome passion, which he describes as "the immoderate seeking for any hoped-for good."[14] For Alberti, will (along with courage) is the means for overcoming difficulty, a necessity, he confesses, even in writing his own text.[15] The next generation of authors would celebrate the willful imagination even more enthusiastically. By the time Scappi and Vasari began their treatises, creative self-expression had already evolved into the excesses of Mannerism.

Both Bartolomeo Scappi (c. 1500–77)—not to be confused with Bartolomeo Sacchi, the man known as Platina—and Giorgio Vasari (1511–73) practiced their art as well as wrote about it. Scappi's origins remain a little vague, but his *Opera dell'arte del cucinare* (*Work on the Art of Cooking*, 1570) seems to have been the capstone of a long career spent mainly in Rome preparing meals for a succession of cardinals and popes.[16] The book's title page identifies him as *cuoco segreto*, or private cook, to Pope Pius V (1566–72), the last of the five pontiffs he is known to have served. Vasari, in turn, spent many years as a painter in Florence, Rome, Naples, and Venice before undertaking his *Vite de' più eccellenti pittori scultori e architetti* (*The Lives of the Painters, Sculptors, and Architects*, 1550, expanded in 1568), the work that would eventually eclipse his artistic reputation altogether.

To be sure, significant differences exist between the *Opera* and the *Vite* apart from their subject matter. Vasari's concern for the historical development of his discipline was certainly more extensive. His *Lives* begins in the thirteenth century with Cimabue (1240–1302) and ends with biographies of artists who were still alive at the time he was writing. In contrast, the earliest meal described in the *Opera* took place in 1536, just thirty years before the author began his manuscript. Regional differences also play a minor role in Scappi's account, whereas Vasari's *Lives* is more sensitive to geography, particularly in the first edition, where his preference for the art of his native Tuscany is quite pronounced. Even in the second edition, one sees a marked contrast between the brevity of his biographies of important, long-lived Venetian artists like Titian (sixteen pages) and the length of his lives of less important, short-lived Florentines like Francesco Salviati (twenty pages). Vasari's aesthetic preferences were not based on patriotism or xenophobia alone, however. Throughout his text, he emphasizes the importance of Florentine *disegno*—by which he means both drawing and design—over Venetian *colore* in artistic expression. Finally, only Scappi thought to include illustrations with his text. Ironically, the *Opera* contains more than two dozen full-page woodcuts of kitchen utensils and food preparations, whereas the *Lives* has no reproductions of the countless works of art that Vasari describes.

What, then, do the two books have in common? Both, of course, are encyclopedic volumes. Not counting its illustrations, Scappi's original text is nearly nine hundred pages long and includes over a thousand recipes along with the name of every dish served at more than a hundred multicourse dinners and suppers. The standard modern edition of Vasari's opus, in turn, comprises four volumes totaling over thirteen hundred pages, with individual biographies of more than 150 artists. The encyclopedic nature of the *Opera* and the *Vite* was hardly unusual for the time. Each work in its way exemplified the rethinking of knowledge in the later sixteenth century. The publication of historical treatises on every subject and the collecting and cataloguing of all manner of natural specimens were widespread at the time.[17] Cardinal Baronio's twelve-volume history of the church, the *Annales ecclesiastici* (1588–1607), and the creation of the Museo degli Uffizi in Florence during the reigns of Cosimo and his successor Francesco de' Medici were parts of the same epistemological trend.

Each book was also the product of a courtly environment: Scappi's, for the most part, answered to the requirements of the Roman Curia, and Vasari's was shaped by Medici court circles in Florence. The dedication of the books to Pope Pius V and the archduke Cosimo de' Medici leaves little doubt about their respective loyalties. But these were also anxious times. Although Scappi makes no mention of this and Vasari only refers in passing to "the troubles" that followed the Sack of Rome (1527) and the expulsion of the Medici (1529), the artificiality of so much of the art produced in this period undoubtedly reflects the insecurities of the age of the Reformation and Counter-Reformation. Together, the *Vite* and the *Opera*, like Baronio's *Annales* and the Medici collections, helped secure the political and public reputation of courts whose boundaries were tightly circumscribed and whose legitimacy was under constant challenge.

More than anything, the virtuosity of a creative performance impressed Scappi and Vasari. For example, one of the menus reproduced in the *Opera* recounts a modest three-course banquet given on a meatless Friday in an unnamed "garden in Trastevere."[18] Only about forty unidentified guests were on hand, but the first two courses consisted of fifty dishes served

on four hundred pieces of gold, silver, and maiolica tableware. Next came twenty-seven desserts served in two hundred sixteen bowls and dishes. Most extraordinary of all were the table decorations. Before the arrival of each course, six edible statues were placed on the table, the first made of sugar; the second, butter; and the third, pasta. The pieces included groups of music-making nymphs, exotic natural creatures, and mythological deities.[19] Given that the iconography of this statuary was neither armorial nor allegorical and the groupings adhered to no coherent theme, the creations were clearly intended for show. The meal ended with the serving of scented toothpicks and, for each guest, a posy of silk flowers with gold stems.

Because the banquet took place on a day of abstinence, the menu consisted entirely of fish, vegetables, and fruit. Individual recipes for every type of food, including meat and fowl, appear elsewhere in the treatise. One of the author's special favorites, to judge from the unusual length of the entry, was roasted peacock. In the previous century, Platina described the bird as "more suitable to the table of kings and princes than the lowly and men of little property," an assessment with which Scappi surely would have agreed.[20] Preparing the bird for the table offered a special challenge. Inspired no doubt by Platina's recipe for cooking the "vainglorious" creature, Scappi is even more extravagant in his use of spices and method of presentation. Once cooked, he suggests, the bird should be reassembled with metal rods and have its feathers reattached *come se fosse vivo*, "as if it were still alive."[21]

Vasari praised artifice in equal measure. In his life of Leonardo, he marvels at the "horrible monster" that the artist reportedly had fashioned nearly a century earlier out of "lizards, newts, maggots, snakes, butterflies, locusts, bats, and other animals of the kind." Emerging "from a dark and broken rock, [the creature] belched poison from its open throat, fire from its eyes, and smoke from its nostrils." Leonardo was so engrossed in his effort, Vasari reports with fascination, "that he did not notice the stench of the dead animals."[22]

In truth, Vasari's aesthetic criteria rose above the level of illusions, and

he reserved his greatest praise for the most refined artistic styles of his day. He revered Michelangelo (1475–1564) above all other artists, and in this biography (at eighty-four pages, the longest of the lives), Vasari discloses what mattered most—and least—to him. His description of the artist's achievement in the *Last Judgment* in the Sistine Chapel (1536–41) is particularly revealing: "Suffice it to say that the purpose of this remarkable man was none other than to paint the most perfect and well-proportioned composition of the human body in the most various attitudes."

Nowhere in his description of the *Last Judgment* does he mention the fresco's horrifying depiction of the Second Coming (Matthew 24:30–31) nor its radical departure from the structured composition of the chapel's ceiling, which Michelangelo had painted thirty years earlier. Indeed, he gives no indication of the artist's tormented state of mind or the skill with which he expressed the uncertainties and pessimism of his age. Rather, in Vasari's view, the *Last Judgment* was a great feast for the eyes; the anatomical idealism, unerring foreshortenings, and uniquely varied poses of its myriad figures struck him "as an example of what can be done when supreme intellects descend upon the earth, infused with grace and divine knowledge." *Grazia*, or grace, was of key importance to Vasari's aesthetics.[23] Although he never defines the term as such, his repeated use of it in the *Lives* indicates that *grazia* is not something to be learned, or even understood by rational means. It is, instead, a natural gift from heaven, free from any trace of labor or industry. Words like *sweetness, facility,* and *elegance* frequently accompany its appearance in the text.

Scappi thought along similar lines, although he refrains from suggesting that fine cuisine is a gift from heaven. The first chapter of the *Opera* opens with a general discourse on the requirements of a master cook, whom he likens to "a judicious architect, who after making a good design, builds a strong foundation above which he constructs marvelous buildings."[24] The analogy he makes between art and cuisine is primarily visual, for the cook's *disegno* should be "beautiful, orderly, and pleasing to the eye." In his opinion, the source of the eye's delight is "*bel colore* and *vaga prospettiva.*"

Bel colore suggests the lovely patina that spices like saffron or cinnamon can add to a dish, but *vaga prospettiva* implies something more ethereal and not so easy to define. *Vaghezza,* the likely root of the word *vaga,* was, like *grazia,* a term linked to the appeal of stylized natural forms.[25] When applied to food, *vaga prospettiva* seems to indicate a preference for mannered appearances over authentic flavors, as when, on one menu, he describes fish molded in the shape of a goat's head and a counterfeit ham made from salmon in gelatin.[26] Both Scappi and Vasari were lovers of artifice, and each in his own way exemplified the period's preference for matters of form over content.

The second part of Scappi's initial chapter discusses the ideal traits of the cook. In addition to being neat, clean, practical, and polite, cooks should embody the virtues of prudence, patience, humility, and sobriety. Vasari does not recommend a comparable set of traits for members of his profession, although throughout the *Lives,* he expresses reverences for most of the same temperamental characteristics. Thus, for example, he praises Fra Angelico for being "quiet and modest" and "of the highest character" while disapproving of "the vileness of the vice of envy" and the "false friendship and rancor" of Andrea del Castagno.[27] For both Scappi and Vasari, the model of ideal moral conduct would have been that prescribed in Castiglione's *Book of the Courtier* (1528), the most widely read book of manners of its age. In the realm of professional performance, one imagines the artist and the cook, like the courtier, aiming to comport themselves with the *sprezzatura,* or seemingly effortless nonchalance, that Castiglione recommends.[28]

Portraits of Professionals

Significantly, Scappi's *Opera* and Vasari's *Vite* were among the first books of their kind to contain engraved portraits of their authors on the title page. Although Vasari's is a self-portrait, the two likenesses (figures 1 and 2) are remarkably similar in composition and mood. Each is set within an elaborately framed oval format with a *stemma,* or coat of arms, adjoining the portrait.[29]

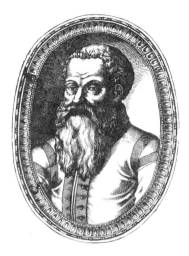 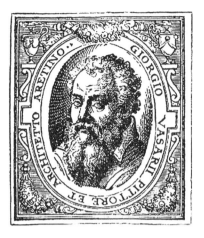

FIGURE 1. (Left) Bartolomeo Scappi. Detail from frontispiece to
Opera dell'arte del cucinare.

FIGURE 2. (Right) Giorgio Vasari, *Self-Portrait.* Detail from frontispiece to
Le vite de'più eccellenti pittori scultori e architetti.

In both woodcuts, the men appear bust length, their heads turned
slightly to the right. Each sports the full beard fashionable in their day,
and both are attired like gentlemen, thereby deflecting our attention from
the professional worlds in which they made their living. Throughout the
Lives, Vasari followed the physiognomic theories popular at the time, at
one point even remarking, "The outer man tends to be a guide to the inner,
and to reveal what our minds are."[30] In drawing each of the volumes' 144
portraits, he created likenesses that serve as parallel texts to the biographies.
Viewing the images of Vasari and Scappi together suggests certain visual/
textual analogies. Apart from their common preference for courtly dress,
their facial expressions share an intelligent, alert, and self-conscious
demeanor. Scappi's professional ideals of "serious," "sober," "prudent,"

and "modest" behavior resonate in both portraits. Although neither man was of high birth, each presents himself as the embodiment of the noble virtues that Castiglione praised in the *Book of the Courtier.*

Portraiture and self-portraiture were primary expressions of Renaissance humanism and hubris. Portraits, in particular, grew more numerous as social conventions trickled down from the upper classes, extending the reach of the genre beyond princes and cardinals to include bankers, businessmen, and even members of the artisanal class. As far as the evidence suggests, many years would pass before cooks would be commemorated in this fashion, but painters began to include themselves as bystanders in narrative paintings as early as the 1420s. Among the first to do so was Masaccio (1401–28), one of the founding fathers of Renaissance pictorialism. In one of the frescoes he painted in the Brancacci Chapel in Florence—a commission that proved to be the most important of his brief career—Masaccio favored his Carmelite patrons and the public at large with a portrait of himself and four shadowy associates standing in the company of Saint Peter (figure 3). The artist appears in the scene showing Saint Peter being enthroned as bishop of Antioch, the saint's reward for performing the series of miracles depicted elsewhere in the chapel. At the time, the picture's convincing reenactment of human behavior, no less than its mastery of linear and atmospheric perspective, must itself have seemed like a miracle. Masaccio stands proudly to the side as if to acknowledge the audience's acclaim for this tour de force of pictorial illusionism. He does not take all the credit, however, for three of his four companions are also identifiable as progressive artists. Standing in front of the master is his collaborator, Masolino, a diminutive painter literally overshadowed by Masaccio's achievement. Standing behind him are the theoretician Leon Battista Alberti and the architect Filippo Brunelleschi, the presumed discoverer of linear perspective. Curiously, the facial features of the fifth man are invisible. Who might he be? In all likelihood, he personifies the medium of sculpture, the only art form not represented in this avant-garde cast of Renaissance artists. Since Lorenzo Ghiberti (c. 1381–1455) and the man known as Donatello (1386–1466) were both deserving of the honor, Masaccio may have sought to avoid giving offense by depicting neither.

FIGURE 3. Masaccio, detail from the
Raising of the Son of Theophilus.

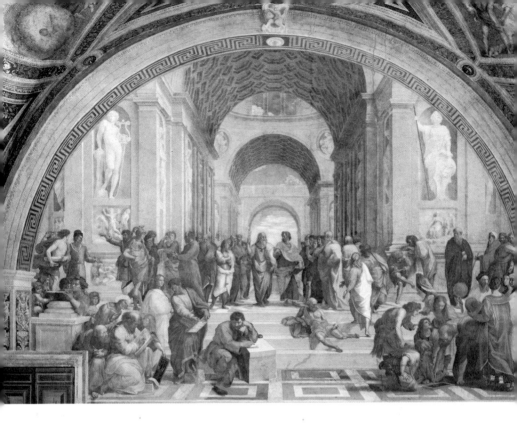

FIGURE 4. Raphael, *School of Athens.*

Mise-en-scène portraits and self-portraits remained popular through-
out the Renaissance. Later in the quattrocento, Botticelli included him-
self among the noble bystanders in his *Adoration of the Magi,* now in the
Uffizi, whereas Ghirlandaio appears as a passerby in the *Visitation* fresco
in the Tornabuoni Chapel in Santa Maria Novella. Sixteenth-century artists
tended to make these appearances more meaningful by casting themselves
or their peers in narrative roles. The most famous of such historiated or
disguised portraits are in Raphael's frescoes in the Vatican *Stanze,* begun
in 1508 at the brightest moment of the High Renaissance. These images
constitute more than clever *omaggi* to deserving friends or rivals because

they are, in fact, key elements in a program that emphasizes the unity of past and present in the classical and Christian worlds. The message of the *School of Athens* (figure 4) is one of reincarnation, specifically the notion that the enlightened papacy of Julius II (who reigned from 1503 to 1513) had engendered a revival of ancient learning and ideals in the artists and savants of his era. Thus, Plato, who stands under the central arch carrying the *Timaeus* under his arm, is represented as Leonardo da Vinci, whereas in the foreground, the seated Heraclitus (to the left of center) and the stooping Euclid (at the right) portray Michelangelo and Bramante, respectively. Raphael, for his part, stands at the extreme right and gazes out at the viewer with the proud expression of someone blessed with a natural sense of *sprezzatura*.

Later in the sixteenth and seventeenth centuries, the fashion was for artists to paint themselves less heroically. Michelangelo did so most famously in the *Last Judgment* by modeling the face of the flayed Saint Bartolomew after his own likeness. Caravaggio, ever aware of his art-historical predecessors, also portrayed himself as the victim in the *David and Goliath* (figure 5) he painted around 1609–10 for Cardinal Scipione Borghese in Rome.[31] At the time, Caravaggio was in Naples—having fled the papal city after committing a murder several years earlier—and had a death sentence hanging over his head. Given that Scipione's uncle, Pope Paul V, was about to consider the artist's petition for a pardon that would have allowed him to return to Rome, Caravaggio's decision to portray himself as the vanquished Goliath may, in effect, have proffered his fictive head in place of his real one. The mise-en-scène would thus have constituted a pungent conceit in which the personal needs of the artist outweighed those of the narrative. In the end, the pope granted the pardon, but in a final and tragic irony, the artist died while making the circuitous journey back to Rome. The mordant wit of Caravaggio's plea was not lost on Scipione's favorite sculptor, the young Gianlorenzo Bernini. Engaging in some interpictorial play of his own, Bernini went on to fashion a *David* for the Borghese Collection in which he depicted himself as the victor.

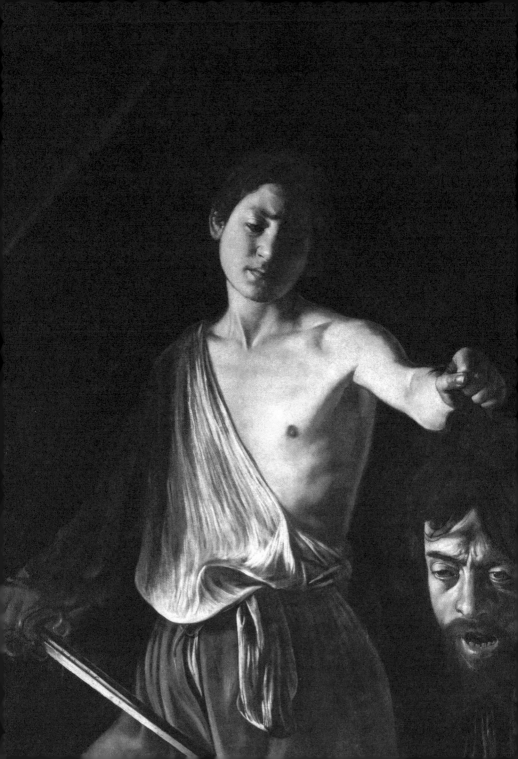

Artistic self-expression became increasingly important in Mannerist and Baroque painting, as did the market for self-portraits. The trend reached a climax in later seventeenth-century Florence when Cardinal Leopoldo de' Medici decided to house his collection of self-portraits in the so-called Vasari Corridor, the long passageway that crosses the Arno River and links the Uffizi to the Boboli Gardens.

No equivalent means of self-expression was available to those who plied their trade in the kitchen. Authors of culinary treatises were better remembered than cooks, particularly after the middle of the sixteenth century, when texts like Vincenzo Cervio's *Il trinciante* (*The Carver*, 1580) or Giovanni Batista Rossetti's *Dello scalco* (*The Steward*, 1584) began to promote the individual skills of their authors. About the same time, printed portraits like Scappi's became standard on the frontispieces of cookbooks.

Maestro Martino has been called "the first celebrity chef," but Platina was almost certainly the first to have his portrait painted.[32] He kneels before Pope Sixtus IV in Melozzo da Forli's famous fresco of 1477 in the Vatican Palace, not to receive recognition for his culinary achievements, however, but to enjoy the honor of having been named prefect of the papal library a year or two earlier. Because Renaissance portraits generally eschewed individual professional attributes in favor of fashionable social conventions, the identity of middle-class sitters could easily be lost after their likenesses ceased to be family property. Thus, we cannot discount the possibility that portraits of early cooks lurk among the countless *anonimi* and *ignoti* that populate galleries of Renaissance painting.

Although portraits of individual cooks were rare, generic depictions became common in the sixteenth and seventeenth centuries. Nearly a third of the engravings in Scappi's *Opera* depict men (never women) at work in kitchens. The figures are fairly nondescript and their clothing typical of their social class. Men attired in similar jackets, breeches, and caps are among the tradesmen Annibale Carracci sketched in the 1580s and those whom Cesare Vecellio included in his famous costume book of 1590.[33] In Scappi's renderings, only the aprons around the men's waists

FIGURE 5. (Opposite) Caravaggio, *David and Goliath*.

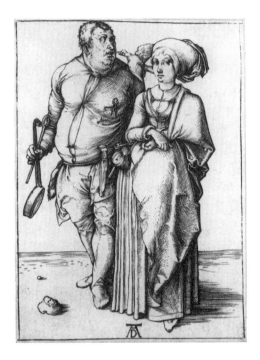

FIGURE 6. Albrecht Dürer, *Cook*.

give a clue to their vocation. Whereas Italian artists had no hesitation ridiculing individuals who sold food in the marketplace—a topic I explore in chapter 5—they seem to have treated those who prepared it with more respect. In this regard, the contrast with attitudes in northern Europe is rather striking. An engraving by Albrecht Dürer from around 1510 (figure 6) depicts an overweight cook standing next to his prim wife and looking a little tipsy. The association of cooks with drunkenness in northern culture seems to have originated much earlier. The medieval phrase "a temperance of cooks" is heavy with sarcasm, and in more than one of the *Canterbury Tales* (1387–1400), Chaucer writes of a cook who "loved the tavern better than the shop" or "gets so drunk he falls off his horse."[34]

Overindulgence in food and drink would remain central to the folk cul-

ture of northern Europe for centuries to come. Rabelais made banquet imagery a key element in the grotesque realism of *Gargantua* and *Pantagruel*, and artists tapped the comedic and allegorical possibilities of comestible imagery, especially in scenes of seasonal feasts and festivities.[35] Among the twelve "months" depicted by the German artist Joachim von Sandrart in 1642 for the dining room of Prince Maximilian of Bavaria was a cook who personified the month of February (figure 7). Though the man appears to be sober, observers would have seen his ample girth and jolly nature as natural signs of the hearty appetites they attributed to those in his profession.

Italian artists of the Renaissance by and large shunned the somatic imagery so common in the post-Reformation north in favor of other types of wit and humor.[36] While Scappi depicted anonymous cooks at work in the kitchen (as in figure 8, for example), the earliest identifiable likeness of an Italian cook dates from the early eighteenth century, long after painters had risen to prominence on stages of their own. This work is not an oil painting but a drawing (figure 9), and happily the artist, the celebrated Roman caricaturist Pier Leone Ghezzi (1674–1755), inscribed the sheet's *verso* with the following notation:

Portrait of Marco Ballarini,
Cook of Giovanni Leoni
Made by me Pier Leone Ghezzi
On May 27, 1707

Because Ballarini, like Leoni, was otherwise destined to remain in the historical shadows, we have no way of knowing how imaginative or memorable his culinary creations were. He is dressed in a gentleman's frock coat but stands before the fireplace in his master's kitchen holding an empty pot and spoon with a full array of cooking utensils visible behind him. Ghezzi emphasized the man's dominance over his craft and his humanity over any demonstration of professional skill. In setting and mood, the portrait of Ballarini resembles Nicolas Poussin's canonical self-portrait (figure 10) from 1650. Both figures express a degree of self-consciousness that borders on diffidence, if not outright reluctance. Poussin was unusual

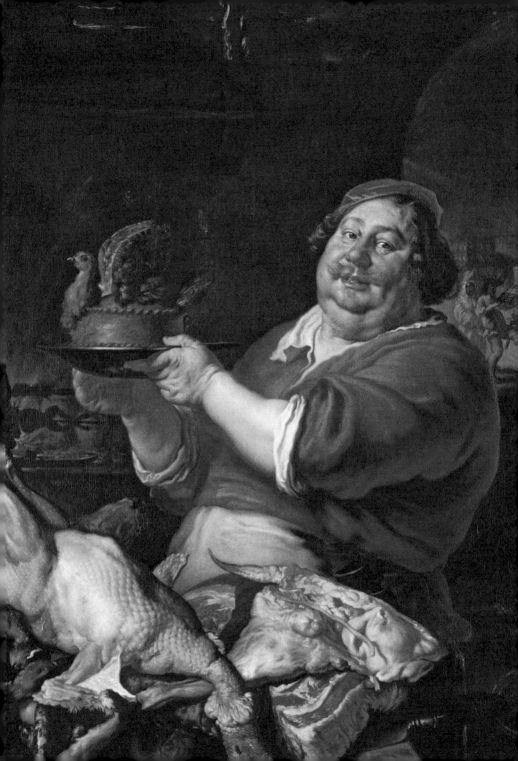

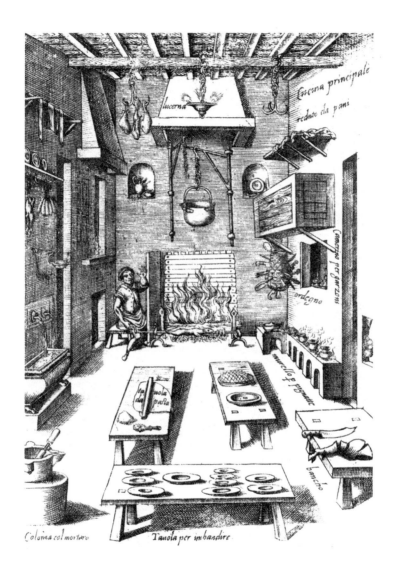

Within the image the following labels appear:
lucerna, *cucina principale*, *reduto da pani*, *camino per garzoni*, *ordegno*, *marcello p pignate*, *bancho*, *tauola da pasta*, *tauola per imbandire*, *Colonna col mortaro*

FIGURE 7. (Opposite) Joachim von Sandrart, *Allegory of the Month of February.*

FIGURE 8. (Above) Bartolomeo Scappi, a cook in his kitchen, from *L'opera dell'arte del cucinare.*

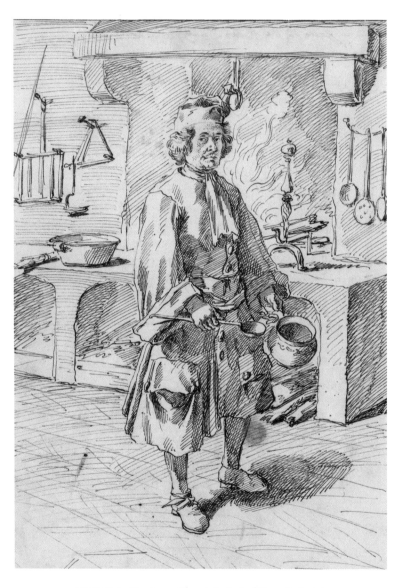

FIGURE 9. Pier Leone Ghezzi, *Portrait of Marco Ballarini.*

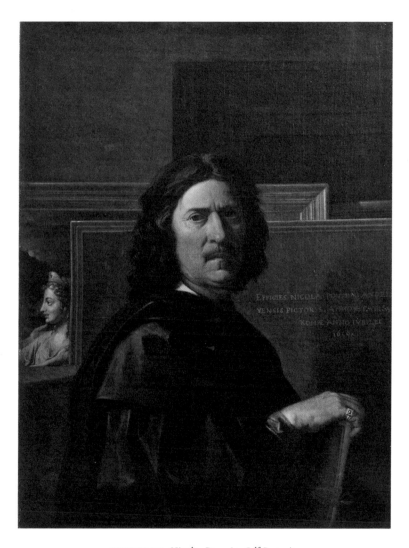

FIGURE 10. Nicolas Poussin, *Self-Portrait.*

in his time—at least among male artists—in portraying himself so matter-of-factly amid the artifacts of his studio rather than as a gentleman or man of leisure. In contrast, Ballarini, like so many premodern female artists who painted themselves before an easel, was probably only too pleased to be remembered for his accomplishments in the kitchen. Ghezzi, for his part, exploited the informality of the drawing medium over the course of his long career, filling several albums with caricatures of individuals in every walk of life. Along with his portrayals of churchmen and aristocrats, he occasionally depicted craftsmen and common laborers, and by chance, his drawing of Ballarini now finds itself in the company of a stonemason named "Beretta" in the same American museum.

Social Inversions

The sixteenth century witnessed upheavals in the social order that manifested themselves in a variety of cultural expressions. These, for the most part, rejected the reasoned ideals of the High Renaissance for ones of a more whimsical or irrational nature. Parmigianino's *Self-Portrait in a Convex Mirror* and Cellini's gold saltcellar (which I discuss in chapter 8; see figure 69), like Scappi's description of edible table decorations or menus that include fish molded in the shape of a goat's head, reflect the capricious wit, even the perversity, of the Mannerist age. Professional identities were equally unstable. The phenomenon is particularly evident in Tomaso Garzoni's encyclopedic treatise *Universal Piazza of All the Professions of the World*, first published in Venice in 1585 and reprinted no fewer than twenty-eight times over the next century. Cooks and painters are among the 150 professions the author catalogues and presents to the reader, in an order so random as to defy traditional hierarchies of "high" and "low" vocations. In taking this approach, the *Universal Piazza* reflects the general leveling of professions—or aristocratic anxieties about such leveling—that characterized the culture of late-Renaissance Italy in general. Although Garzoni's tone is serious, his remarks are often comical—

for instance, when he hails cooks as "philosophers" and mocks lawyers as "pig gelders."[37] The author's learning is equally obvious in his regular references to classical sources. He cites Athenaeus's *Deipnosophistae* (*Sophists at Dinner*) in support of his recommendation that the ideal cook be versed in medicine, music, astrology, architecture, and nature as well as in philosophy. Elsewhere in the same chapter, Garzoni compares the cook to a military commander and cooking to the military arts. And if that analogy were not enough, he goes on to liken them to "prelates" of a scullery crew and Turkish functionaries who rule a domestic domain:

> Rais (naval captains) in charge of the servants, Eunuchs of the house commanding respect, Pashas in control of the wine, Janizaries in charge of the keys, Viziers entrusted with securing the house, in sum, like so many Bellerbei (governors) in being held in the highest regard.

Losing all touch with reality, Garzoni ends the chapter with an allusion to the cook as master of the legendary land of Cockaigne:

> Therefore the most illustrious *panigoni* [gluttons] of Cockaigne go about their business proud and haughty, because they are the *capi* of the pantry, *padroni* of the cellars, *overseers* of the kitchens, *regents* of salami, *jailers* of prosciutto, *captains* of grease, *master executioners* of meat balls. . . . May everyone take off his hat to the cook, because his majesty among other things has dealings with the Emperor Suleiman and . . . it is necessary to stroke him so that he not sometimes mix the alms-box with the kitchen pots.[38]

What cooks thought of such hyperbole about their profession will never be known. Garzoni's portrait of painters, however, was rather less fanciful, even somewhat prosaic.[39] With tangible evidence like Vasari's *Lives* available for consideration—not to mention the paintings themselves—he clearly had less need for fictional embellishment. In real life, of course, painters had little hesitation in creating myths and inversions of their own.

Beyond private musings in the studio, membership in one of the academies could also inspire a fictive identity. Academies were fraternal organizations that proliferated during the sixteenth century to promote conversation among like-minded individuals. In truth, the visual arts occupied a fairly marginal position among them, but two institutions, the Accademia del Disegno in Florence (founded in 1562) and the Accademia di San Luca in Rome (founded in 1593), represented the interests of artists exclusively.[40] Like most academies, these groups were at first loosely organized, but over time, they became elaborately rule-bound. As academic strictures grew tighter, more unruly spirits were moved to rebel, leading them to create so-called counteracademies. This phenomenon again originated with free-thinking literati before eventually extending to artists, but it proved to be the inspiration for some of the period's most bizarre professional inversions.

The Roman Accademia dei Vignaiuoli, or Academy of Vintners, was a case in point. Founded in the 1530s, it was a center for burlesque poetry of a homoerotic nature that frequently took the clergy as its target. Poets like Francesco Berni and Francesco Molza—both of whom I discuss in chapter 5—were especially adept at casting fruits and vegetables as sexual metaphors in innocent-sounding verses like "Ode to the Peach." In contrast, the inversions of academic painters rarely carried similar erotic intent; they generally seemed more interested in the rituals of eating and drinking.[41] One particularly imaginative example was the Accademia della Valle di Bregno, a Milanese "academy" that pretended to reside in the Val di Bregno, a picturesque region of southern Switzerland whose inscrutable dialect the group adopted as its official language. The choice of Bregno (or Blenio, as it was also called) was not just a matter of whimsy, for the region supplied many of the *facchini*, or wine porters, of Milan. Accordingly, the organization's seal depicted the god of wine riding in a chariot drawn by tigers with the motto "Bacco inspiratori," and its regular programming included mock-Dionysiac drinking rituals.

Giovanni Paolo Lomazzo was the most famous artist to belong to the Accademia della Valle di Bregno, which at its height numbered more than

FIGURE 11. Giovanni Paolo Lomazzo, *Self-Portrait.*

a hundred members. In 1568, he was inaugurated as its second elected director, or "abbot," and it is in this role that he appears in a self-portrait now in the Brera Museum (figure 11). Self-portraits, as we have seen, were commonplace in the period, but Lomazzo's compact image carries

an unusually complex iconography. Numerous interpretations of it have focused on the symbolism of his bizarre costume and attributes, but most would agree that the allusions primarily center on Bacchus as protector of the academy.[42]

Even more dedicated to subverting academic procedures and social decorum was the society of Dutch and Flemish painters in Rome known as the Schildersbent.[43] Founded around 1620 and disbanded by papal decree a century later, this group of artists also called itself the Bentvueghels (birds of a feather), and in its prime, numbered over two hundred members. The polemical nature of the organization was twofold: in addition to refusing to pay annual taxes to the Accademia di San Luca, as was required by law after 1633, the members favored genre scenes that, by Italian standards, were "low" in both subject matter and style. Typically their work combined a fascination with everyday life with contempt for the classical tradition. Membership in the Schildersbent was attended by a set of arcane initiation rituals that aimed to undermine any social pretensions the enrollee might possess. As contemporary witnesses describe this so-called rite of baptism, the initiate first had to stand in a darkened room and undergo a test of courage that might involve gunpowder explosions or frightening ghostly apparitions. Next he had to kneel—in some cases naked—while one of the members intoned "mysterious" words and poured wine over his head. The wine that dripped from his face was then collected in a goblet and given to the novice to drink. The entire affair was presided over by a *veldpaap*, or field pope, whose presence underlined the parodic nature of the ceremony.

With the initiation came the bestowal of a nickname that typically alluded to a personality trait of the *groentje*, or greenhorn. Most were harmless enough, but demeaning aliases like "Elephant" and "Ferret" or "Crab" and "Goatsbeard" were not uncommon either. Indeed, the popular name Bamboccianti has been given to those Bentvueghels who worked in the manner of Van Laer, a man whose physical deformity led to his nickname of Bamboccio, or "Clumsy Puppet."[44]

The Bentvueghels' initiation ceremony was a banquet, paid for by the initiate, that could last an entire night and day ("il meno 24 hore," according to a contemporary Italian source). As one might imagine, the wine flowed freely at such events, which typically ended with the participants stumbling out of the inn after daybreak to make their way across Rome to what they mistakenly believed was the Temple of Bacchus (actually the mausoleum of Santa Costanza), where they poured libations on the supposed grave of the god. Finally, as the party drew to an end, the initiates committed more enduring acts of desecration by affixing their signatures and sobriquets to the walls of the ancient structure.

The Bentvueghels, of course, were not Italian, but their subversions of the prevailing artistic and social proprieties were symptomatic of the self-indulgence and lassitude of the Baroque age as a whole. With them, the Renaissance project came full circle. If as painters they were indifferent to the antiquarian longings and traditional iconographies of previous centuries, they owed their existence to the Renaissance invention, or re-invention, of free will. In a period when food became cuisine and virtuoso cooks were poised to become chefs, painters in general—a narcissistic crowd to begin with—increasingly looked to themselves as the subject of their narratives. By the middle of the seventeenth century, practitioners of both professions, whether expressing their artistry on canvas or at the dinner table, had brought the hedonism and hubris of the Renaissance to the point of no return.

Regional Tastes

Renaissance Italy was little more than a state of mind or, as Metternich so famously said, "a geographical expression." Centuries would pass before Garibaldi would realize the long-standing dream of unification and see the peninsula become a nation. Before 1860, the political landscape consisted of a bewildering configuration of independent city-states with constantly shifting borders and allegiances. In 1300, about a hundred of them existed in northern and central Italy alone, but by 1454, only about a dozen remained. Some were republics (Venice, Genoa, Lucca, and Siena), others duchies or principalities (Florence, Ferrara-Modena, Mantua, Urbino, Parma, and Piedmont). Bigger states like Florence tended to annex smaller ones in their region, whereas foreign powers exploited the vulnerabilities of their neighbors at every turn. Thus, Milan was first occupied by France and then by Spain, which by 1559 also controlled all the lands south of Rome as well as the islands of Sicily and Sardinia. Completing the political map were the territories of the papal states, which themselves were subject to expansion and contraction. Each city-state had its own currency and units of measurement, and the little they had in common was limited to a shared classical legacy, a religion, and, in principle, the Italian language at the heart of numerous dialects. More pronounced regional differences existed in Italy at this time than in any of the nation-states of Europe. The distinct preferences and tastes of some of these regions comparably affected the art and gastronomy that sprang from their soils.

The colorful term *campanilismo* expresses the civic pride modern Italians still take in the loftiness of the *campanile* (bell tower) of the cathedral or

town hall of their hometown. Typically, they put city or region above country when identifying themselves to outsiders. The casting of local stereotypes, the most obvious expression of the phenomenon, was already fairly common in the Renaissance. In Teofilo Folengo's mock-epic *Baldo* (1517), the author—in "macaronic" verse no less—covers a wide range of regional differences in the peninsula. Among other observations, he recommends where to pass false money, locate a doctor, and spot the prettiest girls. But he also suggests where to find certain food specialties: Cremona for beans, Comacchio for salted eels, Ferrara for prosciutto, Piacenza for cheese, Parma for the largest melons, and so on.[1] Sadly, Folengo ignores the visual arts in his survey of Italian local cultures. Similarly, no one who participated in the learned conversations known as *paragone*— critical debates on the relative merits of painting and sculpture—seems to have extended the discussion to expression in the culinary arts.

Physical Geography

By definition, traditional geography is the study of the earth, especially the description of land, sea, air, and the distribution of plant and animal life. If in recent years, the discipline has become fragmented to the point of disintegration, newer academic specialties like "area studies" and "cultural studies," which emphasize the importance of "place" in explaining human behavior, have arisen in its stead.[2] Among art historians, the long-forgotten Germanic notion of *Kunstgeographie,* the geography of art, has made a comeback as well. Thomas DaCosta Kaufmann describes this approach as "an account in which location or place of origin becomes an important issue in the distinctive characterization of the work of art, not just a chance or random fact; place may even be established as a determining factor in the existence or appearance of an artwork."[3] By the same logic, culinary history distinguishes foods by their *terroir.*

The Greeks evidently thought in such terms too. Among ancient treatises, Hippocrates' texts *Ancient Medicine* and *Airs, Waters, Places* were the

first to consider the possible impacts of climatic variations, seasonal change, and different types of landscape on human evolution and behavior.[4] In *Ancient Medicine*, the author speculates on how humans, spurred by necessity and dissatisfaction, conquer their environment through the domestication of plants and animals and the invention of cooking. The human diet would not have evolved, he suggests, had people been content with "the same food and drink as satisfy an ox, a horse, and all other animals." In his opinion, dietary change was necessary for the constitution; people were predisposed, he believed, to seek nourishments that "harmonize" with their humoral nature.[5] *Airs, Waters, Places*, especially in its second section, gives more emphasis to ethnographic and geographic factors. Speaking of the Europeans, Hippocrates suggests correlations between human traits and environmental factors like humidity, altitude, and terrain. People living in mountainous regions—rugged, high, watered, and subject to sharp seasonal changes—are more likely to have large physiques, possess endurance and courage, and tend toward wildness and ferocity. By contrast, those living in meadowlike hollows where hot winds prevail are more likely to be fleshy and dark haired, less brave and hearty, and—evoking humoral theory again—"less subject to phlegm than to bile."[6]

The notion that the physical location of a population might to some extent determine its behavioral and cultural development was fairly widespread in the ancient world. Plato, Aristotle, Polybius, and Stabo each accepted the idea that climate, seasonal change, and landscape leave an indelible mark on culture. Pausanias and Pliny the Elder, our principal guides to classical Greek and Roman art, likewise thought in topographical terms. Of the two, Pliny was particularly conscious of the special properties of local materials. Long sections in book 35 of his *Natural History* discuss the geography of natural colors as well as "other inventions that belong to the earth itself."[7] Pliny was conscious, moreover, of the kind of regional differences in painting that would today be labeled a "school," as in the "Neapolitan School" or the "School of Ferrara." He called such geographical distinctions *genera*, classifying, for example, painting from Ionia, Sicyonia, and Attica as the three principal schools of expression.[8]

Vitruvius, the Roman architectural historian, did the same when he cataloged the classical orders according to their place of origin as Doric, Ionic, and Corinthian.[9]

Ancient authors also classified raw and prepared foods by place. Pliny, in book 11 of the *Natural History*, describes cheeses from Nîmes, the Alps, the Apennines, Umbria, and Liguria.[10] Although a number of Roman texts were dedicated exclusively to cookery, only one, Apicius's *De re coquinaria*, has come down to us through medieval manuscript copies.[11] Apicius, who like Pliny and Vitruvius lived in the first century, discusses not only raw ingredients like hyssop imported from Crete or silphium from Cyrene, but foods prepared in distinctively regional fashions. Bread baked "in the Alexandrine" or "Picentine way," "ragout made in the manner of Ostia," and chicken prepared "in the Parthian" or "the Numidian" manner are just a few of the dishes he singled out.

Renaissance authors were no less conscious of geographical distinctions, both in raw materials and (to use Lévi-Strauss's nomenclature) "cooked" cultural productions. Among the visual arts, the media most dependent upon geographical influences were ceramics and architecture. Just as Pliny signaled the major pottery centers in the ancient world, so Cipriano Piccolpasso's *Three Books of the Potter's Art* (1557) laid the foundations for future maiolica scholarship by associating different styles and colors with regional centers in Castel Durante, Castelli, Ferrara, Ravenna, Urbino, and Venice.[12] Today's specialists may expand the realms of inquiry, but geography remains a central feature of their study.

Vitruvius and Alberti, writing nearly fifteen hundred years apart, both attach geographical associations to architecture and recommend the best places to quarry stone and the most advantageous ways to site a building in a particular environment. After noting that "the stone in quarries differs in quality," Vitruvius names the regions in Italy that have the best examples of soft, medium, and hard stone.[13] A little later in the same volume, in a section entitled "Various Properties of Different Waters," Vitruvius considers the regional distinctions among fruits and vegetables, among other things. On the subject of winemaking, for example, he speaks of the

remarkable differences among the vineyards of southern Italy alone. "This could not be the case," he adds, "were it not that the juice of the soil, introduced with its proper flavors into the roots, feeds the stem, and mounting along it to the top, imparts a flavor to the fruit which is peculiar to its situation and kind."[14]

Alberti elaborates on some of the same geographical determinants in a long chapter on the nature of materials. He singles out stone from more than a dozen regions, highlighting the special properties of each type: durability, resistance to fire, or ease of cutting and carving, for example.[15] Although he briefly advises readers on the storage of foodstuffs, he brings climate into the discussion only when recommending how to construct a wine cellar. "Even well-protected wine is ruined by exposure to any wind from the east, south, or west, especially during winter or spring," he warns.[16]

Thus, it was only natural that the porous travertine of Rome, the darker, harder *pietra serena* of Florence, and the sparkling white Istrian marble of Venice preconditioned the distinct architectural styles of each city. Although buildings in all three places embraced the classical idiom, the raw materials from which they were constructed engendered distinctive visual effects. In Rome, where the travertine is too coarse to allow delicate carving, the façades of stone are rarely embellished with the fine relief sculpture so common in Venice. Similarly, the bichromatic effects in Brunelleschi's churches in Florence were possible only through the juxtaposition of the local *pietra serena* with lighter-colored stone or whitewashed plaster.

Other natural resources have prompted other stylistic choices. Nowhere is the architectural vocabulary more regionally distinctive than in Apulia, in the heel of Italy. Buildings in this province are typically overlaid with lavish sculpted relief that mirrors the bountiful local produce—quinces and pomegranates in particular—or in the coastal towns, the fruits of the sea. Lecce, the architectural gem of the region, is full of churches and palaces carved with lush vegetal and marine motifs, the latter including fish scales, seashells, and even tiny suckers. Indeed, similar embellishments appear on the exterior of even the most unprepossessing domestic buildings.[17]

All of these decorative features remind viewers of the importance of food production in the local economy and culture.

Climate can play as much of a role in architecture as it does in agriculture. The pitch of a roof and the size of windows are the most common indications that the design has taken natural conditions into account, but weather affects stylistic preferences as well. Abundant sunshine favors façades with broken surfaces that allow for dramatic contrasts of light and shadow. Because Sicily receives a thousand hours more sunshine per year than Turin, we should probably not be surprised to discover that the area has the most robustly columnar and curved façades in all of Italy. The shadow patterns that play across the south-facing façade of the Cathedral of Siracusa, for example, shift with every hour of the day, not unlike the sunflowers (*girasole*) that are so common to the region.

Economic Geography

In *Culture of the Fork: A Brief History of Food in Europe*, the economic historian Giovanni Rebora posits the theory of "dominant demand," the notion that growth in one economic sector can yield welcome by-products in secondary markets.[18] In food production, for example, the raising of sheep in a particular region not only supplies its inhabitants with meat but brings the corollary benefits of abundant wool, skins, and tallow. For cattle, the source of beef and butter, the primary by-product is, of course, leather. Thus, as the size of a herd increases to satisfy the dominant demand for food, the secondary production of wool, leather, or candles also increases. According to this model, then, it is only natural that modern Florence, home of the world-renowned T-bone steak known as *bistecca alla fiorentina*, is also the producer of Europe's most desirable leather goods. During the Renaissance, sheep were more common than cows, as we learn from a notice of 1550 that records the precise number and species of all the livestock butchered in the previous year ("quanta carne consuma Fiorenza la città sola e di che sorte").[19] Of the 80,000 animals slaughtered, the majority were sheep or lambs, a statistic that neatly correlates with the

record number of cloths and textiles produced at that time by the thriving wool industry, the employer of more than half the city's workforce.[20]

Questions of Taste

Raw materials are important when creating fine art and delectable meals, but the end results depend on the talent and skill with which the ingredients are transformed. Thus, one might ask if the culinary and artistic practices of the Renaissance shared any regional distinctions. Can one speak of Bolognese art and cuisine in the same breath? Or map a geography of "taste," in both senses of the word?

Outside influences sometimes contaminate the indigenous development of local artistic traditions, as when an influential master from one region moves to another. The migration of Tuscan geniuses like Donatello and Leonardo to Padua and Milan—to cite only the most obvious examples— sparked significant stylistic changes in both cities. Shifts in the political climate following foreign invasions also disrupted regional tastes. In art, the local styles that endured the longest tended to be the most insular. Sienese painting is a perfect case in point. Disdainful of the naturalistic effects that were the hallmark of Renaissance art everywhere else, Sienese masters like Sassetta, Giovanni di Paolo, or Nerocchio de' Landi continued to work in the gold-ground manner of Duccio and Simone Martini long after artists in other regions had abandoned the technique. If the geographical determinants of the Sienese school remain uncertain, art historians have little difficulty distinguishing a panel from Siena from one made in, say, Ferrara or Urbino.

Giorgio Vasari assumed innate differences between the artistic creations of various regions—and his preference for Florentine art is unmistakable— but he did not organize his *Lives* geographically. Only in the seventeenth century did a writer, Giovanni Battista Agucchi (d. 1632)—a Bolognese prelate, diplomat, and man of letters—first identify regional schools as such. In his posthumously published *Trattato della pittura*, Agucchi recognized Rome, Tuscany, Lombardy, and Venice as the principal regional

centers. One of his contemporaries, Giulio Carlo Gigli, postulated no fewer than thirteen artistic *patrie* in his own treatise, *La pittura trionfante* (1615). By the end of the eighteenth century, scholars recognized fifteen regional schools: Luigi Lanzi's magisterial *Storia pittorica dell'Italia* (1792–96) named Florence, Siena, Rome, Naples, Venice, Lombardy, Mantua, Modena, Parma, Cremona, Milan, Bologna, Ferrara, Genoa, and Piedmont. Modern surveys of Renaissance art are less sensitive to geography, although Florence, Rome, Siena, and Venice are still considered regional capitals.[21]

Italian regional cuisine, in contrast, may be more celebrated today than ever before. Alternatively, medieval and Renaissance cooking tended toward surprisingly unified "national" norms. An assessment of the thousands of ingredients, recipes, and menus recorded in premodern books of cookery discloses only a small percentage of items identified by region or city, and most such mentions refer to raw produce. Thus, Platina, repeating in the 1460s the view of ancient authors like Varro and Pliny, acknowledged, "We find some things better in one place than another," and he singles out "the Campanian region for the best grain, the Falernian for wine, the Casinan for oil, the Tusculan for figs and honey, the Tarentine for fish, especially bass, Ravenna for turbot and the Sicilian shore for moray eel."[22] But Platina has relatively little to say about local practices of food preparation. Despite spending much of his life in Rome, he notes only three Roman specialties: veal "grilled with coriander or fennel," noodles "with cheese, butter, sugar, and spices," and cabbage "wrapped with well-pounded lard." The only other regional dishes he names are Sicilian macaroni, Bolognese *torta*, and eggs Florentine. A compilation of Italian recipes culled from later authors like Messisbugo (1557), Scappi (1570), Pisanelli (1583), Rossetti (1584), and Stefani (1662) yields similar results, with the number of local specialties rarely exceeding 5 percent of the total.

The most comprehensive of all these texts, Scappi's *Opera dell'arte del cucinare*, contains the greatest number of regional dishes. This cosmopolitan author began his culinary career in Bologna before moving to Rome, where, in the 1550s and 1560s, he served a succession of popes who came from Rome, Tuscany, Naples, Milan, and the Piedmont. His magnum opus was

published in Venice, where it eventually was reprinted six times over the course of the next century.

Scappi's *Opera* consists of six books. Book 1 discusses the necessities of a kitchen, the requirements of its master cook, and how one selects the best raw ingredients. Book 4 recounts the approximately two thousand dishes served at more than one hundred multicourse dinners and suppers, whereas books 2, 3, 5, and 6 provide a total of 1,022 recipes touching on every part of a meal, including dishes in the final chapter that are suitable for the ill and infirm. Altogether, Scappi refers to foods from thirteen regions in Italy, identifying less than 13 percent of the menu items and a little less than 3 percent of the recipes by place of origin.[23]

The banquet menus give a particularly good sense of the local specialties served "throughout Italy, but mainly in Rome" during the middle decades of the sixteenth century.[24] Significantly, the most popular regional dishes of today—*pizza alla napoletana, saltimbocca alla romana, bistecca alla fiorentina, fettuccini alla bolognese, fegato alla veneziana, and risotto alla milanese* (to name but a few)—do not appear on Scappi's lists. Just as significantly, the most frequently cited local items were generally not meat, fowl, or, with the exception of Venice, fish. Olives, however, were always identified by place of origin along with a lesser number of tarts, soups, and pastas. Among the more popular dishes were *ravioli alla fiorentina* and *alla milanese*, Bologna's *torta d'herbe* (herb pie), along with its renowned sausages, and Roman *cascio* (cheese) and macaroni. Yet of all the "imports" Scappi cited, by far the most common were baked desserts. *Mostaccioli* (cookies) from Naples and, to a lesser extent, from Rome were particularly popular, whereas biscotti from Pisa and *offelle* (wafers) from Milan also regularly appeared on the menus.

Scappi's contemporaries offered certain variations on his regional repertory. Giovanni Battista Rossetti was the first to organize an alimentary catalogue with any sense of geography in mind. Yet his *Dello scalco* (published in Ferrara in 1584) did so only for *confetture* (sweets), and not for the principal parts of the meal.[25] Most early books tended to emphasize the quality of individual items such as Parmesan cheeses, Bergamasque

beans, Florentine fennel, and Vicentine rabbits. Ortensio Lando's fanciful *Commentario delle più notabili & monstruose cose d'Italia* (1548), although not exclusively dedicated to culinary matters, was freer with its opinions than most texts. The large sausages of Bologna, Lando explained, were "the best I've ever eaten," the bread in Mantua "is made in Paradise," and the gnocchi with garlic in Piacenza was so good "it could revive the appetite of the dead."[26]

Nevertheless, regional chauvinism leaves a weaker imprint in the culinary literature of Renaissance Italy than one might imagine. The titles of the principal texts give little clue to their place of origin, and any sense of geographic distinctiveness is typically reserved for individual imports, rarely for the homegrown product or for menus as a whole. With time, this pattern would change. In the seventeenth century, Giovanni del Turco featured his native Tuscan cuisine in a trio of manuscripts he called *Epulario e segreti vari* (1602–36), and Bartolomeo Stefani identified himself as "Cuoco Bolognese" on the title page of his *L'arte di ben cucinare* (1662).[27] In Naples, Giovanni Battista Crisci and Antonio Latini put southern Italian cuisine on the map in a similar fashion.[28] Pride of place is implicit in all of these books, even when they include foods from other regions.

Writers on art followed a similar trajectory. The urtext of artistic biographies, Vasari's *Lives,* may have favored Florentine art, but the author includes artists from every part of the peninsula and even a few from Flanders. Seventeenth- and early eighteenth-century sources, in contrast, tend to be more geographically specialized. Between 1642 and 1768, more than a dozen biographies of artists from Venice, Bologna, Genoa, Florence, Rome, Naples, and Messina were published.[29]

Though the effort to link the culinary and visual arts of Renaissance Italy to their geographical settings is by no means unproblematic, the connection is fairly obvious in some instances. Florence and Venice make perfect case studies, each having unique physical features and distinctive art and cuisine. Florence lies inland in the cradle of the Arno Valley whereas Venice floats in a lagoon of the Adriatic Sea. Renaissance Florence was built on a gridlike plan whose straight streets recall its ancient origins as

Roman Florentia, whereas Venice is a Byzantine labyrinth of curved and crooked canals. Florence is mostly monochromatic, tending primarily to sepia tones, whereas Venice is luminous and colorful. The back streets of Florence appear solemn, sober, and typically businesslike in contrast to the mazelike *calle* of Venice, which are enchanting, exotic, even a little sinister. Florence appeals to the intellect; Venice plainly plays on one's mood. In the literature of travel, countless personal accounts attest to the psychological impact of these different environments.

Is it an accident that Tuscan food, like Florence itself, is known for its sobriety? Fynes Moryson, an English Grand Tourist of the early seventeenth century, rather tersely observed, "The Florentines are of spare diet, but wonderfull clenliness," and he contrasted the meals he took there with the "magnificence" and "plentifulness" of ones he enjoyed elsewhere.[30] The first book of cookery from the region, Giovanni del Turco's *Epulario e segreti vari* (1602–36) gives a more detailed account of local fare during the same period.[31] For the most part, the recipes are simple and straightforward. Not surprisingly, meat played an important role in the everyday diet, and the accompanying condiments were comparatively spare. Lard remained the most common medium for cooking all types of meat, and cinnamon (*canella*) was especially popular among spices. Saffron appears but rarely in recipes; the standard herbs, which the author calls "gli erbucci," were parsley, onion, and beet leaves.

Tuscan dining habits seem not to have changed greatly over the years. In his informative and often witty book *Heat*, Bill Buford describes a meal he was recently served in the Tuscan countryside.

> The local crostini . . . smeared with chicken liver pâté were brown. *Pappa al pomodoro*, another local dish, was made from stale bread (the unsalted, flavorless kind) cooked with overripe leftover tomatoes until it degenerated into a dark brown mush: brown on dark brown. The many varieties of local beans: brown. The local vegetables? Green-brown artichokes, green-brown olives, and porcini mushrooms (brown-brown).

If indeed Tuscany was responsible for a sizable portion of the world's best cooking, then it must have been the brown part.[32]

By contrast, traditional Venetian cuisine is colorful and well seasoned. The colors are a reflection of Venice itself, but the seasoning is imported. Already in the thirteenth century, Venetian fleets controlled the spice trade with the East.[33] The Fourth Crusade and Marco Polo's journeys sprang from different motives, but together they procured saffron, tarragon, nutmeg, cinnamon, ginger, and cloves for tables at home. The spices were distributed throughout Italy, but Venetians—who have never been big meat eaters—invented ways of using them to season a variety of other dishes.[34] According to the first Venetian recipe collection, the fourteenth-century *Libro di cucina*, a basic seasoning ("specie fine a tute cosse") included "an ounce of pepper, an ounce of cinnamon, an ounce of ginger, an eighth of an ounce of cloves, and a quarter ounce of saffron."[35] Saffron, of course, is the key ingredient in this list. The most expensive of all the spices, it reputedly takes 70,000 crocus flowers to produce a pound of stigmas. By nature, the color of saffron appeals as much to the eye as its pungent flavor does to the palate. No other spice seems to so readily prompt sensory crossovers. Indeed, the seasoning described in *Libro di cucina* is not only savory to the taste, but its smoky golden hue evokes the dusky gold mosaics of San Marco shimmering in the flicker of candlelight. Artists were naturally drawn to saffron for its hue alone, red in its raw form and golden yellow when immersed in liquid. Cennino Cennini devotes a chapter of his *Craftsman's Handbook* to its use in making yellow dyes or when mixed with verdigris, in making "the most perfect grass-green imaginable."[36]

The otherworldly allusions of gold-leaf panels like Guariento's *Christ the Redeemer* are self-evident (see figure 57 in chapter 6, where I discuss the painting in greater detail), but color also played a significant, if less obvious, role in Renaissance dietary theories. Such beliefs were grounded in both humoral theory and the so-called doctrine of the signatures, which maintained that the shapes and colors of certain plants were inherently

anthropomorphic.[37] The Neoplatonic philosopher Marsilio Ficino was the most formidable advocate of food/color theory, arguing in his *Liber de vita*, or *Book of Life*, also called *De vita triplici*, or *Three Books on Life* (1489), that because yellow foods had an affinity with the sun, they were therefore superior to darker ones. Speaking of saffron, he writes, "Just as saffron seeks the heart, so that it might dilate the spirit and provoke laughter, it does this not only by a marvelous hidden power of the Sun, but because the nature of saffron itself is subtle, amplifiable, aromatic, and bright."[38] Ficino also recommends saffron for the treatment of sleeplessness and melancholia, among other uses.[39] The myth of saffron's healthful properties continued, and in the next century, Baldassare Pisanelli touted saffron in his *Trattato della natura de'cibi et del bere* (1583) as a facilitator of coitus, urination, and childbirth, as well as an aid to the complexion.[40]

In his *Grand dictionaire de cuisine*, Alexander Dumas asks, "Is it to spices that we owe Titian's masterpieces? I am tempted to believe so." "Colorism" was one of the distinctive features of Venetian Renaissance painting, but the term is often misunderstood. Although *colore* may suggest an array of bright colors, in Venice, it describes the effect of earthy tones melting softly together in a warm atmosphere enlivened by free and suggestive brush-work. Florentine art, by comparison, is traditionally known for its *disegno*—the Italian word for both design and drawing—a compositional method that relies more on line than color to achieve its effect. Not surprisingly, Giorgio Vasari, the champion of all things Florentine, celebrates *disegno* throughout his *Lives*.[41] In an introductory chapter, Vasari explains that *buon disegno* originates in the intellect and that paintings composed with lines best express "the conceptions of the mind."[42] To this way of thinking, the locus of *colore* evidently lay elsewhere.

If we compare Florentine and Venetian paintings from around the same period, the regional differences are readily apparent. Botticelli's *Birth of Venus* (figure 12) and the *Pastoral Concert* (figure 13), attributed at times to either Giorgione or Titian, make excellent examples because both feature female nudes in outdoor settings. Thematically and formally, however, the similarities end there. Botticelli's canvas is an allegory of divine and

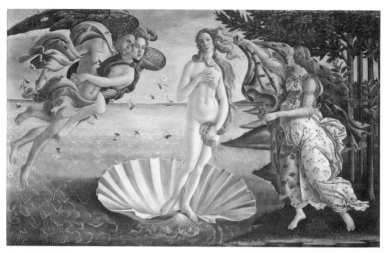

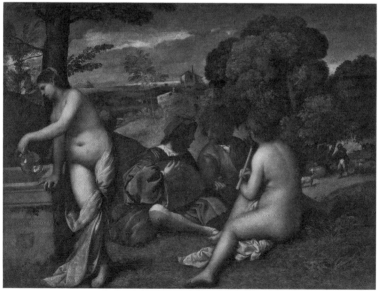

FIGURE 12. (Top) Sandro Botticelli, *Birth of Venus.*
FIGURE 13. (Bottom) Giorgione or Titian, *Pastoral Concert.*

earthly love attuned to the Neoplatonic conceptions fashionable in Medici circles at the time. Reading the picture from left to right, we see Zephyr, accompanied by a nymph, blowing the celestial Venus to shore, where an attendant personified as Spring waits to cloak her in earthly garb. Learned quotations abound in the arrangements of the figures: Venus's pose and gestures repeat those of the classical *Venus Pudica*, or modest Venus (a famous sculpture in the Medici's own collection), whereas her attendant's stance recalls the pose of Saint John in representations of the baptism of Christ. This conscious conflation of classical and Christian ideals originated in the writings of Marsilio Ficino, whose *Theologica Platonica* and *De christiana religione* had been published in Florence a decade or two earlier (just before his *De vita triplici*). The exact meaning of Botticelli's *Birth of Venus* may still be elusive, but its intellectual ambition—or pretension—is clear.

The *Pastoral Concert*, in contrast, has never supported complex interpretations. Indeed, what single narrative could account for the presence of two nude females and two clothed men in a dusky landscape? Why are the women so indifferent to one another? Why are the men dressed in such disparate attire, one in urban finery and the other in rustic costume? Even Vasari, in his life of Giorgione, seems a little exasperated by the artist's tendency "to work with no other purpose than to make fanciful figures to display his art, for I cannot discover what they mean, whether they represent some ancient or modern story, and no one has been able to tell me."[43] The most likely explanation is that paintings like the *Pastoral Concert* were intended as *poesie* in their own right, existing independently of traditional textual sources.

The content of Florentine art, by and large, is more high-minded and didactic than that from Venice, complementing the local preference for *disegno* over *colore* as well as its affinity for greater clarity of organization and crisper handling. To compare the linear precision of Botticelli's stylized waves and foliage with the more painterly treatment of related passages in the Venetian work is to see the contrast in the plainest terms.

From the standpoint of *Kunstgeographie*, or art geography, perhaps the

most striking observation is that the Florentine seascape was painted on dry land and the Venetian landscape by the edge of the sea. Art, of course, is as capable of offering an escape from the commonplace and predictable as of reflecting reality. The fact that European landscape painting originated in Flanders and Venice, seemingly at the same time, is surely no accident. That the flatlands of Flanders were featureless and Venice was built on water obviously led painters in both places to envision an alternative reality of the imagination, a fictional geography that displaced actual experience.

Some forms of "realism," in contrast, may be the product of deeply embedded, even subconscious, ways of seeing. Historians have typically explained Renaissance ideals in "cultural" terms, but a growing body of scholarship now looks to biology's role in artistic creativity.[44] Writers have recently adopted the term *neuroarthistory* to describe the study of the effects of brain physiology on the visual imagination, a determinative process foreseen in the writings of Plato and Aristotle.[45] Goethe clearly understood the proposition when he noted in his *Italian Journey* the "odd idea" that "since our eyes are educated from childhood on by the objects we see around us, a Venetian painter is bound to see the world as a brighter and gayer place than most people see it. We northerners who spend our lives in a drab . . . and uglier country where even reflected light is subdued . . . cannot instinctively develop an eye which looks with such delight at the world."[46]

Modern studies in neuroscience confirm the link between biology and the environment.[47] Because the human brain is only half formed at birth, the neuropsychology of vision develops in partial response to the stimuli it receives in life. Experiments with chimpanzees (whose brains at birth are more completely developed than our own) indicate that the neurons of the visual cortex adapt to perceptual differences in patterns and colors, forming networks that multiply or atrophy in response to local conditions. Studies of people who have experienced injury and sensory deprivation suggest that humans react in the same way.[48] Thus, one can assume that individuals raised in environments particularly rich in certain elemental features, like straight or curved lines, strong colors or soft tones, develop

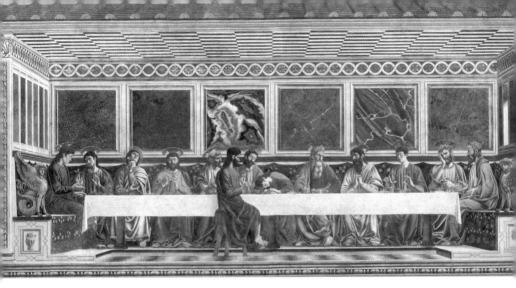

FIGURE 14. Andrea del Castagno, *Last Supper.*

neural networks attuned to the predominant stimuli. A fascinating study by John Onians, "The Biological Basis of Renaissance Aesthetics," pursues the implications of this finding for the history of art. Building upon traditional *Kunstgeographie* as well as modern notions of the "urban unconscious"—a theory first applied to the art of Delft and Leiden[49]—Onians posits the origins of linear perspective:

> If we were to try and predict in which city a preference might develop for pictures configured around lines parallel to the picture plane and receding orthogonals, then a theory that assumes neural networks are passively formed by environmental exposure would prepare us to look neither to Rome with its jumbled rounded ruins, nor to Venice with its sinuous Grand Canal and irregular alleys, nor to Siena with its curved piazza and meandering streets, nor to Bruges or Ghent with their winding waterways and steep gables. The place where we would expect this preference to emerge would be Florence with its river, straight as a canal, its quadrilateral Roman core, and its medieval periphery built around a network of straight roads.[50]

Neuroscience may or may not explain the genesis of one-point perspective, but the straightforward thinking that led to the exacting spatial illusionism of Florentine pictures like Castagno's 1445 fresco of the Last Supper (figure 14) expressed itself with equal purpose in the city's attitudes toward business and banking. In his treatise *On Civil Life* (1430–35), the Florentine Matteo Palmieri recommended the study of geometry for sharpening the minds of children, whereas by the same logic, the banker Giovanni Rucellai advised the study of mathematics "to spur the mind to examine subtle matters."[51] One of the key elements in the success of the Rucellai and Medici banks was the adoption of double-entry bookkeeping, in which each financial transaction is recorded in credit or debit columns.[52] Michael Baxandall was surely on to something when, in 1972, he posited "a continuity between the mathematical skills used by commercial people and those used by the painter to produce the pictorial proportionality and lucid solidity that strike us as so remarkable now."[53]

For centuries, the recipe we now call *bistecca alla fiorentina* has been the signature dish of Florence and the glory of the Tuscan table.[54] The beef itself has a long pedigree going back to pre-Roman times, when Etruscan farmers raised cattle in the Chiana Valley of eastern Tuscany. During the Renaissance, diners knew the classic Chianina steaks simply as *carbonata*, because the meat was typically grilled with nothing more than salt and pepper over the embers of *carbone di legna* ignited from hard oak or olive branches.[55] The proper *carbonata*, according to most authorities, is a *lombata*, or T-bone with filet, at least an inch and a half thick. Only with the culinary regionalism that followed the unification of Italy in the late nineteenth century was the dish named *bistecca alla fiorentina*. Pellegrino Artusi's *Science in the Kitchen and the Art of Eating Well* (1891) was apparently the first cookbook to do so, although the author admitted that its appeal "had yet to spread to the rest of Italy."[56]

Were T-squares and T-bone steaks somehow linked in the Florentine subconscious? Were the taste for simple cuisine and the predilection for linear perspective perhaps related? As one ponders the analogy, Bru-

nelleschi's basilicas of San Lorenzo and Santo Spirito also come to mind. Like the restrained Florentine diet, their interiors are sparely ornamented and their exteriors are left without façades, an anomaly among Italian churches of their time. Looking further across the cultural horizon, we might ask why Girolamo Savonarola, Italy's most puritanical cultural reformer, found as receptive an audience as he did in Florence. One cannot imagine his brand of demagoguery flourishing in Venice or Rome.

The experience of living in Venice would have conditioned a different set of neural networks. The brains of Venetian painters were presumably transformed by the constant sparkle of moving water, colored marbles, golden mosaics, and oriental silks. Venetian patrons, in turn, would have responded positively to such effects and preferred paintings that included them, whether in the golden flashes of Antonio Vivarini or the elusive highlights of a Bellini or Titian. The same factors may also have conditioned the Venetian preference for oil paint, with its greater capacity for capturing brilliance and reflectivity.

Venetian diners, in parallel fashion, were drawn to food embellished with colorful spices and to produce from the city's picturesque markets. Thomas Coryate, author of *Coryate's Crudities* (1611), was among the first to record his astonishment at the "marvellous affluence and exuberancy of all things tending to the sustention of man's life," and he singled out the "great abundance ... of victuals, corne, and fruites" to be found in Venice's "exceedingly well furnished markets."[57] Yet display apparently counted for more than consumption in Renaissance Venice, for in a later passage, the author comments on "the very frugall table" set by the Venetian nobility.[58] The surprising truth of his assessment finds support in the earlier remarks of a Milanese pilgrim, Canon Pietro Casola, who in 1494 passed through Venice on his way to and from the Holy Land. Outbound, Casola dryly noted, "The Venetians are so occupied with their produce that they do not trouble much about what they eat," whereas on his return, still hungry after attending a private dinner, he grumbles, "I think the Venetians consider that the refreshment of the eyes is enough."[59]

The Venetian love of visual display continues to the modern day, as anyone who has visited the outdoor markets near the Rialto Bridge can attest. Elizabeth David paints a colorful picture of these markets in *Italian Food:*

> Of all the spectacular food markets in Italy the one near the Rialto in Venice must be the most remarkable. The light of a Venetian dawn in early summer ... is so limpid and so still that it makes every vegetable and fruit and fish luminous with a light of its own. ... Here the cabbages are cobalt blue, the beetroots deep rose, the lettuces pure green. ... Bunches of gaudy gold marrow flowers show off the elegance of pink-and-white marbled bean pods, primrose potatoes, green plums, green peas. The colors of the peaches, cherries, and apricots ... are reflected in the rose-red mullet and the orange *vongole* and *canestrelle*, which have been pried out of their shells and heaped into baskets.[60]

Elsewhere in the book, David praises the Taverna Fenice, one of the city's most venerable restaurants, for "translating the flavors of Venetian painting into the kitchen."[61]

Comparisons between colors in food and art can also be misleading. As every art student knows, the signature color of Venetian Renaissance painting is Venetian red, a warm scarlet that Titian and Tintoretto commonly used for costumes and draperies. The folds of these textiles are typically rendered with prominent white highlights that suggest the sheen of silk or satin. The combined hues, brushed freely over the canvas, dazzle the eye like a sunset washing over the Venetian lagoon. Remarkably, the same color combination appears in *radicchio di Treviso,* a local leaf vegetable available in every Venetian market. The similarity between the hues of the most prominent drapery in Titian's *Entombment* (figure 15) and those of a fresh head of radicchio (figure 16) might suggest a connection between the two. Pliny informs us that "marvellous red-lined lettuces of the Veneto region" were already present in his day, yet the red *radicchio di Treviso* that is so popular today was reportedly first cultivated in the 1860s.[62] Renaissance radicchio presumably would have been whiter.

FIGURE 15. Titian, *Entombment.*

Rome—the showcase of High Renaissance culture—invariably imported its talent from other provinces. Neither Raphael, Bramante, nor Michelangelo was raised or trained in the Eternal City, and though each responded to the city's classical heritage, the roots of their creative expression lay elsewhere. Surprisingly, of the dozens of artists and architects active in Renaissance and Baroque Rome, only two of consequence were born there: Raphael's pupil Giulio Romano and Caravaggio's follower Artemisia Gentileschi.

Traditional Roman cuisine for the most part was equally eclectic. Even the origins of *saltimbocca alla romana,* now the city's most famous specialty, are a little dubious. In the words of the food historian Waverly Root, "Any Roman will tell you that *saltimbocca* is a purely Roman dish, but I would be inclined to think it is a purely Roman name for a dish which appears in modified forms in several parts of Italy and probably originated

FIGURE 16. Radicchio.

in Brescia, Lombardy."[63] Needless to say, *saltimbocca* does not appear in recipe collections before the nineteenth century and is almost certainly an invention of the modern era. The originality of similar Roman specialties like *pollo alla diavola* and *gnocchi alla romana* is similarly suspect.

Beyond Tuscany and the Veneto, other regions of Italy also saw a renascence of art and cuisine spring from common soil. The most vital expressions tended to occur in areas of political stability where enlightened patronage was considered essential to the prestige of the state. Emilia-Romagna was such a place, with Ferrara, Bologna, and Parma each enjoying creative independence during the Renaissance. By tradition, the residents of all three cities are known for their hearty appetites. Because "the people of Emilia and Romagna are strong, hard working, warm blooded, and above all cordial and *bon vivants*," one Italian source has noted, "it follows that their gastronomy has a robust character, healthy and tasty, with a number of really typical dishes."[64] At the same time, the art produced in each city had distinctive characteristics.

Bologna, the home of one of Europe's oldest universities (and now Emilia-Romagna's capital), has always been noted for its rich cultural climate. The epithet Bologna la Grassa (Bologna the Fat) was coined in the late Middle Ages, not for the girth of the area's population but for the richness of its soil. The land, according to one sixteenth-century chronicle, produced

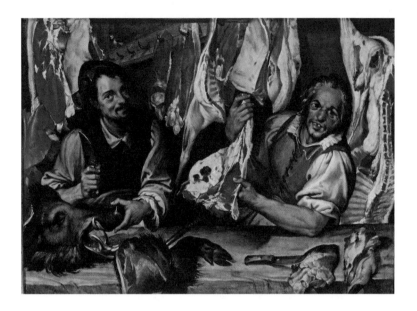

FIGURE 17. Bartolomeo Passarotti, *Butcher Shop*. (Photoservice Electa)

"wheat, wine, and everything necessary to life."[65] Then, more than now, olives were cultivated around Bologna and especially revered throughout Italy, but the most frequently cited prepared foods in Renaissance books of cookery are herb pie (*torta d'herbe*) and large sausages (*salciccioni*). Surprisingly, *tagliatelle* and *tortellini*—the pasta dishes now most commonly associated with Bolognese cuisine—made only rare appearances on early Italian menus, although both were popular locally. According to Bolognese folklore, their origins were anthropomorphic: *tagliatelle* was reportedly the invention of a cook who fashioned it after the flaxen hair of Lucrezia Borgia, whereas the first *tortellini* were said to have been molded directly from the navel of a compliant local woman.[66]

Bolognese painters, who never embraced Mannerism with much enthusiasm, were among the most resolute in rejecting its formal and iconographic excesses. Moreover, they frequently expressed their independence

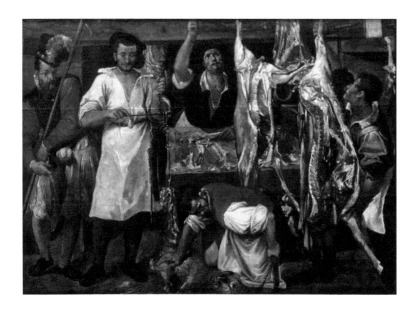

FIGURE 18. Annibale Carracci, *Butcher Shop.*

through down-to-earth depictions of food. Bartolomeo Passarotti (1529–92) was instrumental in making Bologna the primary site of gastronomic naturalism, forgoing a successful career as a portraitist and religious painter in the 1570s to render a series of genre scenes featuring butchers and food sellers. The sources of his imagery were ultimately Flemish (see chapter 5), but the naturalism of works like the *Butcher Shop* (figure 17) was uniquely Bolognese. The meats on display—beef and boar—and the men who offer them eschew the allusions and iconographical complexities of works by his predecessors Pieter Aertsen and Joachim Beuckelaer or his Cremonese contemporary Vincenzo Campi. A few years later, in the early 1580s, the young Annibale Carracci adopted Passarotti's naturalism as part of his own anti-Mannerist polemic when he painted a series of Bolognese *macellerie*, or butcher shops (figure 18). Curiously, neither Passarotti nor Carracci included Bologna's famous *salciccioni* among the meats on display,

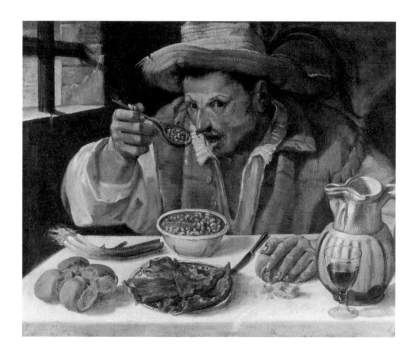

FIGURE 19. Annibale Carracci, *Bean Eater.*

both preferring to portray freshly butchered livestock. Yet Annibale's most renowned genre painting, the *Bean Eater* (figure 19), features the city's preeminent specialty, *torta d'herbe.* The picture may take its modern title from the peasant eating the lowly beans, but the *torta* occupies the most prominent position in the foreground of the composition.

Bartolomeo Scappi includes Bolognese *torta d'herbe* more frequently on his "national" menus than virtually any other regional dish (only Lombard *tortiglioni repieni* appears more often among the fifty-five prepared foods that he cites). Although recipes for herb pie appear in fourteenth-century collections, the identification with Bologna first occurred in the fifteenth century, initially with Maestro Martino and then with Platina.[67] Platina

gives the definitive recipe, which calls for mixing ground cheese with chard, parsley, marjoram, and eggs, seasoned with pepper and saffron, and cooking the pie in fat or butter until the upper crust is raised. Evidently, he was not too fond of it himself, however, for he concludes the recipe with the admonition, "This is even worse than the one above," a reference to a plain cheese pie that he believed "causes blockages, generates stones, and is bad for the eyes and nerves."[68]

By foregrounding Bologna's most famous dish, Carracci drew further attention to the gastronomic realism of the bean eater's meal. Realism in early modern art took various turns—one thinks of Caravaggio's cardplayers, fortune tellers, and musicians, for example—but in Bologna, arguably the premier culinary center in all of Italy, the depiction of food was a more natural expression of local culture than it was anywhere else. For Passarotti and Carracci, Bologna inspired both the reform of painting and the celebration of the legendary local appetite. There, as in few other places, art and cuisine intersected naturally. Pellegrino Artusi attributed Bologna's "rather heavy cuisine" to "the climate [which] requires it," but in addition to the appellation Bologna la Grassa, the city is also known as Bologna la Dotta (Bologna the Learned) for the rigor of its intellectual life. At some level, the psychogeography of the community—composed of naturally skeptical academics, reform-minded artists, and no-nonsense cooks—was bound to express itself in a culture that valued authenticity over artifice. That bologna—a weak derivative of the city's famous mortadella sausage—remains the commonest cold cut in American delicatessens is testament to the endurance of this geographic tradition. By an ironic twist of nomenclature, the dubious stuffings that often went into these once-proud *salciccie* have led the English-speaking world to coin the word *baloney* (or *boloney*) to signify anything that seems false or inauthentic.

Images of Food in Art

Significant Still Lifes

The term *still life* is but a tame translation of *natura morta*, which literally means "dead nature." By definition, one thus might expect still-life paintings to evoke transience and decay, but few painters from sixteenth- and seventeenth-century Italy seemed willing to bear this ethical burden. Though images of skulls, bones, and other symbols of impermanence have come down from classical times, Renaissance artists took little interest in the *memento mori* theme, preferring more recondite interpretations of the natural world. Ironically, the Protestant Netherlands—where the term *stilleven* originated—saw the fullest realization of the moralizing potential of the genre. Northern painters were especially drawn to such didactic themes when the opportunities for depicting sacred narrative began to wane in their iconoclastic societies. The reverse, of course, was true in Italy; there, narration remained the primary goal of high-minded artists, and genre painting was held in low regard. Nevertheless, two types of still-life painting stand out in Renaissance Italy: *xenia*, and what later came to be known as *bodegónes* in Spanish painting.

Xenia

In the ancient world, hosts sent their house guests gifts of food (or realistic depictions of food) known as *xenia*, the Greek word for hospitality. Vitruvius briefly if somewhat elliptically describes the practice in his *Ten Books on Architecture:*

> When the Greeks became wealthier and more refined, they outfitted their guest quarters with well-stocked pantries for visitors about to ar-

rive, and on the first day would invite the guests to dinner, after that sending over chickens, eggs, vegetables, fruits and other country produce. For this reason painters who imitated such "hospitalities" called them "xenia."[1]

If paintings of comestibles could take the place of the real thing, the same was true of literary images. Martial gave the title *Xenia* to his little book of epigrams describing the five courses of a Roman banquet.[2] The poems, he explains to the reader, "you can send to your guests instead of a gift, if a coin shall be as rare with you as with me."[3] All the painted or written *xenia* in the ancient world had one thing in common: a powerful sense of realism. Every example that has come down to us shows a fascination with the shapes and textures, even the flavors and aroma, of the edibles on display.

One of the *topoi* of art criticism in antiquity centered on the ability of realistic images, and still-life painting in particular, to fool the observer into confusing art with life. The urtext of the aesthetic was a passage in Pliny's *Natural History* describing the work of the Greek painter Zeuxis. In this first-century account, Pliny writes,

> Zeuxis painted a boy carrying grapes, and when birds flew down to settle upon them, he was vexed with his work and remarked ... "I have painted the grapes better than the boy, for otherwise the birds would have been afraid."[4]

Pliny then describes a competition that ensued between Zeuxis and another painter named Parrhasios. In response to Zeuxis's picture of grapes,

> Parrhasios then displayed a picture of a linen curtain, realistic to such a degree that Zeuxis, elated by his own effort in painting the birds, cried out that it was now the turn of his rival to draw the curtain and show his own picture. On discovering his mistake he surrendered the prize to Parrhasios, admitting candidly that while he had only deceived the birds, Parrhasios had deceived himself, a painter.[5]

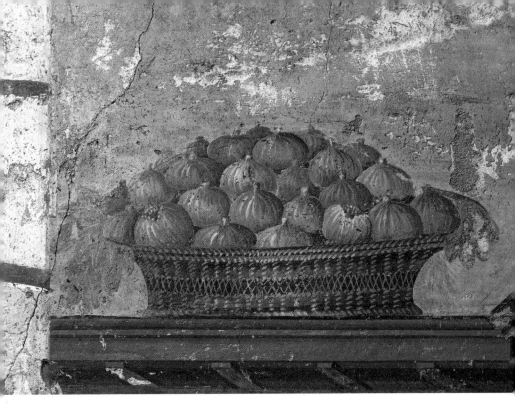

FIGURE 20. *Basket of Figs.* Fresco from Villa di Poppea, Oplontis.

Although no works by Zeuxis or Parrhasios survive, numerous ancient
frescoes and mosaics depicting trompe l'oeil birds and fruit have sur-
faced in modern excavations.[6] Works like the *Basket of Figs* from Oplontis
(figure 20) reveal a commitment to realism that would be remarkable in
any age. In this fresco, an intricately woven basket appears on an illu-
sionistic shelf painted high on the wall in the villa's *triclinium,* or dining
room. Most remarkable, given the work's early date, is its *di sotto in su,* or
"worm's eye," perspective, which is perfectly adjusted to the sight lines
of a spectator standing below it. Viewed in situ, the painted space
appears to be an extension of the real space of the room. The artist
achieved this illusion not through the use of mathematical or linear

perspective, which was only invented during the Renaissance, but simply from direct observation. The natural light illuminating the scene from above enhances the sense of reality, making the ripe figs look good enough to eat.

Renaissance artists would have had few if any opportunities to see such virtuoso (and as yet unexcavated) images, but they would have been familiar with them through literary sources like Pliny. By the sixteenth century, his *Natural History* was so popular that it has since become known as "the household encyclopedia of the period," whereas the Zeuxis tale, according to a contemporary source, was "known even by young children."[7] Fashioning works *all'antica*, or after the antique, was of course the signature trait that gave the Renaissance its name.

Renaissance and Baroque painters also took inspiration from ancient *ekphrases*, short rhetorical exercises that put pictures into words. The most famous of these was the *Imagines* of Philostratus, a third-century collection of poems purportedly describing paintings that hung in a villa on the Bay of Naples.[8] Most of the verses describe images of mythic figures or places, but two bear the title "Xenia." One of these verses evokes a basket of figs much like the one from Oplontis.

> It is a good thing . . . not to pass over in silence the figs in this picture. Purple figs dripping with juice are heaped on vine-leaves; and they are depicted with breaks in the skin, some just cracking open to disgorge their honey, some split apart, they are so ripe. Near them are [other] figs, some still green and "untimely," some with wrinkled skin and over-ripe, and some about to turn, disclosing the shining juice . . . while a sparrow buries its bill in what seems the sweetest of them. . . . The basket is woven, not from alien twigs, but from branches of the plant itself.[9]

Six of the eight editions of Philostratus published during the sixteenth century were printed in Italy, an indication of the book's popularity at the time.[10] Titian, probably the first artist to be inspired by *Imagines*, painted

two of its more fanciful narratives between 1518 and 1523 for a special gallery in the castle of Alfonso d'Este, duke of Ferrara. These canvases, which were to be part of a larger series of mythological pictures, portrayed the festival of Venus and the bacchanal of the Andrians.[11] By nature, the artist was not a realist, nor was he particularly drawn to the challenge of painting *xenia* or other deceptive depictions. Indeed, as the Mannerist fashion for artifice and stylization swept through Italy in the sixteenth century, naturalism remained nothing more than an undercurrent flowing against the prevailing tide.

One Renaissance artist who did endorse the ancient ideals of mimesis and deception was Leonardo. Throughout his voluminous notebooks, he repeatedly compares an artist's talent to the reflections of a mirror, even advising painters to "take the mirror as your master" or use it to check the accuracy of "what you have [already] portrayed from nature."[12] Like Zeuxis and Parrhasios, Leonardo was intrigued by the ability of a two-dimensional image to fool the eye. "I once saw a painting," he wrote,

> which deceived a dog by means of its likeness to the master. The dog made a great fuss of it. And in a similar way I have seen dogs barking and trying to bite painted dogs, and a monkey did an infinite number of stupid things in front of a painted monkey. I have seen swallows fly and perch on iron bars which have been painted as if they are projecting in front of the windows of buildings.[13]

In practice, Leonardo painted very little that could stand up to the mirror test. Although he drew fastidious studies of plants and foliage on paper and occasionally inserted highly realistic details in the margins of paintings like the *Last Supper* and *Madonna of the Rocks*, his main interest was the human figure. In this focus, he was not alone, for what he called "fictions signifying great things" continued to dominate the pictorial repertory of his day. Eventually, still-life painting did appear in the margins of Renaissance art, and the legacy of Leonardo's "hypernaturalism" was instrumental in nurturing its growth.[14]

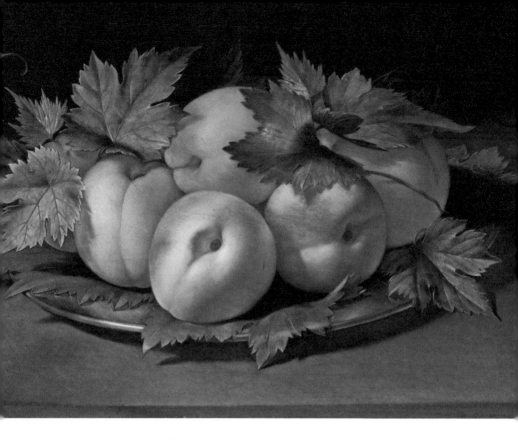

FIGURE 21. Ambrogio Figino, *Plate of Peaches*. (Photoservice Electa)

The Milanese artist Ambrogio Figino (1548–1608) was apparently the first to paint a still life recalling *xenia* from the ancient world.[15] His *Plate of Peaches* (figure 21), circa 1591–94, uses shadow and a warm palette to make the fruit look appetizing. Ripe and unblemished, the peaches appear real enough to touch, pick up, and bite into. Like classical *xenia*, his image plays on the concept of synesthesia, the notion that one sense can stimulate another. In the *Plate of Peaches*, sight directs the palate. Although Figino most likely did not see any ancient *xenia* with his own eyes, he could easily have had Pliny or Philostratus on hand. A literary pedigree is hard to prove, but the fact that the picture immediately prompted a poetic response of its

own may tell us something about how it was originally understood. An inscription on the back of the panel transcribes a madrigal by Gregorio Comanini that celebrates the verisimilitude of Figino's art and posits its superiority over nature itself.

These beautiful fruits
were not made by Art
For Art cannot produce such beautiful things
Neither can Nature preserve for long
this delicate and frail fruit
that only lasts for a few days
But, oh Figino, this is the strength and power
of your immortal style
which triumphs over Art and surpasses Nature.[16]

Other Lombard artists also took up the challenge of stimulating the palate by pleasing the eye. Fede Galizia (1578–1630) painted a number of still lifes in a similar manner (figure 22), the earliest dated 1602. Like Figino, she shunned the homoerotic associations that sometimes attached to peaches (a topic I explore in chapter 5), presenting them as fresh and wholesome instead. The relatively high vantage point and symmetry of her spare arrangements convey a sense of wonder and detachment not unlike that expressed in the work of Spanish painters like Sánchez Cotán and Zurbarán. Ultimately, however, detachment was not the direction the Italian still life would take. Abundance and accessibility, even appetite, became the norm after 1600, thanks in part to the example set by Caravaggio.

For art historians, Caravaggio's *Basket of Fruit* (figure 23) in Milan's Biblioteca Ambrosiana is a canonical example of early Baroque naturalism. Born and trained in Lombardy, Caravaggio (1571–1610) was nurtured in the same artistic milieu as Figino and Galizia, but his genius emerged only after he moved to Rome, where he adapted his natural affinity for empiricism to the sophisticated tastes of his adopted city. His biographers report that he painted numerous still lifes before gravitating to narrative

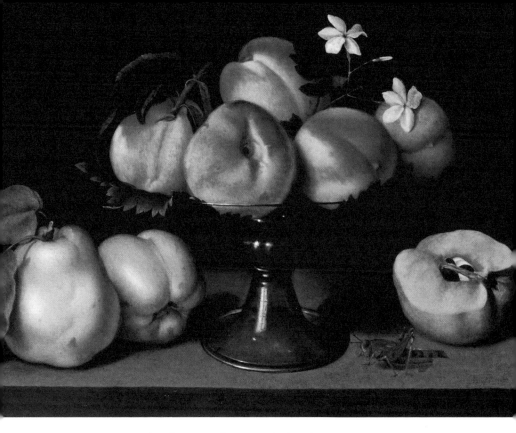

FIGURE 22. Fede Galizia, *Crystal Fruit Stand and Peaches.* (Photoservice Electa)

compositions, but the Ambrosiana *Basket of Fruit* is the only such picture to survive from his early years.

Although painted in Rome, presumably between 1596 and 1598, the *Basket of Fruit* was soon sent to Milan, where it entered the renowned collection of Cardinal Federico Borromeo.[17] Borromeo owned a number of important still lifes, but Caravaggio's picture was among his favorites. In *Musaeum,* a guidebook he wrote for visitors to the gallery that eventually became the Ambrosiana, he claimed that the Caravaggio stood in a class by itself and had no rivals among modern works of its kind.[18]

Caravaggio was a many-faceted genius whose paintings can rarely be

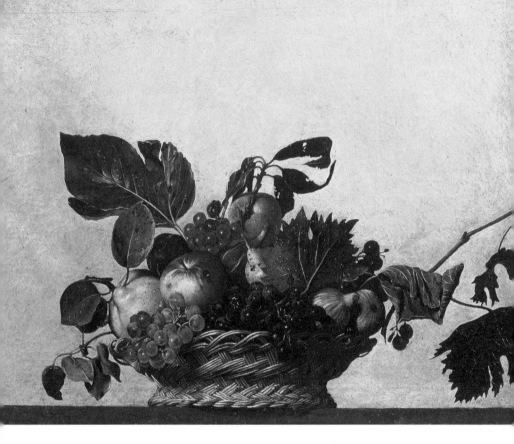

FIGURE 23. Caravaggio, *Basket of Fruit.*

reduced to a single motive or message. One striking aspect of his *Basket of Fruit* is its resemblance to scientific illustrations like Jacopo Ligozzi's renderings of botanical specimens in the 1570s.[19] The mimetic quality of the *Basket of Fruit* is only part of the story, however. Years ago, Charles Sterling remarked that the painting was conceived "in the antique manner," an offhand observation worthy of further consideration.[20] If Caravaggio's inspiration did come from antiquity, the source, of course, was more likely verbal than visual.[21]

Scholars have noted more than half a dozen paintings by Caravaggio that may have been inspired by ancient authors like Philostratus, Pliny, or Ovid. These works are all from the early 1590s, painted when realism was an essential part of the artist's polemic against the prevailing norms of Mannerism. Most of his early paintings are figural, but the *Basket of Fruit* tested the limits of naturalism by eschewing narrative iconography in favor of a subject from everyday life. Vincenzo Giustiniani, one of Caravaggio's ardent supporters, quoted the artist as saying, "It was as difficult to make a good painting of flowers as one of figures."[22] These often-repeated words indeed have the ring of a polemical statement.

On more than one occasion, Caravaggio tempered the realism of his art by fashioning paintings after venerable works from antiquity or the Renaissance. This practice was nowhere more evident than in the *Victorious Love*, which belonged to Giustiniani. As if to forestall criticism of the full-frontal nudity of the beguiling Cupid, Caravaggio based elements of the boy's pose on a work of Michelangelo as well as on two antiquities in Giustiniani's collection. The visual sources were only part of the picture's pedigree, however. Underlying the conception of the highly sexualized Cupid were a pair of literary traditions, one celebrating pederasty, as exemplified in the *Greek Anthology*, and the other, more generally perhaps, echoing the Petrarchan evocation of Amor as "a boy with wings, not painted but alive."[23] These poems all aimed to arouse the erotic appetite, in the same fashion that *xenia* sought to arouse the appetite for food. The *Basket of Fruit* had no sexual innuendos that needed masking, but Caravaggio applied the literary patina to camouflage the picture's "low" subject matter. The doctrine of *ut pictura poesis*, the notion that a painting, like a poem, should elaborate a narrative, was still so widespread in Italian art that Caravaggio evidently thought he needed to elevate his still life in the aesthetic hierarchy. Had he had access to Roman wall paintings like the Oplontis *Basket of Figs*, he might have emulated *xenia* directly, but ekphrastic verses provided the still-greater challenge of turning words back into pictures.

The *Basket of Fruit* is remarkably like the *xenia* Philostratus described: "Fruit in clusters heaped in a basket, and the basket is woven, not from alien twigs, but from branches of the plant itself. . . . You would say that even the grapes in the painting are good to eat and full of winey juice." Philostratus's *Imagines* was available in a number of printed editions, but we do not know whether Caravaggio read any of them. The only clue to his reading habits is in an inventory of his household furnishings from the summer of 1605. From this account, we learn that among his meager possessions were just twelve books, whose authors or titles are not named. Caravaggio's exposure to books would hardly have been limited to the ones he owned, however. His principal early patron, Cardinal Del Monte, owned more than three thousand uncatalogued volumes at the time of his death in 1626, and he was presumably the person who commissioned the *Basket of Fruit* as a gift to Cardinal Borromeo.[24]

Caravaggio's circle of friends included poets as well as the prostitutes and disorderly persons so often associated with his name.[25] He painted a portrait of Giambattista Marino, the most celebrated poet of his age, and Marino, in turn, addressed madrigals to him and his work. Marino had antiquarian leanings of his own, going so far as to put together a collection of poems about painters and painting, written in obvious emulation of Philostratus. The *Basket of Fruit* probably did not remain in Rome long enough for Marino to write about it, but the epitaph he penned for Caravaggio grasps the realism of the work perfectly:

Death and Nature made a cruel plot against you,
Michele;
Nature was afraid
Your hand would surpass it in every image
You created, not painted.
Death burned with indignation,
Because however many more
His scythe would cut down in life,
Your brush recreated even more.[26]

Some early biographers and critics disparaged Caravaggio's art for being insufficiently idealized and lacking respect for the art of the past.[27] In their eyes, the true-to-life imperfections and blemishes of the *Basket of Fruit* further degraded its trivial subject matter. Poets like Marino recognized, as so many others did not, how closely Caravaggio's intentions matched those of classical painters like Zeuxis and Parrhasios. In ancient Greece and Rome, paintings of food were a favorite test of an artist's mimetic ability, and later Renaissance artists like Figino, Galizia, and Caravaggio eagerly embraced the genre as they renounced the formal and textual complexities of Mannerism. The painters probably had to rely solely on literary descriptions of *xenia*, but the challenge of rivaling the legendary realism of their ancient forebears may have been hard to resist.

Few Italian painters of the seventeenth century took as minimalist an approach to the still life as Caravaggio did. As the genre grew in popularity during the Baroque period, compositions tended to become more complex and decorative.[28] The *xenia* tradition continued, however, in the work of a handful of artists who were also known for their interest in scientific illustration. One of these was Filippo Napoletano (born c. 1585–90, died 1629), whose *Bowl of Fruit* (figure 24) in Palazzo Pitti, Florence, bears a remarkable resemblance to more than one ancient still life.[29] Could the artist have seen such a work in his travels between Rome, Florence, Tivoli, and Naples?[30] The excavation of Hadrian's Villa in Tivoli had been under way since the sixteenth century, and Napoletano might have encountered an ancient mosaic or fresco while working in the vicinity.

Another artist whose work recalls classical *xenia* is Giovanna Garzoni (1600–70), a miniaturist who rendered exquisite watercolors of fruit and vegetables on parchment. Her interests in botany and the accuracy of her illustrations have led to her work being called "a splendid synthesis of art and science rivaled by few specialists in this genre."[31] Her *Plate of Figs* (figure 25) is more appetizing than either the Oplontis *Basket of Figs* or the botanical illustrations by Jacopo Ligozzi she undoubtedly saw when she was in Florence working for the Medici.

Significantly, the two artists most committed to creating modern *xenia*—

FIGURE 24. Filippo Napoletano, *Bowl of Fruit.*

Fede Galizia and Giovanna Garzoni—were women. Narrative painting remained the province of men throughout the sixteenth and seventeenth centuries, whereas female artists traditionally occupied themselves with the lesser genres of portraiture and still life. Historically, a woman's vocation for art naturally was tied to her responsibilities in the kitchen.[32] Shopping for the most attractive and appetizing foods and preparing them at home were important activities that marked the rhythm of women's daily lives. That food became a dominant theme for creative women blessed with a gift for visual expression is thus not surprising. Still-life painting, unlike other genres, carried the advantage of a classical pedigree. For an artist who was drawn to the subject but who also wished to be taken seriously, re-creating ancient *xenia* was like having one's cake and eating it too.

FIGURE 25. Giovanna Garzoni, *Plate of Figs with Two Small Pomegranates.*

Bodegónes

Bodegón is the Spanish word for tavern. Horozco's dictionary, *Tesoro de la lengua castellana o española* (1611), defined it as "a rough public eating place where offal was consumed," but already in the sixteenth century, the word also denoted paintings of kitchen and market scenes.[33] The earliest of these *bodegónes* were actually Italian and Flemish, not Spanish. Still lifes by Vincenzo Campi (c. 1530–93) and Pieter Aertsen (1508–75)—like those I discuss in chapter 5—were imported during the artists' lifetimes by Spanish collectors. Thus by 1585, according to Antonio Campi, the artist's brother and biographer, Vincenzo's reputation extended as far as Spain, "where many of his pictures had been sent" from his native Cremona.[34] Collection inventories of the period not only confirm the popularity of

these *bodegónes de Italia* but also suggest how quickly Spanish artists began making copies and variants of them.[35] With time, the subject evolved in Spain and became a distinctive genre.

Food and hunger played a special role in early modern Spain. Throughout the sixteenth century, particularly in the 1590s, drought and famine were widespread.[36] Not surprisingly, the search for nourishment became a central theme of art and literature. In prose, the picaresque novel emerged with the publication in 1554 of the anonymous *Lazarillo de Tormes*. Over the next half century, numerous works of fiction—Alemán's *Guzmán de Alfarache* and Cervantes's *Don Quixote*, most famously—would address or at least reflect the hardships of Spanish life.[37] The leitmotifs of the genre are fairly consistent: the narration is autobiographical. The protagonist is young and from the lower class. He is a beggar and sometimes a rascal, and he spends his days satisfying primary needs like hunger. The following scene from *Guzmán de Alfarache* exemplifies the type:

> I arrived at an inn sweaty, dusty, footsore, sad, and above all with a longing to eat, my teeth sharp and my stomach weak. It was noon. I asked what there was to eat? They told me they had nothing but eggs. It wouldn't have been so bad if they were plain eggs. But that cunning cook ... had the leftover hatched eggs mixed in a box with the good ones. ... She saw me a ruddy-cheeked, round-faced, innocent youth ... and asked "From where do you come, sweetie?" I told her I was from Seville. Then coming closer to me she gave me a chuck under the chin and said, "And where are you going little fool?" Oh God! How with that stinking breath it seemed that I drew old age and all its evils upon me. And then if my stomach had had something in it, it would have been vomited at that point as my guts almost kissed my lips.
>
> I told her that I was going to court, and that I wished to have something to eat. She made me sit down on a wobbly little bench and on top of a block she placed a baker's long-handled broom and a saltcellar made from a broken pitcher, a fragment full of water for chickens, and a half loaf of bread blacker than her tablecloth. Then she served an omelet on

FIGURE 26. Juan Sánchez Cotán, *Quince, Cabbage, Melon, and Cucumber.*

my plate, which could be called more appropriately a smear of eggs. The
bread, jar, water, saltcellar, salt, tablecloth, and cook were all the same.[38]

The publication of *Guzmán de Alfarache* was so successful that a spurious
Secunda parte appeared in 1602, two years before Alemán produced a sequel
of his own.

At the same time, an artist in Toledo by the name of Juan Sánchez Cotán
(1560–1627) was creating a new kind of still life strikingly different from
those of Campi or Aertsen. Compared to these artists' bountiful market
scenes (which I discuss in chapter 5; see figures 50, 52, and 53), his *Quince,
Cabbage, Melon, and Cucumber* (figure 26) in the San Diego Museum of

Art is a paradigm of austerity and restraint. The foodstuffs are spare and the human presence, nonexistent. Sánchez Cotán's still lifes are not true *bodegónes* because of the absence of people, but they capture an even more elemental side of the Spanish hunger for food.

Quince, Cabbage, Melon, and Cucumber was one of twelve still lifes cited in a testamentary inventory of Sánchez Cotán's studio in 1603, the year he renounced secular life to become a lay brother in the Carthusian charterhouse in Granada. This retreat is considered the central element in his · life by modern critics prone to interpreting the mysteriousness of his still lifes in otherworldly terms.[39] Yet the most mystifying aspect of Sánchez Cotán's depictions of fruit and vegetables—their enframement in a darkened window or niche—may not have appeared as surrealistic to his contemporaries as they do now. In the days before refrigeration, produce was stored in a *cantarero* or *despensa*, a primitive larder much like the one depicted in *Quince, Cabbage, Melon, and Cucumber*.[40] Another common way for Renaissance cooks to keep food from spoiling or out of the reach of vermin was to suspend it on strings, and depiction of this practice is also a common feature of Sánchez Cotán's still-life paintings. Yet even after we learn about such everyday habits, an aura of mystery continues to hang over these pictures. Clearly removed from the hustle and bustle of the market scenes depicted by Campi or Aertsen, Sánchez Cotán's compositions differ just as markedly from the one contemporary still life most often compared with it, Caravaggio's Ambrosiana *Basket of Fruit* (figure 23).

Despite the apparent effects of spoilage and insect predations upon the fruit, Caravaggio's *Basket* has a powerful and palpable presence. Sánchez Cotán, by comparison, renounces all sense of desire in his *Quince, Cabbage, Melon, and Cucumber*. Although he renders each fruit and vegetable with meticulous and unidealized accuracy, the picture promises neither nourishment nor the warmth of a convivial meal. Paradoxically, the food that appears so real and close at hand remains inaccessible. One commentator has even labeled the image "anorexic," using the word in the literal Greek sense of "without desire."[41]

Several aspects of the picture subvert any sense of sustenance one might expect in a still life. The lighting, for example, produces an unnaturally harsh tenebrism that juxtaposes the luminous foodstuffs against a dark background. The background, in turn, is entirely achromatic, whereas the fruits and vegetables in the foreground are rendered in cool, unsensuous tones, so unlike the warm and vibrant palette of the Caravaggio. The artist's handling of the paint is tight and dry. But perhaps the most haunting aspect of the image is its uncompromising geometric order. Edible items stored in a larder have never been so carefully arranged. In actuality, Sánchez Cotán conceived his composition according to the mathematical principle of topology, which focuses not just on the shape of things but also on the formal and structural relationships between them. In *Quince, Cabbage, Melon, and Cucumber*, the spherical and cylindrical motifs appear in a precisely logarithmic progression, with the strings marking the vertical coordinates of the curve. The underlying calculus is such that an exponential decay curve is formed when the centers of gravity for each fruit and vegetable are joined.[42]

The combination of strong light, weak color, and painterly and mathematical precision makes the painting appear magical, even mystical. The presumed ethereality of the artist's religious practices may underlie his vision, but the still life also mirrors the parsimonious diet of the Spanish underclass. Real hunger and the quest for nourishment are, of course, addressed more explicitly in true *bodegónes* that contain the human figure, and nowhere do we see this effect better than in the early genre paintings of Velázquez, small masterpieces the artist made in Seville in the years before he became court painter in Madrid.

Velázquez's *Old Woman Cooking Eggs* (figure 27), now in Edinburgh, is an exemplary early *bodegón*. Dated 1618, the painting recalls the tavern scene from *Guzmán de Alfarache*, although this old woman appears more sympathetic than the "cunning" harridan described in the text. But if Velázquez did not follow Alemán's narrative in a literal sense, his work shares *Guzmán's* interest in dramatizing the human anxieties arising from

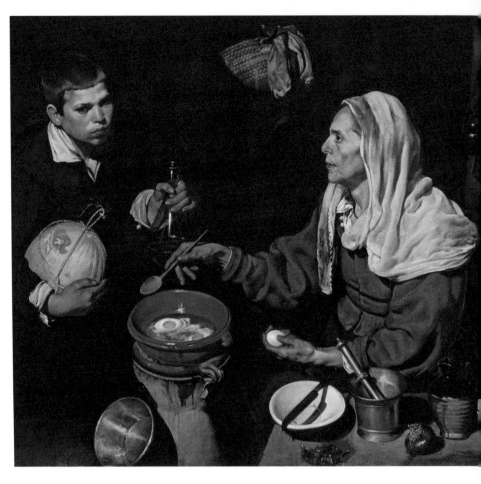

FIGURE 27. Diego Velázquez, *Old Woman Cooking Eggs.*

the search for adequate nourishment. Clearly, this theme meant more in Spain than it did anywhere else.

The meal that the woman is preparing in this picture is either a traditional garlic or onion soup garnished with eggs or, as seems more likely, *huevos a la flamenca.*[43] Velázquez lavished considerable detail on the cooking, whatever the dish: charcoal glows in the brazier beneath the earthenware bowl containing the eggs; the eggs cook in the oil as the woman hovers over

them with her wooden spoon; the albumen coalesces, and a crispy brown edge, or *puntilla*, forms around the eggs. A tiny highlight on the side of the bowl reflects the white of the albumen, which contrasts with the golden egg yolk, while oil trickles down the side of the small earthenware vessel to the woman's side. The arrangement of circular, spherical, and cylindrical forms is as carefully thought out as the compositions of Sánchez Cotán. The young man and the old woman make no eye contact with one another, instead staring soberly into space, the resulting mood more meaningful than one might expect from a work of pure genre. The prominence of the eggs in the composition might be the key to unlocking this meaning: eggs, of course, symbolize fertility and regeneration as well as Christian resurrection (a fact that explains their popularity at Easter). But was Velázquez really thinking in religious terms when he created this painting? Unlike El Greco, Zurbarán, Murillo, and other great painters of the Spanish Golden Age, he was neither especially spiritual nor naturally drawn to religious iconography.

Nevertheless, in another depiction of food preparation datable to the same year, Velázquez unequivocally bound the secular and the sacred together. His *Kitchen Scene with Christ in the House of Martha and Mary* (figure 28) shows two women preparing a simple meal with some of the same utensils that appear in *Old Woman Cooking Eggs*. In this painting, the main course is fish, although two eggs, some pimento, and a few cloves of garlic, all realistically rendered, suggest an *alioli*, one of the most popular Spanish sauces. Fish, of course, like eggs, were also early symbols of Christ. But rather than hinting at Christological symbolism, as he did in the *Old Woman Cooking Eggs*, Velázquez included the Savior himself in the background of the *Kitchen Scene*. Several northern European artists had already created comparably compartmentalized compositions in which the background iconography served as commentary on food imagery in the foreground. We can assume that Velázquez was familiar with such pictorial inversions since his treatment echoes the northern prototypes quite closely.[44]

According to the biblical narrative that inspired Velázquez's scene

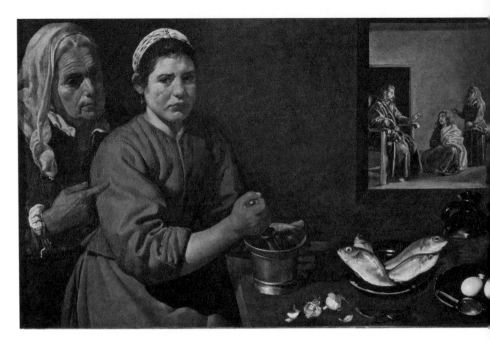

FIGURE 28. Diego Velázquez, *Kitchen Scene with Christ in the House of Martha and Mary.*

(Luke 10:38–42), Martha complains to Christ that her sister Mary is so occupied with prayer that she has no time to help in the preparation of his meal. His reply assures Martha, with the barest hint of reproach, that Mary's faith is, in fact, superior to her own good works in the realm of grace and salvation. In Velázquez's picture, the solemn-faced women in the foreground apparently reenact this theological debate. The issue had become central in the wake of the Reformation, with northern Protestants upholding the *sola fides* (faith alone) argument while Catholics emphasized the importance of "works" born of free will. Glumly sticking to her chores, the young woman in the picture seems indifferent to the ministrations of her older companion, her behavior the exemplar of Catholic belief.

The content of the *Kitchen Scene* strengthens our suspicion that the profane imagery of the *Old Woman Cooking Eggs* also carries a spiritual message. Ambivalent meanings abound in Velázquez's art—and they are part of his greatness—although later in life, as a court artist, he turned more routinely

to classical mythology for subject matter. Thus, a later commission like the *Spinners* sets the Ovidian fable of Arachne in a contemporary weaving workshop and, in reverse fashion, his *Mars* portrays not a mythic deity but an aging soldier weary of war.

Perhaps the best-known scene of hunger and thirst that Velázquez painted is the *Water Seller of Seville* (figure 29), which he apparently produced just before departing from Seville in 1623. Three-quarters of a century later, this work was catalogued as "a portrait of an *aguador* called *El Corzo* [the Corsican] of Seville," an indication that the picture's realism was legendary even if the assertion may have been apocryphal.[45] Water sellers were a common sight on the streets of Spain in the days before private homes had running water. And Spaniards liked their *agua*. According to *A Treatise on Water*, written in Madrid in 1637, "one of the great virtues of Spaniards is that they drink much water, being less enslaved to wine than other Europeans."[46] Periods of prolonged drought made the supply especially precious.[47]

When water is scarce, it is more likely than ever to become a metaphor for the sustenance of life. In the *Water Seller*, the glass is the formal and iconographic center of the composition. With a grave demeanor, the old man hands it to the boy, while in the murky background, a third figure—said to represent middle age—has already raised a glass to his lips. Offering water to the thirsty was, of course, one of the Seven Acts of Mercy and an emblem of Christian charity. Given the chalicelike shape of the glass—whose form is repeated throughout the composition—and the solemnity of the wordless encounter, the scene reverberates with sacramental overtones. Because an air of sanctity permeates the performance of his lowly task, the water seller in the picture has been called "a paradigm of benevolence."[48]

"Should we not esteem *bodegónes?*" Francisco Pacheco wrote in his 1649 *Arte de la pintura*.[49] Pacheco was a painter as well as a theoretician of the arts, but his enduring fame mainly stems from his role as Velázquez's teacher, and later his father-in-law. In responding to his own rhetorical question, Pacheco says, "Certainly, if they are by my son-in-law [for in these] he found the true imitation of nature, inspiring many with his

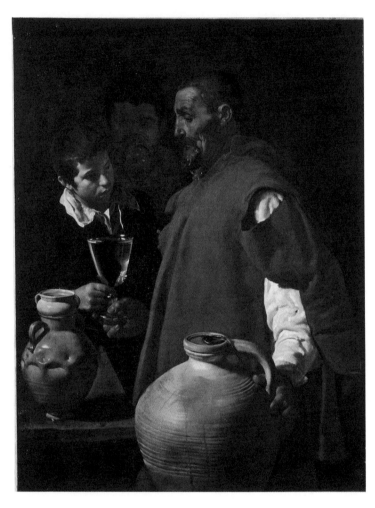

FIGURE 29. Diego Velázquez, *Water Seller of Seville.*

FIGURE 30. Francisco de Zurbarán, *Still Life with Lemons, Oranges, and Tea.*

powerful example." Indeed, the *bodegón* tradition lived on for years after Velázquez gave it up. Paintings of thoughtfully, even reverently rendered food became increasingly popular in Spanish and Italian art.

Making distinctions between true *bodegónes* and *xenia,* not to mention some of the other types of still-life painting that also flourished in the seventeenth century, is not always easy.[50] One thinks, for example, of the work of Velázquez's contemporary, Francisco de Zurbarán (1598–1664), an artist for whom genre painting was but a minor sideline in a career devoted to devotional imagery. His *Still Life with Lemons, Oranges, and Tea* (figure 30) of 1633 is a masterpiece of simplicity and restraint, its depiction of the fruit, flowers, basket, cup, and saucers so perfectly idealized and the whole composition so symmetrically arranged that they seem to negate any expectation of availability or satisfied desire. Yet despite the picture's dark and spare setting, its dramatic illumination imbues it with a mysterious intensity not unlike that in the work of Sánchez Cotán. To meditate on this picture is to feel removed from reality. A passage from the Book of Deuteronomy may come to mind: "Thou shall take of the first fruit of the

earth ... and shall put it in a basket ... and the priest shall take the basket out of thine hand and set it down before the altar of the lord."

Sánchez Cotán and Zurbarán both had the ability to discover metaphysical spirituality in ordinary sustenance. For Zurbarán, this focus can only have come naturally, given that he deployed the same formulations in his portrayals of solitary saints, for which he is so much better known. Yet just as Sánchez Cotán's imagery may have been rooted in personal beliefs, Zurbarán's expression has sometimes been linked to quietism, a popular if controversial religious practice that emphasized withdrawal from the senses and psychic "self-annihilation" to move the soul to a state of imperturbable tranquility.[51] The iconic stillness in Zurbarán's work may correspond to the movement's spiritual goals, but we have no evidence that the painter embraced the doctrine. His employment by some of Spain's strictest monastic patrons—including the Carthusians, Dominicans, Mercedarians, and Franciscans—might also explain the austerity of his art.

The Spanish theologian Miguel de Molinos summarized the devotional practices of his day in his *Dux spiritualis*, or *Spiritual Guide*, of 1675. Although he was a vociferous proponent of quietism—a belief that eventually led to his imprisonment for heresy—Molinos's tract recognized more than one type of worship: "There are two ways of praying: humbly, dryly, without comfort and darkly, or tenderly, fondly, lovingly, and full of feeling."[52]

If Zurbarán's iconic images exemplify the first attitude, the work of yet another Sevillian artist, Bartolomé Murillo (1617–82), represents the second. Murillo primarily painted religious subjects, and his numerous depictions of the Immaculate Conception are full of a sentiment that nineteenth-century viewers found ethereal, although to our eyes, it may seem effusive, if not a little sappy and insincere. Nonetheless, one cluster of Murillo's pictures has retained its popularity to the present day: the *bodegónes* he painted in midcareer, around 1650. His *Boys Eating Grapes and Melon* (figure 31), now in Munich, is one of the most often reproduced of all Old Master paintings.

The theme of this picture is resolutely picaresque, but the mood of the boys is not as dour as that of the subjects in Velázquez's *Old Woman Cooking*

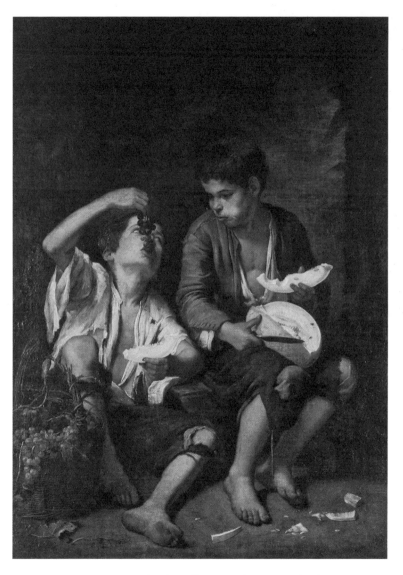

FIGURE 31. Bartolomé Murillo, *Boys Eating Grapes and Melon.*

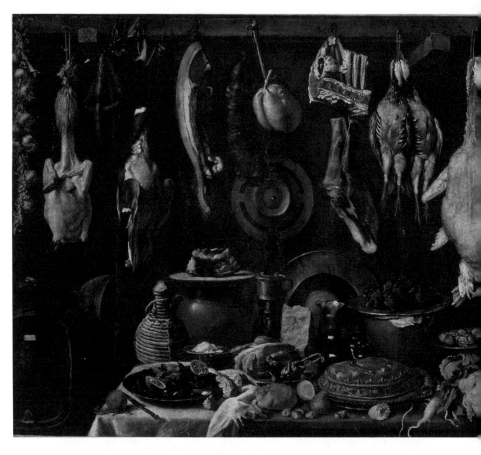

FIGURE 32. Jacopo Chimenti da Empoli, *Still Life of a Butcher's Counter.*

Eggs or the *Water Seller.* The lads are barefoot and scruffy, but they appear carefree and good-natured as they contentedly munch on fruit they can only have stolen or acquired by begging. Formally and iconographically, the hard edge of the earlier *bodegónes* has softened; Murillo's composition and brushwork are looser, and the comestibles have no bite of their own. By this point in the mid-seventeenth century, the genre seems to have run its course in Spain, although it continued to survive as a decorative idiom.

In Italy, the cornucopian displays of Vincenzo Campi evolved in a rather more straightforward manner than did still lifes in Spain. Bolstered by the example of Passarotti (figures 54 and 55), Carracci (figures 18 and 19), and Caravaggio (figure 23), seventeenth-century Italian still lifes also became more decorative over time. Yet a few Italian artists reversed the trend and chose to model their work on Spanish *bodegónes* instead. The Florentine painter Jacopo Chimenti da Empoli (1551–1640) initiated this development in works like *Still Life of a Butcher's Counter* (figure 32) in the Uffizi, one of about a dozen still lifes he painted between 1621 and 1625. Chimenti never left his native Tuscany, but his composition bears a remarkable resemblance to ones by the Spaniard Alejandro de Loarte (born c. 1595–1600, died 1626). Since Loarte's still lifes all date from the last four years of his short life, one of them presumably entered a Florentine collection immediately upon its completion.[53] The social context for Chimenti's work in Archducal Florence could hardly be more different from Loarte's in Castile, but by the end of the first quarter of the seventeenth century, the appeal of the seemingly artless Spanish *bodegón* evidently transcended its humble origins to gain favor in even the most sophisticated settings.

Sacred Suppers

From the moment Adam and Eve ate the forbidden fruit in the Garden of Eden, food has played a significant role in sacred scripture. Indeed, ritual meals have been central to the Judeo-Christian tradition, with some of the most dramatic moments in the Old and New Testaments occurring at dinnertime. Belshazzar's feast and Herod's banquet, or later, the Last Supper and the Supper at Emmaus, are critical turning points in longer narratives of spiritual disjuncture or renewal. Yet the Bible is consistently vague on the menus and provides few details. The meal Elisha served to the prophets in Gilgal (2 Kings 4:38–41) is described more fully than most: at a time of famine, he made a stew of herbs and wild gourds, but finding the dish unsavory, added flour to the pot. The accounts of virtually all other biblical meals are even less informative. The Last Supper, the *ne plus ultra* of New Testament dinner parties, took place one evening during Passover (Matthew 26:20) in "a large room upstairs, already furnished" (Mark 14:15, Luke 22:12), or according to John, just before Passover (John 13:1). But in describing the meal, the Gospels mention only bread and wine, not the Pascal lamb, bitter herbs, and *haroseth* that were traditional for the occasion.[1] Instead, the evangelists rightly emphasize the significance of Christ's institution of the Eucharist and his announcement of Judas's betrayal.

Surprisingly, the first pictorial representation of the Last Supper was not made until the sixth century. A mosaic in Sant'Apollinare Nuovo in Ravenna (figure 33) shows Christ and the Apostles seated on a curved *sigma*, or bench, encircling a table laden with food. No wine is in evidence, nor does the artist include a Passover lamb, but six loaves of bread are

FIGURE 33. *Last Supper.* Sixth-century mosaic, Ravenna.

set about a platter of fish. Fish, of course, were favorite early Christian symbols of Christ that appeared on the walls of Roman catacombs when Catholicism was still an iconoclastic religion. In typical Byzantine fashion, the hieratic composition of the Ravenna mosaic emphasizes the symbolic over the literal aspects of the meal.

Many centuries would pass before Christian devotional practices sanctioned any significant elaboration of biblical texts, and the secularism and antiquarianism of the Renaissance were the forces necessary to bring this about. The addition of superfluous figures and imaginary settings to scenes known only from minimal textual descriptions soon became one of the hallmarks of postmedieval art. The elaborations were sometimes fashioned

FIGURE 34. Giotto di Bondone, *Last Supper.*

all'antica—that is, with classical costumes and props—sometimes spurred by an interest in scientific perspective or human anatomy and often based on an effort to blur the distinctions between sacred and secular experience. Giotto (1267–1337) was the first artist to incorporate, if only tentatively, some measure of all three. His thirty-eight frescoes in the Arena Chapel in Padua (1305–10) are landmarks in the history of art, the earliest images to depict biblical narratives in realistically furnished and human-scale settings. The Last Supper and the Wedding at Cana are both represented in the Arena Chapel, not as static icons but as stories that unfold before our eyes.

Giotto's *Last Supper* (figure 34) is staged inside a cutaway building with curtained windows and a tiled roof. Outside, the sky is blue and not gold as it customarily is in medieval representations. The worldliness of the setting is a fitting backdrop for the human drama that unfolds as Christ announces his betrayal. As the artist does throughout the fresco cycle, in this scene he accentuates the individuality of the diners while downplaying the miraculous aspect of the story. Thus Giotto's apostles, unlike their counterparts in the Ravenna mosaic, react in markedly different ways as they contemplate Christ's words. John alone leans upon the Savior, a realistic detail illustrating the scriptural passage "So lying thus, close to the breast of Jesus, [John] said to Him, 'Lord, who is it?'" (John 14:23–25). Less interested in the meal than in the drama of the occasion, the artist placed little more than bread on the table.

Giotto's contemporary, Duccio di Buoninsegna (c. 1260–1319), lavished far greater attention on the table in his *Last Supper* (figure 35), a panel destined for the Maestà altarpiece (1308–11) in Siena Cathedral. This picture of the event is the first to depict an actual feast, with ample food and drink being consumed by an animated group of diners. Duccio rendered the scene from multiple viewpoints—a lower one that showcases the figures and a higher one that allows us to see more of the table. Loaves of bread, a pitcher with glasses of wine, and several bowls and knives along with an earthenware platter of food sit upon a lovely damask tablecloth. The substance of this meal is neither a symbolic fish nor a Passover lamb but a suckling pig. The choice seems curious because Mosaic law deemed the pig to be unclean, and by Duccio's time, the animal had become a symbol of greed and lust. The only Christian association with a pig involved not Christ but Saint Anthony the Great, the third- and fourth-century Egyptian hermit on whose feast day (January 17) pork was traditionally served. Many medieval feast days, by contrast, were days of abstinence.[2] According to the fourteenth-century poet Simone Prudenzani of Orvieto, the ritualized holiday menus of his day were porkless as well: lasagne at Christmas, eggs and cheese at Ascension, and macaroni on Shrove Tuesday.[3]

The dish Duccio had in mind when he painted his *Last Supper* might have

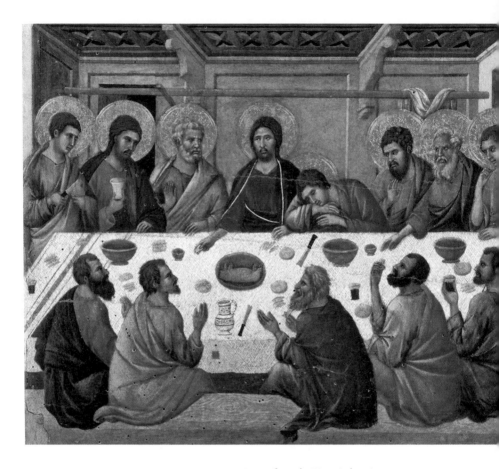

FIGURE 35. Duccio, *Last Supper*, from the Maestà altarpiece.

been similar to one described a century later by Maestro Martino, whose recipe
called for turning the *porchetta*, or suckling pig, inside out before roasting.

First, make sure that it has been well-skinned and that it is white and
clean. Then slit it lengthwise along the backbone and remove its innards
and wash well. Chop the innards finely with a knife together with good
herbs, and take some finely chopped garlic and a bit of good lard, and
a little grated cheese, and a few eggs, and crushed pepper, and a bit of
saffron, and mix all these things together and put them right into the

piglet, inverting it and turning it inside out as you would with a tench [a fish]. Then sew it together and tie it up well, and cook on a spit or on a grill. But cook it slowly so that both the meat and the stuffing will be cooked. And make some brine with vinegar, pepper, and saffron, and add two or three sprigs of laurel, or sage, or rosemary, and baste the piglet repeatedly with the brine.[4]

Depictions of the Last Supper proliferated in the fifteenth century as never before. In many respects, the story was the perfect quattrocento subject, a religious narrative easily attuned to the formal and expressive ideals of Renaissance humanism. In fact, no other New Testament subject better suits the desire for formal symmetry and a secular interpretation of sacred narrative. The appetite for depictions of the Last Supper was particularly strong in monastic communities, many of which commissioned them for the walls of refectories, or dining halls.

Leonardo's *Last Supper* (figure 36), painted in the 1490s in Santa Maria della Grazie in Milan, may be the most famous of the refectory paintings, but its composition was hardly unusual for its time. Andrea del Castagno (figure 14), Cosimo Rosselli, Domenico Ghirlandaio, and Pietro Perugino were just a few of the artists whose interpretation of the subject anticipated Leonardo's masterpiece. Like most quattrocento treatments, his version uses elaborate perspectival effects to draw the viewer into the pictorial space while applying an overlay of vernacular embellishments to enhance the "realism" of the scene. In place of the more historically accurate D-shaped *sigma* of the Ravenna mosaic, Leonardo followed the example of most fifteenth-century artists by introducing a table arrangement from his own time. Such temporal anomalies were common in Renaissance devotional art as painters sought to engage the viewer in a dialogue with the image.[5] For monks dining in the presence of Leonardo's *Last Supper*, the fresco would have seemed like an extension of their own world.

Goethe preserved the experience of seeing the fresco in its original setting during his travels in Italy in the 1780s, just before Napoleon occupied the refectory and converted it into a prison.

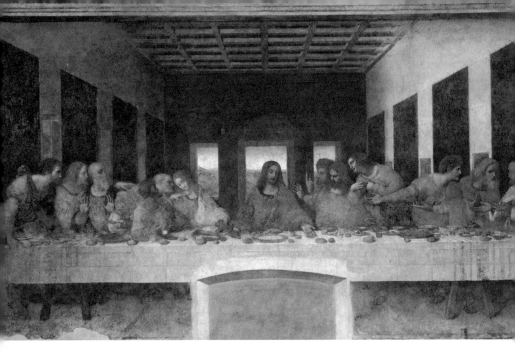

FIGURE 36. Leonardo da Vinci, *Last Supper.*

We have in our travels, seen the refectory, several years ago, yet undes-
troyed. Opposite the entrance, on the narrow side of the room, stood
the Prior's table; on both sides of it, along the walls, the tables of the
monks, raised, like the Prior's, a step above the ground; and then, when
the stranger, that might enter the room, turned himself about, he saw, on
the fourth wall, over the door, not very high, a fourth table, painted, at
which Christ and his Disciples were seated, as if they formed part of the
company. At the hour of the meal, it must have been an interesting sight
to view the tables of the Prior and Christ, thus facing one another, as two
counterparts with the monks seated between them.[6]

Goethe then offers his thoughts about the empirical nature of Leonardo's
realism:

There is no doubt that the table-cloth, with its pleated folds, its stripes
and figures, and even the knots at the corners, was borrowed from the

laundry of the convent. Dishes, plates, cups, and other utensils were prob-
ably likewise copied from those that the monks made use of.

Neither Goethe nor any other early source comments on the food on
the table. In most depictions of the Last Supper, bread is on hand, as are
wine and perhaps a prepared dish or two, but the meal is usually a spare
one. The tabletop in some instances disappears altogether because of the
artist's adoption of a low vantage point in deference to the sight lines
of diners seated below (figure 14). A notable exception to the formula is
Zanino di Pietro's fresco from 1466 in the church of San Giorgio in San
Polo di Piave, a town in the hills north of Venice. The scene follows the
classic fifteenth-century composition, with Judas sitting across the table
from Christ and the other disciples. The handling of figures and drapery in
the painting may be somewhat naïve, but the meal itself is rendered with
unprecedented naturalism (figure 37). Observing the scene from a high
viewpoint of the kind Duccio favored years earlier, the viewer looks down
on a table strewn with platters of fish, some already cut into sections, and
a number of whole and dismembered crayfish. Because crayfish are one
of the great specialties of the region (Waverly Root calls San Polo di Piave
"the capital of crayfish"), local residents could not have been surprised to
see them depicted in the village church. The presence of no fewer than six
carafes of wine on the table may have seemed just as natural, in so much as
Piave was also famous as a wine-growing region. Raboso remains its most
distinctive product, a red wine rich in tannins that mellows nicely with
age. Given the iconographical importance of wine in the Last Supper, it is
not surprising that five of the carafes are filled with red wine, but the sixth
—the one the apostle at the right pours into his glass—contains white. In
all likelihood, this wine would be a local Tocai or Verduzzo, a wine today
described as having a "snappy acidity to offset [its] youthful fruitiness."[7]
In depicting food and drink, the artist who painted this *Last Supper* clearly
was inspired by local dining customs.

Leonardo took his food just as seriously.[8] The composition of his *Last
Supper* may be conventional, but recent research has demonstrated that

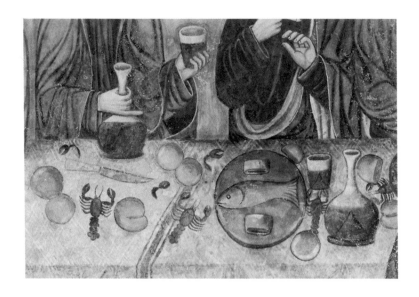

FIGURE 37. Zanino di Pietro, detail from the *Last Supper*.

he rendered the meal in the painting with the same "incredible diligence" and "cunning realism" that Vasari observed—and Goethe later admired—in other details of the mural.[9] Unfortunately, Leonardo's efforts in these passages virtually disappeared over the years as a result of the failure of his experimental technique. The picture's condition started to deteriorate almost as soon as it was completed, and by modern times, it was but a shadow of its former self. Flaking pigment was only part of the problem, however, because later "restorations" managed to obscure the authentic image further. Apart from a few pewter dishes, glassware, and some loaves of bread on the barely visible tabletop, little could be seen or said about the substance of the supper. Fortunately, a scientific treatment completed in 1997 uncovered some pertinent details. At least one of the platters on the table (figure 38), long thought to hold bread, now appears to contain grilled eel. The eel is garnished with orange slices, and other pieces of fruit—

FIGURE 38. Leonardo da Vinci, detail from the *Last Supper*.

pomegranates perhaps—some still with their leaves attached, accompany the requisite bread and wine.

The Judeo-Christian tradition offers no iconographic justification for serving eel at religious feasts, so the artist presumably introduced it for reasons of his own. Did Leonardo love to eat eel? Evidence of his dining habits is somewhat contradictory. On the one hand, we have reason to believe that he was a vegetarian who shunned meat and fish altogether. In a letter of 1516, a certain Andrea Corsali wrote that Leonardo, like "certain infidels ... does not feed upon anything that contains blood, nor [does he] permit injury to be done to any living thing."[10] Further support for this

hypothesis comes from two of his notebook entries. In one he claims a carnivorous man "is not the king of animals but rather the king of beasts, whose gullet is the tomb for all animals," and in another he asks, "Does not nature bring forth a sufficiency of simple things to produce satiety?"[11]

On the other hand, we know that meat and fish were served in his house. A dozen or so grocery receipts interleaved among the approximately 5,000 pages of notes he left behind attest to the fact. One of these receipts, datable to 1503–4, accounts for the purchase of "peppered bread, eels, and apricots," among other things.[12] Leonardo may have been a vegetarian, but the grocery lists show that meat, in one instance *bon bove*, good beef, was a staple in his kitchen. However, because the artist always had pupils and servants in his house—his notes regularly refer to them by name—we do not know who consumed what: the eels, the meat, or any of the other items on the lists, such as beans, peas, mushrooms, salad, fruit, and wine. Only in 1518, the last year of his life, did Leonardo take note of a meal of his own, concluding a sheet of geometric formulations with an abrupt "etcetera" followed by the remark *perche la minestra si fredda*, "because the soup is getting cold."[13]

The eels in the *Last Supper* may or may not have been on Leonardo's diet, but they certainly enhance the realism of the representation. Eels were especially popular in Renaissance Italy because they could survive out of water for days and be transported considerable distances in grass-filled baskets or, once dead, be preserved in brine.[14] Bartolomeo Scappi reported that the best ones came from Comacchio, near Ferrara, and one sixteenth-century cookbook gives thirty-one recipes for preparing them.[15] Eels, like other common foods, also gave cooks an opportunity to showcase their abilities in virtuosic ways. But the eels in the *Last Supper*, to judge from what remains of them, appear to have been prepared simply. The best-selling cookbook of the period, Platina's *De honesta voluptate et valetudine* (*On Right Pleasure and Good Health*), contains two basic recipes:

When an eel is captured, skinned and gutted, cut it up in large enough pieces and cook well on a spit near the hearth, with bay leaves or sage

placed between the pieces, always moistening the meat with the brine they call *salimola*. When it is nearly cooked, add some meal or ground bread, sprinkling with cinnamon and salt, encrusting it all around. If you want it boiled, cook thoroughly with parsley, sage, and a few bay leaves and cover with verjuice and pepper.[16]

We know that Leonardo was familiar with Platina's cookbook, for in one notebook passage he praises its author's ability to "blend simple things together in an infinite variety of ways," and in another he lists it among the books in his personal library.[17] Like Leonardo, Platina was particularly fond of vegetables, so much so that one of his rivals, Giovanni Antonio Campano, accused him of being unable to sing "because his mouth was full of leeks and his breath reeked of onions."[18] In overseeing the menu for the *Last Supper*, Leonardo evidently thought a roasted eel was more palatable than the flesh of a lamb, even if he might himself have preferred a salad of arugula and chicory.

Garnishing fish with orange slices seems to have been especially popular in the period after Platina published *On Right Pleasure*.[19] The practice persisted for years, and Cristoforo di Messisbugo's account of a sixteen-course seafood dinner he prepared for the archbishop of Milan in 1529 still mentions oranges and other citrus fruits as the garnish for a variety of fish dishes.[20] Leonardo may have seen this style of presentation at the table of his Milanese patron, Ludovico Sforza, and decided to include it in the ducal commission for the *Last Supper*. Revising the menu to suit contemporary tastes, if not his own, the artist added a dash of realism to a sacred meal in which the main course had largely been forgotten.

Table scenes became even more popular in the following centuries. Old Testament subjects like Belshazzar's Feast, the Feast in the House of Levi, the Feast in the House of Simon the Pharisee, and the Marriage at Cana provided an ideal opportunity to depict a sumptuous banquet in lavish surroundings, whereas New Testament stories like Christ in the House of Mary and Martha and the Supper at Emmaus allowed artists to investigate the dining habits of those at the opposite end of the social spectrum.

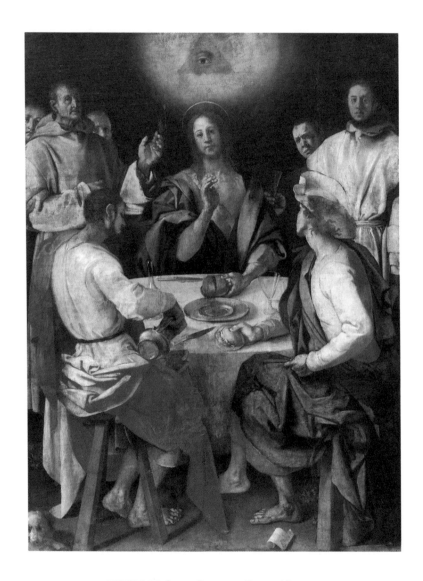

FIGURE 39. Jacopo Pontormo, *Supper at Emmaus.*

Moreover, table scenes were not the only subjects to reflect the polarities of Renaissance material culture. The same social distinctions are depicted in scenes of the Nativity, which typically show the Holy Family accompanied either by rustic shepherds or by well-heeled magi.

Jacopo Pontormo, who was destined to become a central figure in Mannerist art, was born in 1494, the year Leonardo began his *Last Supper*. Pontormo painted only one table scene during his career, and the subject he chose was the Supper at Emmaus (figure 39), a story rarely depicted in previous centuries but one that soon eclipsed the Last Supper in popularity. The drama turns on the moment when two skeptical disciples, who initially fail to recognize the posthumous Christ as they share a table in an inn, finally realize who he is. The biblical account (Luke 24:28–32) is typically spare, noting only that the now-lost town of Emmaus was "about seven miles outside Jerusalem," and that "when he sat down with them at the table, he took bread and said the blessing, and [only then did] they recognize him; and he vanished from their sight."

Pontormo painted his *Supper at Emmaus* for the *foresteria*, or guest-house, of the Certosa del Galuzzo, the monastery outside Florence to which the artist retired during the plague of the 1520s. Apart from the triangular symbol of the Trinity that was added later (in accord with Counter-Reformation orthodoxy), Pontormo's depiction of the supper is strikingly realistic. The serene figure of Christ addresses the two apostles as several monks look on. Vasari claimed that some of the figures in the painting were "marvelous portrait likenesses" of Certosan lay brothers from the monastery.[21] Other realistic elements include two cats hiding beneath the table and a small dog and a fallen scrap of paper in the foreground. The animals add a charming note of domesticity to the scene, whereas the scrap of paper, inscribed 1525, records the date of the painting. Curiously, Pontormo took little interest in elaborating the meal itself despite the high vantage point from which we view the table.

By chance, we know a few things about Portormo's own eating habits, at least from the last years of his life. A diary he kept between 1554 and 1556 while he was at work in the choir of San Lorenzo in Florence reveals

little about his creative practice but provides rich details of his personal life, especially his diet. In one week in January 1555, for example, he consumed:

Monday: 14 ounces of bread, roast pork, grapes, cheese and an endive salad
Tuesday: 10 ounces of bread
Wednesday: 14 ounces of bread, roast pork, an endive salad and cheese and dried figs
Thursday: 15 ounces of bread
Friday: 14 ounces of bread
Saturday: no supper
Sunday: blood pudding, slices of liver and pork[22]

Bread was clearly an important part of Pontormo's diet; it was the sole ingredient of half his meals. Should we be surprised, then, that he limited the food in the *Supper at Emmaus* to just two loaves of bread yet included extraneous details like the household pets? Pontormo, however, did not skimp on drink. One of the apostles, distracted from the drama unfolding before him, fills a glass from a ceramic pitcher of wine, and a second carafe, presumably holding water, and two more glasses are in evidence. Scripture says nothing about wine at the Supper at Emmaus, although allusions to the Eucharistic supper were not infrequent in depictions of the theme. But Pontormo was personally fond of the grape, and his diary records frequent refills of his cask with wine from Radda and Calenzano, or from a friend named Piero.

Three-quarters of a century later, Caravaggio painted his own *Supper at Emmaus* (figure 40). Unlike Pontormo, whose dyspepsia is evident from his diary and whose temperament Vasari described as solitary and despondent, Caravaggio had social ambitions and carnal appetites. Protected from his indiscretions by powerful churchly patrons, his erotic imagination crossed the boundaries of gender and class alike. Overripe boys and spoiled fruit and vegetables account for much of the iconography of his early paintings. Although his *Supper at Emmaus,* now in London, is a mature work painted

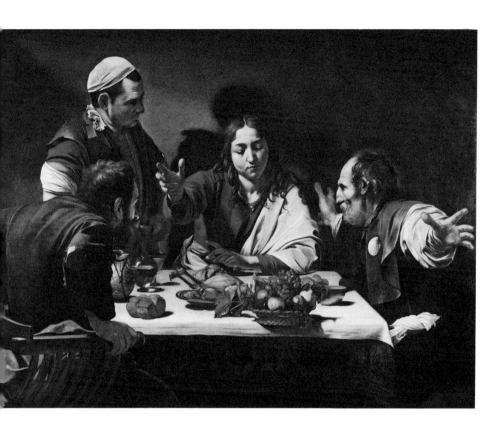

FIGURE 40. Caravaggio, *Supper at Emmaus.*

in 1601, Caravaggio's treatment is as uncompromisingly secular as that of his earlier genre pictures.

The inn in this *Supper* offers the sense of "public privacy" considered essential to the modern restaurant.[23] As in the Pontormo version of the event, Christ and the disciples sit on individual chairs rather than on a long bench, and a waiter stands ready to serve their individual needs. The table is well provisioned.[24] A crisp white tablecloth, laid over an authentically depicted Ushak carpet, draws the eye to the center of the composition, where an appetizing meal awaits the diners. The ceramic serviceware is clearly of contemporary Roman manufacture, as is the Savonarola chair from which one of the apostles has begun to rise. Bread is present, of

course, as are water and wine. But the main dish appears to be guinea hen, and a basket of blemished fruit—a trademark of Caravaggio's early days—seems to be the dessert.

In his *Opera dell'arte del cucinare* (1570), Bartolomeo Scappi gives more than two dozen recipes for preparing poultry, one of which might have been used to prepare Caravaggio's bird.[25] Gillian Riley provides a modern version:

> Wash and wipe the bird dry. Anoint inside and out with oil and stuff with the juniper berries and herbs, saving a few to tuck around it in the pan. Scatter with chopped garlic, salt and pepper. Cover and bake in a moderate oven until done, about 1½ hours. Test for doneness after about 1¼ hours; the juices should run clear when a skewer is inserted into the thigh.[26]

The social realism of Caravaggio's *Supper at Emmaus* made a powerful impression on younger artists, some of whom were so taken with his unidealized style that they suppressed its narrative content altogether. Later biographers, like G. P. Bellori, held this against him, lamenting that his "indecorous" naturalism "often degenerated into common and vulgar forms."[27] Bellori was undoubtedly thinking of the disreputable tavern scenes by artists like Manfredi, Valentin, and the Dutch Bamboccianti, all of whom exaggerated Caravaggio's naturalism while generally overlooking his spiritual message.

A few of Caravaggio's followers gave a particularly Roman interpretation to the Emmaus theme by making plates of cabbage, one of the city's gastronomic specialties, the centerpiece of the biblical meal.[28] One example in a painting attributed to Bartolomeo Cavarozzi (figure 41) appears to have been inspired by a well-worn recipe for "Roman cabbage" that first appears in Platina's *On Right Pleasure:*

> Toss cabbage which you have torn in your hands into boiling water. When it is semicooked and its own water thrown away, transfer into another pan and wrap with well-pounded lard. Also put in as much rich broth as necessary. Let boil a little, for it does not require much cooking.[29]

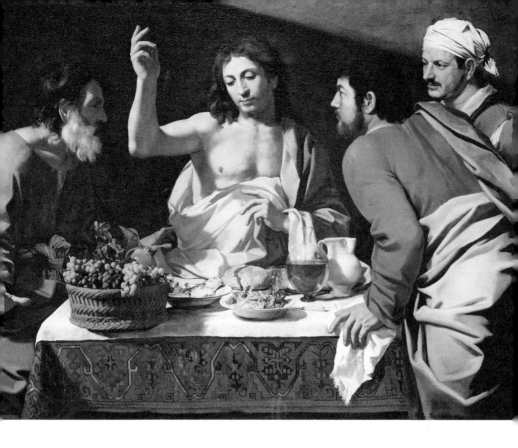

FIGURE 41. Attributed to Bartolomeo Cavarozzi, *Supper at Emmaus.*

Unlike most authors of Renaissance cookbooks, Platina could not resist appending his thoughts on the nutritional benefits of the foods he describes. Eating cabbage, he claims, is an excellent cure for drunkenness and is also "effective when its juice is mixed with wine, against the bite of a rabid dog."[30] Later authors dispensed with the medical advice and concentrated on ways of making the lowly vegetable more appetizing by dressing it with spices or cheese.

In Venice, Jacopo Bassano (1515–92) and other members of his illustrious family were renowned for painting sacred suppers in an even more rustic manner, but the norm in that insular and exotic city was generally to choose subjects that could be staged as urbane dinner parties mirroring

the genteel tastes of the nobility. The most notorious of these depicted feasts was the Last Supper painted by Paolo Veronese for the Refectory of Santi Giovanni e Paolo, locally known as San Zanipolo (figure 42). No church in Venice had a finer pedigree: it is the final resting place of twenty-five doges, and since the fifteenth century, the funerals of all doges have taken place there.

Veronese completed his enormous canvas (nearly forty feet long and seventeen feet high) in April 1573, entitling it the *Last Supper*. Installed in the refectory, it must have seemed like a spectacular Venetian stage set modeled after the city's most prominent Renaissance monument, the façade of Sansovino's Library of St. Mark's. No fewer than four dozen richly attired people are present at the banquet, although one cannot easily distinguish the saintly guests from the many servants who wait upon them. Wine is much in evidence, as are several loaves of bread, and the main dish—served from the large bowl in the center of the table—is some kind of fowl. Veronese was apparently more interested in the serviceware than the food, however, for he rendered the silver urns and platters with greater attention to detail than he did the meal itself. One guest picks his teeth with the tines of an elegant silver fork, seemingly oblivious to the events around him.

Veronese must have been bitterly disappointed by the response of his Dominican patrons. Rather than celebrate the beauty and ingenuity of his creation, they objected to the number of extraneous elements that accompanied the narrative. The matter did not end there: three months later the painter was summoned before the Holy Office of the Inquisition to explain his intentions.[31] Fueled by the recent recommendations of the Council of Trent, whose final session in 1563 upheld didactic exactitude in the arts above all other considerations, the Inquisitors went after the artist with Counter-Reformatory zeal. Their questions suggest that they had looked carefully at the painting. Why, they asked, had the artist included "a man with a bloody nose," "armed men, dressed in German style," "a clown with a parrot on his fist," and "dwarfs, drunkards, and other lewd things"? When asked whom he supposed to have been present at the Last Supper,

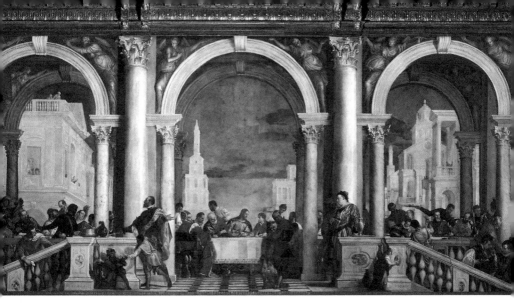

FIGURE 42. Paolo Veronese, *Feast in the House of Levi.*

Veronese responded, "I believe Christ and the Apostles were there. But if in a painting there is space left over, I fill it with figures from my imagination." At the end of the hearing, the artist was ordered to make certain "corrections" in the composition, but the only change he made was to rename the work *Feast in the House of Levi.*

Among painters of the period, Veronese may have been the only one brought to trial, but even the "divine" Michelangelo did not escape the censorious eyes of the Catholic Reform movement. From the moment his fresco of the Last Judgment was revealed in the Sistine Chapel in 1541, complaints were voiced about its many nude figures. No fewer than three popes called for painting over the offending genitalia, and a fourth even considered destroying the fresco altogether. With this sort of piety and prudery in mind, the Venetian painter Jacopo Tintoretto began work on his own *Last Supper* in 1592 in San Giorgio Maggiore (figure 43). In light of Veronese's summons by the Inquisitors two decades earlier, one would expect Tintoretto to have underplayed the secular elements in his version of the subject, but he did not. Domestic pets, inattentive servants, and pro-

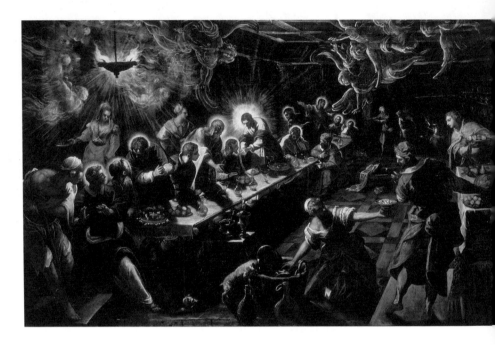

FIGURE 43. Jacopo Tintoretto, *Last Supper.*

digious quantities of food abound in the foreground. Yet the artist avoided reproach by spatially separating the vernacular from the scriptural while bathing the entire scene in an otherworldly light that emanates from the halos of Christ and the apostles. Because the painting's secular embellishments were both marginalized and overshadowed by the supernatural presence, its propriety went unchallenged.

As the seventeenth century unfolded, the zealotry of the reform movement abated, and *lassismo*, or tolerance (some would say hypocrisy), of all kinds became more common. One painter, Bernardo Strozzi (1581–1644), put the open-mindedness of his age to a unique test. Strozzi was born in Genoa, where as a youth he first studied painting before unwisely joining the Capuchin order and retiring to monastic life. Eventually his

FIGURE 44. Bernardo Strozzi, *Supper in the House of Simon.*

passion for painting came into conflict with his religious devotion, and on more than one occasion, his order sought to constrain his artistic activities. In 1630, he was imprisoned for attempting to abandon his vows, but he managed to escape and flee to Venice.

Although Strozzi's *Supper in the House of Simon* (figure 44) currently hangs near Veronese's *Feast in the House of Levi* in the Galleria dell'Accademia in Venice, he originally painted the picture for a private chapel in Genoa, probably in the late 1620s. The composition's viewpoint is so low as to reveal little of the tabletop, yet Strozzi provided an abundance of food, despite the fact that the biblical account—once again—says nothing about the content of the meal (Luke 7:36–51). Attendants enter and leave carrying trays laden with dishes as Christ (on the left) lectures the Pharisee Simon (on the right) on matters of sin and redemption, the lesson taken from Mary Magdalene, who kneels at his feet. Christ's posture is demonstrative as he chastens his host by pointing his failings out to him. Among the other diners, the figure to Simon's right (figure 45) plays an important supporting role, not in the conversation but in drawing attention to the food. Oblivious to the conversation, he stares at the spoonful of *brodo* he

holds in his hand. The man's senses of sight and taste are at once engaged, as if he just discovered an insect in his minestrone. By introducing this note of naturalism into the narrative, Strozzi created a "double drama," contrasting the religious conversion of Simon with the baser appetites of one of his guests.[32] Here again, a dinner party provides the setting for a biblical lesson, but the food is now more than a mere accessory to the story. The self-absorbed diner could well represent the artist, mirroring the conflict he obviously experienced between the sacred and profane inclinations of his life. In painting this detail at the center of his composition, the artist focused attention on the interplay of faith and skepticism that was the central conundrum of his age.

FIGURE 45. (Opposite) Bernardo Strozzi, detail of
Supper in the House of Simon.

Erotic Appetites

As Renaissance culture grew more secular, artists expanded their thematic repertories to include subjects drawn from the natural world and from daily life. The emergence of landscape and still-life painting from the shadows of biblical and mythological narrative was among the most visible signs of this change. But because "history" painting continued to dominate the aesthetic hierarchy, painters drawn to these lowly themes frequently justified their efforts by including historical and allegorical allusions in their work. Some still-life artists imitated ancient *xenia* or steeped themselves in moral and social commentary (see chapter 3), whereas others brought new types of still life into being. One sixteenth-century artist, Giuseppe Arcimboldo, spent his career fashioning human likenesses from ordinary foodstuffs, like fruit and flowers. The wit of his canvases stems from the surprising transformation of one genre (still life) into another (portraiture). Such inversions were typical of Mannerist art.

Witty puns flourished in the sixteenth century, when political and spiritual instability led to unresolved tensions between a nominally empirical way of thinking and an underlying propensity for allusion and dissimulation. The Renaissance taste for learned erotica, as opposed to popular pornography, was steeped in metaphors, puns, and elaborate rhetorical devices.[1] Already in the fifteenth century, Poggio Bracciolini anthologized the best jokes of his day—some of them quite lewd and anticlerical—in his *Facetiae* (1450). Three-quarters of a century later, Baldassare Castiglione devoted a long section of his *Book of the Courtier* (1528) to cataloguing the many forms of wit he thought a gentleman should possess. More than one modern study has examined Renaissance erotica with this perspective in mind.[2]

Within this milieu emerged a species of still life in which artists exploited the sexually suggestive shapes of certain fruits and vegetables. At the same time, other painters liked to depict scenes that satirized the eating habits and sexuality of the lower social classes.

Fruits and Vegetables

The perception that certain fruits and vegetables like figs, peaches, melons, and squash were sexually suggestive rested at least partly on the belief that the shapes of plants are inherently anthropomorphic. This notion, the "doctrine of signatures," had long been familiar to herbalists seeking signs of the efficacy of God's creations.[3] The idea gained currency in 1588 with the publication of Giambattista della Porta's *Phytognomonica*, a semiscientific volume with illustrations comparing various botanical species with human organs.[4] Together, wit and pseudoscience sustained the metaphorical play of food and sex for nearly a century, beginning in the High Renaissance and ending in the early years of the seventeenth century. In papal Rome, demographically the most male of European cities, sexual puns were more widespread than anywhere else.

The first painted still lifes to carry an erotic charge seem to have originated within the circle of Raphael between 1517 and 1518. In the Loggia di Psiche at the former Villa Chigi (now Farnesina), Giovanni da Udine framed the master's frescoes of the goddess and attendant deities with garlands of suggestively arranged fruit and flowers (figure 46).[5] Half a century later, the biographer Giorgio Vasari acknowledged this conceit in his life of Giovanni, observing, "Above the flying figure of Mercury he fashioned a Priapus from a gourd and two eggplants for testicles ... while nearby he painted a cluster of large figs, one of which, over-ripe and bursting open, is penetrated by the gourd."[6]

"But why say more?" Vasari concludes, his disdain apparent for what had become a popular comic genre by the middle of the century. By then, compositions framed with garlands of tumescent fruits and vegetables adorned even the most respectable locations, including the occasional

FIGURE 46. Giovanni da Udine, detail of fresco in Loggia di Psiche.

chapel or church.⁷ Before long, the imagery began to emerge from the margins onto the main picture plane, and to spread from Rome to other artistic centers. In northern Italy, a Friulian follower of Titian, Niccolò Frangipane, made something of a specialty of depicting allegorical and musical scenes containing overt sexual metaphors. His *Allegory of Autumn*, now in the Museo Civico in Udine (figure 47), leaves little to the imagination. A leering satyr pokes a finger into a split melon and with his other hand grasps a sausage that lies near a cluster of cherries, his gestures vividly evoking the erotic dreams of the youth napping next to him. In another work, the *Madrigal Singers*, Frangipane satirized the refinement of music

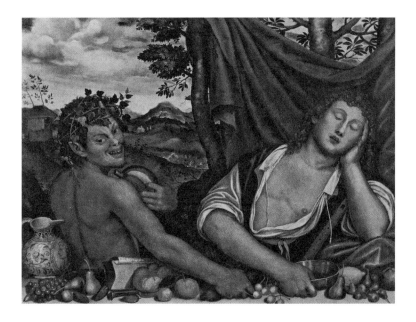

FIGURE 47. Niccolò Frangipane, *Allegory of Autumn.*

by arranging the singers around a table coarsely festooned with peaches and sausages.[8]

Sixteenth-century authors were equally drawn to the congruities of fruit and vegetables with sex. As with painting, the locus of the genre was in Rome, where the Accademia dei Vignaiuoli, or Academy of Vintners, was founded in 1527. This group was renowned for celebrating the harvest season with recitations of bawdy poems about sexually suggestive crops, and they identified themselves by pseudonyms like Signor Radish, Carrot, or Cardoon.[9] The poets' humor was usually fairly crude, but a few academicians like Francesco Berni and Francesco Molza published some verse that was quite clever. Berni devoted one poem to the velvet-skinned peach. Although he wrote this poem around 1522 and the first Italian-English dictionary was not published until 1598, its definition of *pesca* as "a young man's bum," and *dare le pesche* as "to give one's taile, to consent

to buggerie" had probably not changed during the intervening years.[10] Accordingly, Berni addresses his peach:

Oh fruit blessed above all others
Good before, in the middle and after the meal,
But perfect behind.[11]

Berni's poem suggests that priests were especially fond of peaches, sexual jibes at the clergy being a common staple of the genre. Molza, in turn, composed a poem upholding the desirability of "feminine" figs over "masculine" peaches and apples. Sodomy was treated lightly in this era, and despite strict proscriptions against it, only the most flagrant violations were prosecuted.[12]

Anthologies of burlesque poetry printed in the sixteenth century include the work of luminaries like Pietro Aretino and Benedetto Varchi as well as artists like Michelangelo and Agnolo Bronzino.[13] Bronzino switched as effortlessly between Petrarchan and burlesque modes of expression as he did between painting and poetry. His ode to the "blessed" onion is a marvel of sexual innuendo, combining humor, wit, equivocal meanings, and capricious literary allusions.[14] In the same vein, a border he designed for the *Meeting of Joseph and His Father*, a tapestry now in Palazzo Vecchio, Florence, depicts phallic bottle gourds cavorting with abandon.[15]

In painting, the eroticized still life reached its climax around 1600 in the work of Caravaggio. An empiricist by nature, Caravaggio painted no fewer than a dozen pictures—most of them figural—that contain some seventeen types of fruits and vegetables. Botanists claim these canvases offer a unique perspective on horticulture at the time, even depicting identifiable insect predations and disease damage.[16] Some of these arrangements are iconographically insignificant, but others, like the one in *Young Bacchus* (figure 48), have an aura of decay about them that is perfectly attuned to the depravity of the figures themselves. Fruit appears in nearly all Caravaggio's so-called soft-boy pictures, accompanying what is clearly a homoerotic invitation in each.[17]

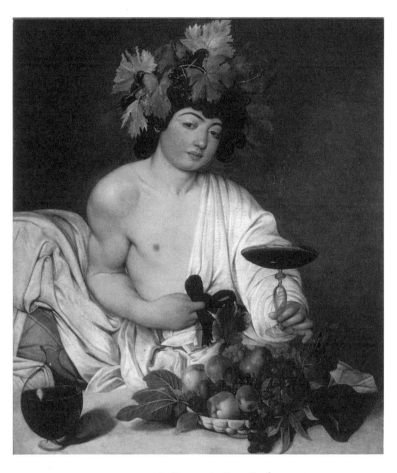

FIGURE 48. Caravaggio, *Young Bacchus.*

A work recently attributed to Caravaggio, the *Still Life with Fruit on a Stone Ledge* (figure 49), is every bit as suggestive as the *Bacchus.*[18] This painting is the first erotic still life to stand alone, its imagery no longer confined to the margins or overshadowed by human presence. Caravaggio had painted at least one independent still life before this one—the small though mon-

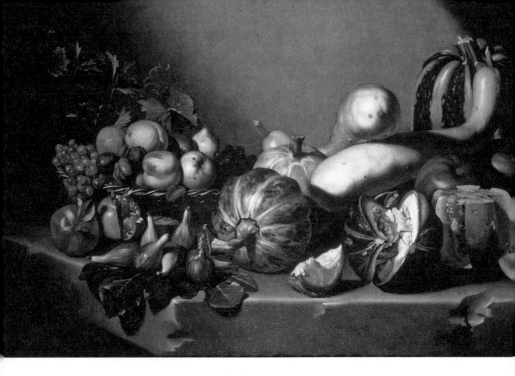

FIGURE 49. Caravaggio, *Still Life with Fruit on a Stone Ledge.*

umental *Basket of Fruit* in Milan (figure 23)—but the *Still Life with Fruit on a Stone Ledge* is formally and expressively more ambitious.[19] In a composition as dramatic as that of his most stirring altarpieces, Caravaggio arranged the display of melons, pomegranates, gourds, figs, and other fruits to suggest sexual tumescence and the acceptance of penetration. Once one notices the stem of the central melon aimed toward a burst fig and the two bottle gourds lying languidly over a pair of sliced melons, are other readings even possible?

According to his earliest biographer, Giovanni Baglione, Caravaggio's personality was "proud and satirical . . . quarrelsome and belligerent."[20] Baglione had reason to know because he had been the target of some scurrilous verses composed by Caravaggio and his friends. The verses—which contained no references to fruits or vegetables—were written in 1603, the same year that the *Still Life with Fruit on a Stone Ledge* is believed

to have been painted. Baglione sued the writers for libel, and the testimony from that trial, along with a host of other documents, attests to Caravaggio's lifelong inclination toward aggressive and frequently violent behavior.[21] Unfortunately, we have no way of knowing if the *Still Life with Fruit on a Stone Ledge* was intended to "give the fig"—a euphemism for an obscene gesture, first found in Dante—to a particular individual or was merely a generic visual pun.[22] Whatever the motive, the luscious and allusive fruits represent the full maturity of a comic genre that was, at best, a puerile form of humor. Later, Dutch and Flemish painters took up the theme, but the erotic still life was the invention of the Italian Renaissance. Its off-color wit was perhaps the perfect metaphor for the culture of post-Reformation Rome, in which the quest for religious and political orthodoxy may have only increased uncertainties and humor was the only acceptable outlet for transgressive desire.

Fish, Poultry, and Red Meat

Although the taste for eroticized fruit and vegetables was cultivated in papal Rome, the northern cities of Cremona and Bologna created their own metaphors for carnal desire. Meat and fish were the preferred foodstuffs, with beans or cheese sometimes thrown in for good measure. The phenomenon was more short-lived than it was in Rome, appearing mainly in the 1580s in the work of a handful of painters—notably, Vincenzo Campi (d. 1591), Bartolomeo Passarotti (d. 1592), and Annibale Carracci (d. 1609). Unlike their Roman counterparts, these artists took their inspiration from outside sources, their point of departure being the work of two still-life painters from Antwerp, Pieter Aertsen (d. 1575) and Joachim Beuckelaer (d. 1574).

The genre scenes that these five artists painted signal an important shift away from the formal and textual complexities of Mannerism, which had prevailed in European art for most of the sixteenth century. In both northern and southern Europe, the depiction of butcher shops and fish stalls challenged Renaissance assumptions that a painting's subject matter

be ennobling and its description of life idealized. The market and kitchen scenes of Campi and Passarotti, like those of Aertsen and Beuckelaer, contain imagery that deliberately mocks both assumptions. Indeed, one scholar suggested that Aertsen's pioneering work anticipated the polemical depictions of everyday life associated with Baudelaire's call for "modernity" in the art of nineteenth-century France.[23]

In Aertsen's *Market Woman at a Vegetable Stand* (figure 50), dated 1567, a young produce vendor stands amid a cornucopian display of fruits and vegetables that includes a prominent bottle gourd in the foreground. A butcher with a cow occupies the background in the upper left corner, and a pair of lovers embrace in a doorway at the upper right. The juxtaposition of the kissing couple with the bountiful foodstuffs underscores the association of sexual appetite with pleasures of the palate, and of abundance with fertility.[24] The Roman playwright Terence captured the spirit of such images with the succinct phrase *sine Cerere et Baccho friget Venus*, "Without Ceres and Bacchus, Venus freezes," or "Without food and drink, love grows cold."[25]

Allusions to the erotic temptations of the marketplace had antecedents in the classical world. When Cicero ranks honorable and dishonorable trades at the end of the first book of his *De officiis*, he singles out fishmongers, butchers, cooks, and poulterers as the least respectable. Because these tradesmen catered to physical appetites, he dismissed them as *ministrae voluptatum*, or ministers of sensual pleasure. In the Middle Ages, Saint Augustine also warned against the impious links between the enjoyment of food and sexual arousal. Erasmus carried the discourse into the sixteenth century, repeatedly linking food with sexual desire and emphasizing *temperantia* (moderation) in all things.[26] Erasmus upheld Ciceronian ethics as well, recommending that people learn *De officiis* by heart.[27]

In his *Confessions*, Augustine ranked lust of the eyes (*concupiscentia oculorum*) above lust of the flesh (*concupiscentia carnis*).[28] Later Protestant reformers questioned the role of image making in general, warning that even religious depictions could harbor the temptations of *voluptas oculorum*. Eventually, in the 1570s, the northern and southern Netherlands went

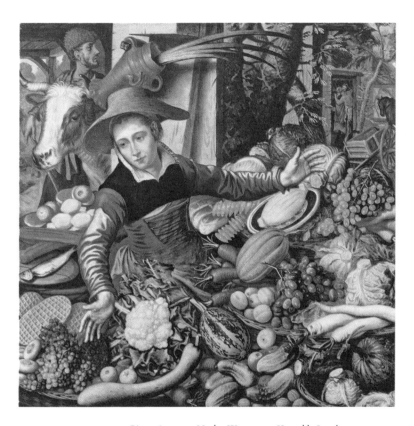

FIGURE 50. Pieter Aertsen, *Market Woman at a Vegetable Stand.*

their separate ways on this matter, among other issues. The more reform-minded northern provinces embraced an iconoclastic position toward devotional imagery, whereas Catholics in the south maintained their traditional belief in the efficacy of art as an aid to worship.

Pieter Aertsen, active mainly in Catholic Antwerp, clearly conceived his *Market Woman* with Ciceronian proscriptions in mind, but in other pictures, he went further and contrasted ungodly temptations with explicit references to Christ. In these works, he depicted the same abundant

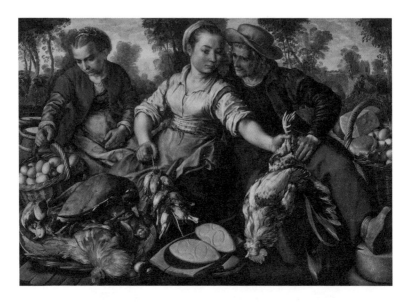

FIGURE 51. Joachim Beuckelaer, *Market Scene.*

foodstuffs in the foreground but included small scenes from the New Testament in the background. Thus, we have bounteous still lifes with titles like *Christ in the House of Mary and Martha, Christ and the Adulteress,* and *Ecce Homo.* Each, in all likelihood, sought to remind the viewer how easily one could succumb to *voluptas oculorum* and miss the Lord altogether. At second glance, any impure thoughts in the viewer's mind might be chastened by Christ's sacred presence.[29]

Beuckelaer, who was a nephew and student of Aertsen, painted in a similar vein. Fewer of his works depict religious subjects—even marginally so—and most are more explicitly erotic. Many resort to crude visual puns in which fish, fowl, eggs, and vegetables stand in for sexual organs. In the *Market Scene,* now in Salzburg (figure 51), a woman holds a skewer of songbirds in her lap while reaching with her other hand to grasp a rooster strategically positioned over the genitals of her male companion. Deciphering the ico-

nography of this picture requires no knowledge of Cicero or Saint Augustine. Such works were part of popular culture, often derived from well-circulated prints and proverbs of the period. One such contemporary woodcut, the *Allegory of Marriage*, depicts a prancing rooster atop a scroll that reads:

I am called a proud cock
Who knows how to keep his hens in order
So that they will do my will.
I keep watch vigilantly and call them often.
I turn around a lot and take good care of them.
Whatever man does not do the same
Is a hen, not a cock,
And will not be able to wear the pants.[30]

Beans, Rough Bread, and Dark Wine

The exchange of art and ideas between northern and southern Europe gained impetus in the later Renaissance, both through trade and the wider availability of printed materials. Italian collectors with business interests in Antwerp imported Flemish pictures almost as soon as they were painted.[31] Around 1580, Vincenzo Campi and Bartolomeo Passarotti—who were from Cremona and Bologna, respectively—began to pattern their paintings on such works. Formally and expressively, they followed the Aertsen-Beuckelaer idiom, but neither Italian took much interest in the religious texts or proverbs that so frequently underlay the realism of their models. Nonetheless, these north Italian kitchen and market pictures were hardly unadulterated slices of life or meaningless exercises in naturalistic depiction.

Campi's *Fish Vendors* in the Brera Museum (figure 52) is typical of the artist's work. The crowded composition juxtaposes two scenes: on the right, a woman dumps a basket of fish onto an already disorderly array of seafood, and on the left, a coarse-looking, wine-drinking couple consume a simple meal while a crying infant and an unruly dog vie for the woman's attention.

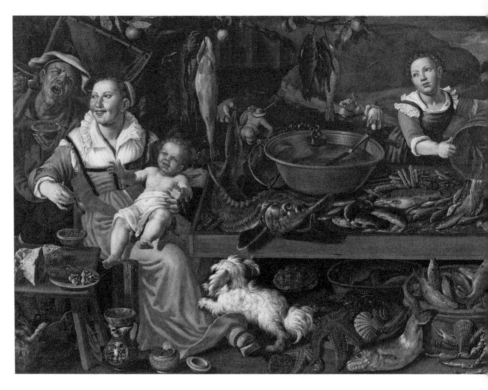

FIGURE 52. Vincenzo Campi, *Fish Vendors.*

The overall tone is fairly comical, which to some scholars recalls the sort of *pitture ridicole,* or comic paintings, discussed in the widely read Catholic Reformation treatise *Discorso intorno alle imagini sacre e profane (Discourse on Sacred and Profane Images).* Published in 1594 by the Bolognese bishop Gabriele Paleotti, this tome devotes an entire chapter to the effectiveness of *pitture ridicole* in deriding wanton and dissolute behavior.[32] However, the caricatured stupidity of Campi's male figure was not likely to give pause to potential gluttons, nor, in Paleotti's words, to provide "the means for helping to exercise virtue." Overall, such pictures—and Campi painted more than a dozen of them—tend to convey amusement rather than moral improvement, and parody rather than sympathy.

A recent study by Sheila McTighe supports the interpretation that such paintings were tools for parody.[33] She observes that peasants in paintings

like the *Fish Vendors* "do not eat the food that they display: they swill beans, with a meal of hard cheese, walnuts, rough bread, and dark wine set before them."[34] Baldassare Pisanelli describes the supposed dietary significance of this fare in *Trattato della natura de'cibi et del bere* (*Treatise on the Nature of Food and Drink*).[35]

In the 1585 first edition of the *Trattato*, Pisanelli simply lists various foods and their supposed links to the four humors.[36] Later editions expand on this information, indicating the degree to which wet, dry, hot, or cold foods were, by their elemental nature, suitable for individuals possessed of one humor or another. That much followed fairly standard Renaissance beliefs about the effects of diet on temperament and the humors.[37] But Pisanelli goes beyond humoral theory to suggest that some foods are intrinsically better for noble and delicate people and others better for farmers or those who work with their hands.[38] The type of food being eaten in Campi's *Fish Vendors* is classified as appropriate "only for the peasant and those who labor heavily." Beans, Pisanelli notes, are the lowest form of sustenance: "being of poor nourishment to delicate persons, they should be left to working people, and countryfolk." The squash, scallions, cheese, dark bread, and red wine consumed in this and other pictures by Campi are also linked to the poor. The foods for sale, in contrast, nourish people at the other end of the social spectrum. The finest, most delicate, and noblest foods were thought to be poultry and fish. Of these foods, Pisanelli claims that birds that fly—*animali volatili*—through air, the lightest of elements, are nutritionally sound for those "who have no profession, and who attend to their studies and to contemplation."[39] Surely the fact that Campi's *Poulterers* (figure 53) are selling the very doves, quail, pheasants, blackbirds, woodcock, partridge, and turkey that Pisanelli recommended is no accident. These foods, he says, "harm none but rustic people... [giving] asthma to the *villino* or peasant."[40]

An erotic charge runs through Campi's pictures, sparked as much by the natural associations of the foodstuffs as by the suggestive manner in which they are arranged. Indeed, fish, fowl, beans, and wine have been linked with salacious behavior in Western culture since Greek and Roman

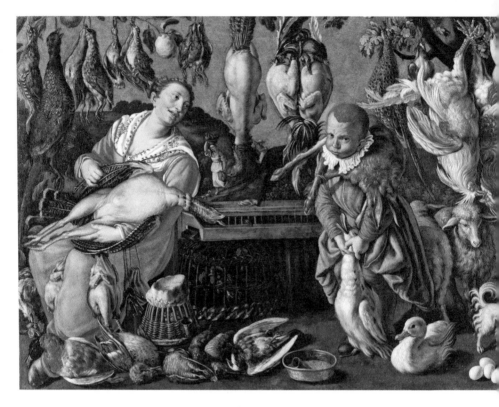

FIGURE 53. Vincenzo Campi, *Poulterers.*

times. Fish, because of their phallic shape, were eroticized by Ovid and bore the association throughout the Renaissance. Francesco Berni, author of the bawdy poem about peaches, penned even naughtier verse about eels and fish.[41] Wasting few words on the subject, the period's principal theorist, G. P. Lomazzo, associated fish simply with "ribalderia" in his 1584 *Trattato dell'arte de la pittura* (*Treatise on the Art of Painting*).[42] The beans and wine that the peasants are consuming in the *Fish Vendors* embody their own sexual allusions. Aristotle and Empedocles related beans to testicles, and this association remained popular in the Renaissance, when more than one poet turned to the theme.[43] Wine, for its part, accompanies personifications of adultery and debauchery in Ripa's *Iconologia*, and its effects are all but universally linked to lasciviousness.[44]

Campi reinforces the sexual symbolism in these works with the poses and vulgar expressions of his subjects. Could the birds cradled by the woman and boy in the *Poulterers* be any more suggestively arranged? Could the bean-slurping father in the *Fish Vendors* appear more dissolute, or the dog, notorious as a breed for its unbridled appetite, more rambunctious? Even the bawling infant plays a role in the commentary: the offspring of poorly nourished parents, he cries from the bite of a crayfish, another creature associated with sexual arousal.[45] Campi parodies both the figures and their diet, casting them together as caricatures of low birth and crass appetites. The owner of no fewer than five of these scenes, Hans Fugger of Kirchheim, reportedly had a ribald sense of humor, and his tastes were by no means unique.[46]

In Bologna, Passarotti depicted similar scenes. Although primarily a painter of realistic portraits and conventional altarpieces, he was a man of many interests who founded a museum to house his collection of curiosities.[47] Bologna was a center for the study of natural history in this period, thanks to the specimen collections of Ulisse Aldrovandi, his exact contemporary.[48] Passarotti's empirical nature and curiosity about the world enabled him to master the technical challenges of depicting both perishable foods in genre scenes and spontaneous human expression in his portraits.

Most scholars presume that Passarotti's first attempt at linking food to the baser instincts was the *Merry Company*, now in a private collection in Paris (figure 54). The iconography of this picture, painted around 1577, leaves little to the imagination. Five dissolute partygoers and an adventurous dog gather behind a table laden with bread, wine, figs, garlic, and salami—a spread presumed to nourish their unruly appetites. Carlo Cesare Malvasia, the artist's seventeenth-century biographer, found the picture's exaggerated tone "fuori misura," or beyond measure.[49] Although the composition may highlight the evils of lust, envy, and intemperance— prime targets of church reformers like Paleotti and Lomazzo—its wit turns the image into an object of amusement rather than censure.

Four of Passarotti's food paintings were conceived as a series: the *Butcher*

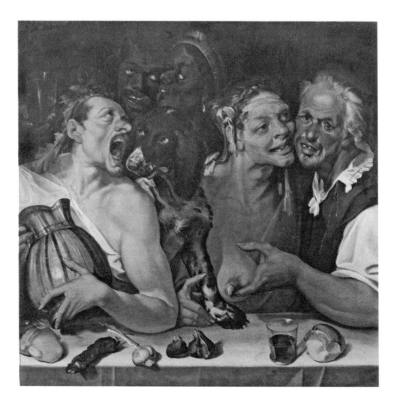

FIGURE 54. Bartolomeo Passarotti, *Merry Company*.

Shop, the *Fishmongers*, the *Poulterers*, and the *Chicken and Vegetable Sellers*. Presumably postdating the *Merry Company* by a couple of years, these works were destined for the Mattei, a family of discriminating collectors in Rome.[50] Unlike the hyperbolized, make-believe world of the *Merry Company* or Campi's *Fish Vendors*, this group of images reveals the more sober side of working-class life. Even the dry handling and duller surfaces of the canvases seem part of an effort to avoid artfulness. Not surprisingly, Passarotti's representational mode has been compared to the unembellished descriptive style of contemporary scientific illustration.[51]

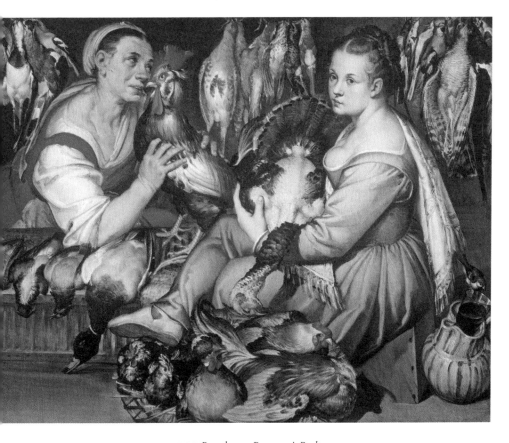

FIGURE 55. Bartolomeo Passarotti, *Poulterers.*

The thematic repertory of the Mattei cycle still nods to the Flemish tradition of Aertsen and Beuckelaer, although Passarotti's content varies from picture to picture and is never quite the same as that of his northern models. In the *Poulterers* (figure 55), an older woman caresses a live rooster while her younger, buxom companion cradles a dead turkey, each oblivious to the presence of other fowl and the pitcher of wine by their side. Despite the scene's blatant realism, more is going on than first meets the eye. The placement of the cock beak by jowl with the harridan presumably signals the woman's futile and unbecoming remembrance of her youthful sexuality, whereas the more passive roosters, confined to a basket beneath

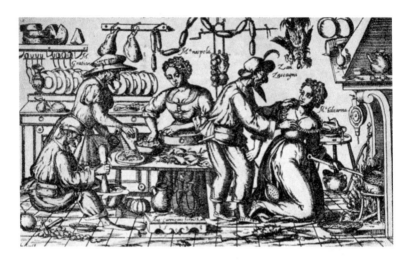

FIGURE 56. Antonio Carrenzano, scene from the *Commedia dell'Arte* illustrating the preparations for the wedding feast of Zan Tripuando.

the young woman's modestly crossed legs, allude to virtue.[52] Although the old woman has a more decorous demeanor than her counterpart in the *Merry Company,* she is still an object of derision. Italian comedies of the period frequently made libidinous old women targets for ridicule.[53] The most famous example is Pietro Aretino's *La cortigiana* (*The Courtesan*) of 1525, in which a sly old crone, Alvigia, engages in a series of inappropriate love affairs that lead to her downfall.[54] Because audiences of the time would have understood the cock both as a sexual symbol and as an emblem of fools, the inclusion of a bird in such scenes was all but inevitable. With time, the comedic combination of poultry and sex became more commonplace in both painting and the theater. A print illustrating a particularly ribald scene from the *Commedia dell'Arte* (figure 56) shows a lecherous chef attacking a comely young woman beneath two cocks and an array of phallic sausages and skillets.[55]

In contrast to his *Poulterers,* Passarotti's *Butcher Shop* (figure 17) could

hardly be more straightforward. The artist portrays the two butchers with the same lack of idealization as the cuts of beef and boar on display. Spatially and psychologically, the viewer takes the place of a customer standing at the counter about to make a purchase. Parody plays no part in the transaction, and the only possible allusion—the boar as a symbol of luxury—would be highly unlikely in this context.[56] The picture was radical for its day, rejecting as it did the textual and stylistic conventions of Mannerism in favor of imagery that takes an essential step toward Baroque naturalism. Indeed, the *Butcher Shop* questions the limits of realism, probing the relationship between art and life, subject and viewer, much as Manet's *Bar at the Folies-Bergère* would do more famously three centuries later.

Passarotti was more reluctant to abandon conventional sexual iconography in the other two pictures in the series—the *Fishmongers* and the *Chicken and Vegetable Sellers*. The tendency to hover between moralizing or satirical allusions, on the one hand, and unidealized realism, on the other, would remain characteristic of food painting for some time to come. Annibale Carracci grappled with this dichotomy in several pictures during the early years of his career. Annibale eventually turned to the classical and religious narratives that would bring him renown, but his genre paintings—which include pure landscapes—played an important remedial role in his search for an alternative to Mannerism. As we saw in chapter 2, two canvases, the *Butcher Shop* (figure 18) and the *Bean Eater* (figure 19), signaled his quest for gastronomic realism in his native Bologna, a city whose identity has always been linked with the culinary arts.

The *Butcher Shop* depicts nearly life-size figures in a complex but realistic arrangement. Unlike Campi's and Passarotti's paintings of similar subjects, the butchers go about their business, cutting, weighing, and hanging their meat on hooks, unmindful of the presence of the viewer/consumer. Carracci was obviously drawn to such figures and in these years made a series of drawings cataloguing the occupations of Bologna's tradespeople. After his death, these sketches were engraved and published in the *Arti di*

Bologna, a volume that is still an invaluable guide to the commercial life of the city. Annibale may even have included autobiographical details in the picture, in so much as he was the nephew of a butcher and probably knew the trade firsthand.[57]

The apparent realism of the *Butcher Shop* is compromised, however, by at least two layers of allusion. The most surprising one is his "borrowing" of the overall composition and several individual figures from a fresco of Raphael's in the Vatican.[58] Annibale's conflation of art and life might have been born of formal necessity but more likely stemmed from his desire to elevate the lowly subject matter into a higher aesthetic realm. Realist painters, as Leo Steinberg once noted, have long raised such "internal safeguards" against dismissal of their efforts as nothing more than simple mimesis.[59] The presence of a pair of anomalous figures among the toiling butchers also gives pause. Who are the old woman and the halberdier standing in the margins of the composition? Are they customers, meat inspectors, or simple passersby? Both figures seem more like social stereotypes than authentic likenesses. Of the two, the woman is the more believable, although, like the old crones in Passarotti's *Merry Company* and *Poulterers,* her presence could also symbolize the carnal appetite. In Italian, *carne* means meat, and, like so many of the names and shapes of food discussed here, the word was easily turned into a sexual pun (*carnale,* not surprisingly, means the same in Italian as it does in English). However, the woman's grim visage in Annibale's *Arti di Bologna* is so similar to that of the *straordinario di carne,* the inspector of butcher-shop weights, that we should probably consider her role here to be similar.

The halberdier standing at the left is a comic figure. He wears the uniform of the *gonfalonieri,* Bologna's ceremonial civic guard, but his silly pose is more that of a *Commedia dell'Arte* charlatan than of a serious standard-bearer. His witless expression, rakishly tilted cap, and prominent codpiece at once mark his dissipation and ridicule his sexual prowess. Perhaps the only conclusion we can draw from these figures' presence in the *Butcher Shop* is that the artist sought to satirize civic officials and upscale

consumers, not, as Campi and Passarotti did, to ridicule members of the working class. Together, the allusions to art and class rivalries transform the viewer's expectation of the subject, recasting the "low" material into "high" art with pictorial intelligence and wit.[60] That ability, to be sure, is the sign of a major talent, and the reason Annibale soon moved on to narrative painting, the gold standard of artistic ambition and achievement in his time.

A year or two after completing the *Butcher Shop*, Annibale painted the even-more-memorable *Bean Eater* (figure 19), a candid view of a person simply eating his lunch. Judging from the man's garb and demeanor, he is clearly a *villino*, or country bumpkin. The meal so carefully laid out before him is consistent with the peasant diet Pisanelli describes in his treatise: beans, dark bread, a *torta da bietola* (chard pie), scallions, and red wine—all foods "not to be eaten except by those who labor hard."[61] But in this context, the food probably signifies something more than lower-class humors and appetites. Scallions, according to Pisanelli, "serve no other purpose than to incite the libido."[62] In addition to increasing one's readiness for coitus, eating scallions produces "a notable increase in sperm." Thus, a link between food, sex, and procreation may underlie the eroticism of many of these Italian genre scenes.

Pisanelli was not alone in scrutinizing the relationship between diet and offspring. In 1600, a Bolognese cartographer and cosmographer named Gioseppe Rosaccio expanded the discourse in his *Microcosmo dell'anima vegetabile*, where he wrote that beans, dark bread, red meats, and dark wine

make semen gross and of bad temperament; the son that is generated will have the force of a bull, but will be wild and of bestial temper. It is because of this that among country people it is a miracle if one turns out acute of intellect and apt for learning, particularly where such rough foods are consumed. This is why they are born slow and rough, from having been generated through such foods. The contrary is true of city-folk, whose sons have more intellect and ability.[63]

The belief that certain foods could biologically alter the disposition of the human body was quite common at this time. A number of Bolognese medical and natural-history texts—including one by Aldrovandi—support the idea that "gross" foods make gross sperm, which, in turn, generate bestial children. The urtext of the genre was a 1575 book by the Spaniard Juan de Huarte entitled *Examen de ingenios*. The volume was so popular that by the end of the next century, it had been reprinted no fewer than seventy times in several languages.[64] Huarte's treatise was a pioneering study in differential psychology that advocated ability testing and vocational counseling among other things. But together with these enlightened ideals, the author expressed more specious views about the role played by the humors, climate, the shape of the brain, and diet in shaping human intelligence. The book's conclusion—a set of dietary recommendations for couples wishing to have children—had a tremendous impact on later authors and painters, especially in Bologna. The genre paintings of Passarotti and Annibale Carracci were certainly nourished, if not conceived, with just such fallacies in mind.

Food in the Studio, Art at the Table

Eggs, Butter, Lard, and Oil

The more progressive artists and cooks of the Italian Renaissance were attentive to the technical aspects of the craft they inherited from the Middle Ages, particularly when choosing a binder to moisten and meld their colors or flavors. In each case, the binder was organic and readily available: eggs, animal fat, butter, or oil. The professional overlap was greatest with eggs and oil—the substances most commonly used in studios and kitchens—but no single binder prevailed in cuisine the way oil eventually would in painting. In both métiers, the binding ingredient affected the quality of the final product, whether it was an altarpiece or a plate of food. Moreover, the effects of these ingredients were at times surprisingly comparable.

Cennino Cennini (c. 1370–1440) wrote his *Craftsman's Handbook* (*Il libro dell'arte*), a compendium of early fifteenth-century artistic techniques, just before the most important innovations of Renaissance art and cuisine took place.[1] His text is more useful, therefore, for its compilations of traditional late-medieval materials and methods than for its insights into progressive practices. In his chapter "How to Paint on Panel"—which Cennini concedes is "really a gentleman's job"—he addresses the requirements of working on wood, the most common support in the later Middle Ages:

> And by the grace of God it is time for us to come to painting on panel.... And it is true that the painting of the panel is carried out just as I taught you to work in fresco, except that you vary it in three respects. The first, that you always want to work on draperies and buildings before faces. The second is that you must always temper your colors with yolk of egg, and get them tempered thoroughly—always as much yolk as the color which

you are tempering. The third is that the colors want to be more choice, and well worked up, like water.[2]

Egg yolks were not the only edible substance found in painters' studios at this time. In earlier chapters, Cennini recommends glues made of cheese and fish for joining wood panels and strips of parchment.[3] He recommends the use of bone dust to prepare the panel for painting and describes the colors one can make by grinding wild plums, berries, and saffron. Cennini was certainly aware of the relationship between artistic and culinary materials, for he offhandedly advises gathering the bones "just as you find them under the dining-table" and stirring the egg white used for bole (the reddish clay ground on which artists applied gold leaf to gild a panel) with a whisk "as if you were beating spinach, or a *purée*."[4]

Among the other foodstuffs one could find in artists' workshops were almond gum, cabbage, garlic juice, grain, grapevines, honey, salt, vinegar, and wine.[5] But eggs were the critical ingredient in tempera painting. Whereas whole eggs seem to have been reserved for *a secco* (dry) retouching of frescoes, only the yolks were used in painting with tempera. The scientific explanation is as follows:

> The yolk is an emulsion consisting of droplets of fatty material suspended and emulsified in a matrix of egg proteins in water. The first stage in the drying of egg tempera paint is therefore the evaporation of the water, followed by the denaturing of the egg proteins to a hard waterproof film (familiar to anyone who has delayed the washing of an egg-coated plate or utensil). Providing the pigment to medium ratio is correct, the resultant paint film is arguably the toughest and most long-lasting of all the media used for easel painting.[6]

Paintings made with egg tempera have a singular look, for once the pigment dries, the colors become matte and opaque. Ralph Mayer, author of *The Artist's Handbook of Materials and Techniques*, suggests that with tempera, "the fourth or optical function of the medium scarcely exists, and

FIGURE 57. Guariento da Arpo, *Christ the Redeemer.*

when the paint is dry the colors resemble their original state more than they do the deep-toned colors of oil paint. Depth of tone, if desired, must be brought out by a final application of varnish or transparent glazes."[7] Guariento da Arpo's *Christ the Redeemer* (figure 57) exemplifies the unique qualities of late-medieval panel painting. The artist, a Paduan follower of Giotto, conceived his *tondo* (circular painting) in the compressed format typical of the mid-fourteenth century. Christ is depicted half-length and frontally against a gold background. The image is iconic and otherworldly, with no interest in narration nor hint of continuing action. The opacity of

the pigment and the purposeful brushwork are in perfect harmony with the static composition. As a general rule, Mayer adds, "tempera techniques are not well suited to casual or spontaneous styles."[8] Late-medieval painters occasionally used oil glazes to brighten their pigments, but not until the later quattrocento—when narration and figural movement became more important—did oil come into its own as a binding medium.

Giorgio Vasari began his famous *Lives of the Painters, Sculptors, and Architects* (first edition, 1550) with an extended discourse on technical matters pertaining to architecture, sculpture, and painting. In the section on painting—which in the book's expanded second edition (1568) runs to some eighty pages—he acknowledges that tempera panels made by "the old masters" like Giotto "have been preserved in great beauty and freshness for hundreds of years," but "working in oil has come later, and this has made many put aside tempera."[9] Vasari's next chapter, "Of Painting in Oil on Panel or on Canvas," extols the virtues of this "most beautiful invention and convenience to the Art of Painting."

Vasari attributes the invention of oil painting to the Flemish painter Jan van Eyck (c. 1389–1441), despite the fact that Cennini had already recommended applying oil-based pigment as a glaze over tempera to achieve a softer pictorial effect.[10] But Flemish artists were indeed the first to paint exclusively with an oil medium, and their work then inspired Italian masters of the later quattrocento, particularly in Venice. The key figure in the introduction of oil, ironically, was neither Flemish nor Venetian, but a Sicilian, Antonello da Messina (c. 1430–79). How and where Antonello came to learn the oil technique remains a mystery—Vasari's claim that he was a pupil of Jan van Eyck is unlikely given the barely overlapping life spans of the two artists—but once he discovered it, he renounced tempera altogether. Antonello's *Ecce Homo*, a signed and dated work of 1473 (figure 58), demonstrates the greater fluidity and subtlety of the medium. Compared to Guariento's *Christ*, Antonello's figure is more natural in every respect. The format of *Ecce Homo* is just as compressed, but the absence of the conventional gold-leaf background, not to mention Christ's asymmetrical pose and the implication of space suggested by

the post behind his head, is a hallmark of Renaissance realism. The differences in medium are particularly apparent in the flesh tones of the two paintings. That the complexion glows in the Antonello and seems dull in the Guariento is the result of the binder each artist chose to use.

The turning point in Italian painting came in 1475, the year Antonello was commissioned to paint the San Cassiano altarpiece in Venice. In addition to this work, a *Madonna Enthroned*—only fragments of which survive—Antonello painted during his brief stay in the republic a handful of portraits that had a tremendous influence on local artists like Bellini, Giorgione, and Titian. Giovanni Bellini (1430–1516) was the first Venetian to master the oil medium, and the optical effects of his *Madonna Enthroned* (San Giobbe altarpiece, figure 59) surpass even those of Antonello in luminosity and depth.[11] In Vasari's words, "The oil softens and sweetens the colors and renders them more delicate and more easily blended than do the other mediums."[12] Almost overnight, oil became the binder of choice, and Leonardo, Raphael, and other central Italian painters exploited its potential for creating more natural, expressive effects. The smoky *sfumato* that shrouds the *Mona Lisa* (begun in 1503) in such mystery could only have been achieved with oil glazes.

Walnut and linseed oil were favored in the studio. Vasari claimed walnut oil was "better because it yellows less with time" but tended to turn rancid before it could be used.[13] Linseed oil was pressed from seeds of the flax plant, which was also the source of the fiber used to make linen. The switch from painting on panel to painting on linen canvas—again first popularized in Venice—went hand in hand with the adoption of the oil medium, the combination of the two allowing for the most spontaneous visual effects of all.

The movement from egg tempera to oil occurred at the same time that dining habits were undergoing related changes of their own. Not only did wooden trenchers, like wooden panels, begin to disappear in the later Renaissance as more elaborately decorated tableware took their place (see chapter 7), but the preference for binding agents shifted as well.

FIGURE 58. (Opposite) Antonello da Messina, *Ecce Homo.*

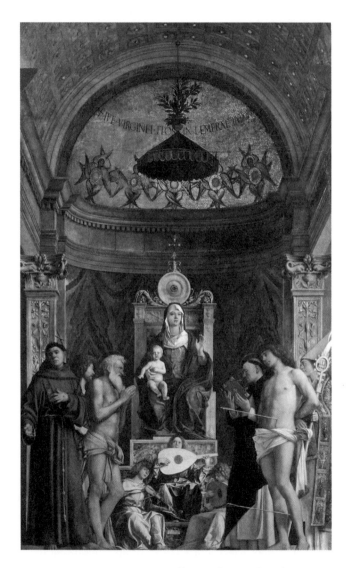

FIGURE 59. Giovanni Bellini, *Madonna Enthroned.*

Olive oil was the typical culinary binder in ancient Rome. Because olive groves, like wheat fields and vineyards, were abundant in the agricultural economy, oil was a natural choice. The recipes Apicius gives in his *De re coquinaria* (*On the Art of Cooking*) recommend it more than any other fat, suggesting to the modern reader a cuisine "literally oozing with oil."[14] Although animal fats occasionally made their way into Roman kitchens, their association with northern, "barbaric" peoples limited their use to tables of the lower classes.[15]

By contrast, medieval diners of every social class preferred to cook with pork fat. The change in medium reflected shifts in both agriculture and religion, the former the result of a turn to a forest-based economy, the latter the consequence of dogma and proscription. Lard was indeed the defining ingredient of Christian cookery because Muslims and Jews were forbidden to eat it (Mohammed justified the proscription on the highly imaginative grounds that pigs were originally spawned from the elephant excrement that collected on Noah's ark).[16] Accordingly, Christians viewed the Arab preference for oil as a cardinal vice of Islam. One fifteenth-century Spaniard minced no words when he denounced "their disgusting stews, which they make with olive oil."[17]

The sixth-century writer Anthimus, the first in the Middle Ages to address dietary matters, dedicates a disproportionately long section of his treatise to lard.[18] Although vegetable oils—particularly almond, olive, walnut, and poppyseed oils—were certainly available in the medieval West, they were generally reserved for salad dressings and as a substitute for pork fat on days of abstinence and during Lent. Pork fat in all its forms—fresh and salted pork belly, fatback, and lard—was the mainstay of roasting and frying, whereas cooks sometimes laid lardoons, or strips of fat, over meats to keep them tender and moist while cooking.[19] Indeed, the fourteenth-century *Liber de coquina* called for lard in more than a quarter of its recipes.[20] The use of animal fat was not limited to the preparations of meat and fowl; early recipes for fish, tarts, and, in one instance, a vinaigrette also included it.[21] But the fat of choice was always pork; beef and calf fat, along with butter, are rarely mentioned in medieval culinary sources. Such was the importance

of lard in early kitchens that the term *larder* came to designate the area for storing preserved food of all kinds. Butter first came into widespread use during the Renaissance, just as oil was making a renascence of its own.

By the time Bartolomeo Sacchi (Platina) composed his *De honesta voluptate et valetudine* in the 1460s, goose fat had also become a popular medium in the kitchen. In book 2, he explains that cooking fat "is made from the fat of a pig or geese in this way: put finely cut fat in a pot over live coals so that it does not absorb smoke as if you had put it over flame. Put in as much salt as you think is enough. When it has melted and before it cools, strain it into a collection jar, and lay it away for use so you can use it when you wish."[22]

Following an earlier compilation of recipes by Maestro Martino, Platina also recommends using olive oil as a preservative or in the preparation of dozens of dishes ranging from seasoned asparagus to grilled sturgeon. Beyond suggesting these conventional applications, he offers his view of the fruit's therapeutic benefits. "The property of oil is to warm the body ... [for] oil helps wonderfully against cold. Drunk on an empty stomach, it either kills worms or drives them from the stomach. It is considered an antidote, especially against poison, for drunk with warm water it brings up the poison with vomit."[23] The thought of drinking olive oil may seem distasteful to today's palates, but at least some of Platina's recommendations have found confirmation in modern medical literature.[24]

By the sixteenth century, both olive oil and butter gained in popularity for cooking. For oil especially—one of the mainstays of ancient Greek and Roman cuisine—the revival was consonant with Renaissance antiquarian ideals in general. We know that Apicius's *De re coquinaria* was widely read in the Renaissance because no fewer than seven editions (all in Latin) were printed between 1490 and 1542, and most fifteenth- and sixteenth-century culinary tracts freely acknowledge the book's importance.[25] Yet the move to oil reflected more than an affinity for the classical past. A number of cultural and economic factors played significant roles in altering dietary habits as well.

In Spain, the conversion to oil had religious overtones. After Muslims and Jews were converted or expelled in 1492, a curious thing happened in the re-Christianized country: Christians assimilated Muslim tastes in their architecture, ceramics, and cuisine. The hybrid *mudéjar* style originated with Moorish craftsmen working on Christian buildings after the reconquest. With time, Islamic structural and decorative elements like *artesonado* (stalactite) ceilings and *azulejos* tiles made their way into the common vocabulary. In the kitchen, Arab specialties like gazpacho went on to become signature examples of Spanish cuisine. Until tomatoes became available in the sixteenth century, the soup's ingredients were bread, garlic, olive oil, vinegar, salt and water.[26] Olive oil, significantly, came into its own in Spain only after the Muslim and Jewish presence had ended. The Spanish olive industry expanded rapidly in the seventeenth century, according to Felipe Fernàndez-Armesto, precisely because consumers and growers finally felt "uninhibited by confessional hatred."[27]

In Italy, olive cultivation was tied to religion in a different way. The consecrated oil used for confirmation, ordination, and extreme unction could only be olive oil.[28] Likewise, the oil burned in the lamp of the host and the Holy Sacrament had to be olive oil. The Benedictines, in particular, were renowned for spreading olive culture and for introducing new methods of terracing on steep hillsides. Only after being cultivated on church lands for ritual uses did the liquefied fruit appear in abbey and priory kitchens.

Cooking with oil grew in popularity in the secular world more or less independently of its adoption in religious venues. Because planting and sustaining an olive orchard cost less than maintaining a pig farm, and oil was easier to export at competitive prices, there were economic incentives for making the shift. Indeed, as Giovanni Rebora has observed, the planting of olive groves for food supplies and for export was essentially a mercantile phenomenon. The Venetians, renowned entrepreneurs, grew few olives on their native soil but cultivated them on the Greek islands in their possession, selling the oil throughout Italy and the Germanic countries. The revival of the screw press—a device known in ancient Rome that had

gone out of use during the Middle Ages—brought about new efficiencies in the processing of olives.[29]

The importance of olive oil in late Renaissance cuisine is evident from the role it plays in Bartolomeo Scappi's magisterial treatise on the art of cooking, published in 1570.[30] Scappi's six-book, nine-hundred-page *Opera* contains more than a thousand *capitoli*, or chapters. Right at the beginning of the first book, just after outlining the requirements of a master cook (chapter 1) and the design of a commodious kitchen (chapter 2), he tells the reader how to recognize *la bontà* (the quality) of olive oil and how to best preserve it.[31] Scappi first distinguishes between seven types of oils: *forti* (strong), *dolci* (sweet), *grievi* (heavy), *leggerieri* (light), *torbidi* (unclear), *chiari* (clear), and *coloriti* (colored). Unlike Platina, Scappi does not recommend the oil for drinking but for cooking. He reports that oils made from "large sweet [olives] are better for minestre and potages than for frying, but oils made from ones that are small and clear are more appropriate for frying, while those made from olives that have turned green and have been sorted, and not crushed, are perfect. The ones that turn orange are often the heavy ones; but be warned that if the oil foams when it is fried it is not so good." In subsequent shorter chapters, the author discusses lard, which he recommends for "frying pastries and making tarts and minestre," and butter, whose uses he does not specify. Interestingly, toward the very end of his last book, Scappi returns to the subject of olive oil and offers the reader additional advice on how to maintain its purity.[32]

Butter, of course, was a third option in the kitchen. Pliny described it as fit only for "barbarian tribes, where it distinguishes the rich from the poor." However, like lard, it gradually shed its "humble" associations as it entered Italy from northern Europe during the late Middle Ages and early Renaissance.[33] Eventually, the bovine origin of butter became acceptable to the church, and in 1491, the consumption of butter during Lent was granted a special dispensation.[34] From the fifteenth through the seventeenth centuries, the use of butter slowly increased in Italian cooking, commencing with its adoption as a flavoring for soup or pasta and ending with its substitution for lard or oil in cooking meat or preparing sauces.[35]

The recipes in Scappi's *Opera* use all three cooking fats, but oil and butter clearly predominate and are frequently offered as alternatives to one another. Cooks had long used oil to prepare fish during the Lenten season and on other meatless days, and Scappi offers dozens of well-seasoned elaborations on the menu. But he also provides recipes for soups, fritters, and pies that use oil. Some years earlier, Cristoforo Messisbugo published a more modest volume on cookery that suggests many of the same choices of fats. His *Libro novo*, first printed in Venice in 1552, recommends using lard in the preparation of fowl, tripe, and some soups and broths but favors either *buon olio* or butter for practically everything else. Tarts, fritters, fish, and soups, along with a number of *magre*, or meatless dishes, mainly use oil, whereas butter (occasionally with oil as an alternative) is the choice for making a long list of pastas. From the vast number of recipes that have come down to us, we can conclude that when abstinence was not a factor, flavor determined the selection of cooking fats.

Both Messisbugo and Scappi, like Platina, were part of the cultural elite. Messisbugo was an aristocrat who, in addition to his appointment as *scalco*, or chief steward, to Cardinal Ippolito II d'Este, served in the ducal court of Ferrara, held ambassadorships, and, in perhaps his finest moment, was ennobled as Palatine Count by the emperor Charles V. Scappi, as he repeatedly reminds us in the *Opera*, worked principally in Rome in the service of cardinals and popes. The readers of their cookbooks, like Renaissance collectors and patrons, came from the upper classes of society and undoubtedly made their menu and recipe choices without regard to costs, cultural associations, or the nutritional benefits of foods.

Yet, many medieval and early Renaissance recipes draw on the theory of the four humors.[36] When in the 1460s Platina wrote that "the property of olive oil is to warm the body," he was not thinking of the reader's physical comfort. He was espousing the age-old belief that the humors corresponded to the four bodily fluids: blood, phlegm, yellow bile, and black bile. Blood was considered hot and moist; phlegm, cold and moist; yellow bile, hot and dry; and black bile, cold and dry. Each, in turn, presumably influenced a person's physical constitution or "complexion." Thus, a predominance of

blood led to a sanguine personality; phlegm, to a phlegmatic one; yellow bile, to a choleric temper; and black bile, to melancholy. Illness could affect the balance, but in a healthy person, the humors would ideally be in perfect equilibrium. If they were not, dietary changes could remedy the situation. When Platina recommended olive oil as a "warm" liquid, he evidently had these ideas in mind. Approximately 10 percent of his chapters reflect humoral theories, but, significantly, his beliefs did not persist for long. By the sixteenth century, neither Messisbugo nor Scappi had occasion to mention the humors or suggest any connections between health and cuisine. Jean-Louis Flandrin has called this separation of medical and culinary literature "the liberation of gourmandise" and sees the period as central to the phenomenon.[37]

The sixteenth century in Italy was an age of spiritual and political anxiety, thanks to a number of disquieting historical events such as the Reformation, the Sack of Rome—the worst of a series of foreign invasions—and various plagues, floods, and famines. The ideals of the High Renaissance that culminated with Julius II's visionary patronage of Bramante's new St. Peter's, Michelangelo's Sistine Chapel ceiling, and Raphael's Stanza della Segnatura came to an end soon after the pope's death in 1513. Almost overnight, the serenity and timeless beauty of Michelangelo's *Pietà* and Raphael's *School of Athens* gave way to haunting expressions of doubt and—paradoxically perhaps—stylized pursuits of grace and virtuosity. Most art historians describe the art of this period as Mannerist; Vasari himself originally coined the expression *di maniera* to denote such subjective deviations from the classical ideal.[38]

One can readily find parallels between the sensory effects in late-Renaissance art and cuisine. An unexpected link appears on one of Michelangelo's grocery lists (figure 60). In the most mundane of moments, the artist itemized three Lenten menus for a housekeeper who presumably was illiterate and needed pictures to illustrate the ingredients. Text and images are thus conjoined on the same page. The first menu calls for two rolls, a jug of wine, pasta, and a herring; the second—doubtless intended to serve two—specifies salad, a choice of wines, a plate of spinach, four anchovies,

FIGURE 60. Michelangelo Buonarroti, grocery list.

and pasta; and the third includes six rolls, fennel soup, and herring again. Although the meals were not elaborate—in keeping with his taste, according to early biographers—the arrangement of words and pictures on the sheet is interesting in itself.[39] As one perceptive art historian has noted, "The diagrams start well-intentioned and in tidy alignment with their corresponding legends [but] soon grow unruly. At the third or fourth item, the pressure of pen on paper intensifies; things batten and swell and begin to fall out of line; jugs, loaves, fishes double and treble in size . . . and spill down the sheet like a discharged cornucopia."[40]

Composed on the back of a letter written in 1518, this presumably coeval shopping list dates from the period between the artist's two campaigns in the Sistine Chapel—after 1512, when he completed the ceiling, and before 1534, when he began the end wall. Is it a coincidence that the top of the sheet begins in the orderly fashion of the ceiling and descends to the sprawling disorder of the *Last Judgment?* More likely, these offhand and perhaps impatient scribbles express the artist's increasingly unruly state of mind.

Of course, Michelangelo executed his paintings in the Sistine Chapel in fresco, not in oil. To see the effect the oil medium could have on works conceived around the same time, we can look at the paintings of the Florentine artist Jacopo Pontormo (1494–1556). Pontormo's pictures share some temperamental characteristics with Michelangelo's, even if they evoke dreamier states of consciousness. His 1525 *Deposition* (figure 61) in San Felicità, Florence, is a case in point. If we compare this altarpiece with Bellini's *Madonna Enthroned* painted nearly half a century earlier, the rejection of the classical ideals of the quattrocento is readily apparent. Symmetry and orderly perspective give way to an unstructured composition in which figures float through the air, seemingly defying gravity as they cluster together in an otherworldly setting. The effortlessness and fluidity of their movement, like the shifting colors in their garments (*colori cangianti* in Italian), were clear by-products of the medium of oil paint. Yet where Bellini used oil to invest static forms with translucency and depth,

FIGURE 61. Jacopo Pontormo, *Deposition*.

Pontormo exploited the medium's potential for spontaneous brushwork, lively gesture, and chromatic blending.

Although the changes in cuisine were by no means as abrupt as those in painting—Renaissance cookbooks still feature numerous medieval recipes—they did occur, sometimes with an eye for the varied colors and virtuosic flourishes so typical of Mannerist art. Like Pontormo's *Deposition,* the *zabaglione* that Scappi was the first to describe in 1570 would have been a pale and frothy novelty to diners. Scappi's recipe for this "most luxurious of all desserts of the caudle type" calls for fifteen fresh eggs, ten ounces of a sweet wine like *malvasia moscatella,* and ten ounces of chicken broth, cooked in a copper pot with four ounces of fresh butter and served with cinnamon and fine sugar.[41]

Ironically, eggs came into favor in Renaissance cuisine at the very time that Renaissance painters had all but given them up. Ken Albala has coined the word *ovophilia* to describe the proliferation of recipes calling for eggs in sixteenth-century books of cookery.[42] Eggs served both as flavor enhancers and as "binding liaisons," taking the place of bread crumbs as the thickener in countless dishes. New ways of preparing them—poaching, frying, baking, roasting, and grilling—or turning them into omelets, custards, and garnishes became commonplace. Indeed, as Albala notes, the inclusion of eggs in so wide a variety of recipes was one of the hallmarks of Renaissance cookery. More than any other food, eggs became a showcase for Renaissance chefs hoping to impress their patrons with culinary innovations. The trend culminated in the French haute cuisine of the following centuries, which expanded the repertory to egg-based sauces like mayonnaise, hollandaise, and béarnaise along with that most heavenly dessert, the soufflé.

The popularity of oil and butter in sixteenth- and seventeenth-century cuisine was part of a larger movement away from the dark, heavily spiced, and vinegar- or verjuice-laden sauces of previous centuries. Lighter fare—notably fowl, veal, and sturgeon—went hand in hand with a taste for sweeter flavors and colorful garnishes. Color, even bright colors, had

certainly been an important part of medieval cuisine, but the contrast of colors prescribed in sixteenth-century recipes, like the *colori cangianti* of late Renaissance painting, was special to the age.

We can imagine the delight of the diner sitting down to a plate of *pastelli,* or pastry shells, of the sort that Messisbugo describes: filled with meat cooked in butter and then garnished with lemon slices, fresh fennel fronds, saffron, and unripe grapes or sour black cherries; or in the meatless version, filled with smoked mullet cooked in oil and then accompanied by artichokes and pumpkin and glazed with orange juice.[43] Interest in creating dishes with dazzling contrasts of color, texture, and flavor only increased in the next century. For a *minestrina* that sounds truly sumptuous, Vittorio Lancelotti proposed in his *Scalco practico* (1627) a stew of artichokes, pigeon meat, chunks of sweetbreads, veal rolls, chicken crests and livers, aromatic herbs, and slices of prosciutto in a broth of egg yolks and lemon juice, garnished with fried asparagus.[44] As binders grew richer, with roux and butter-based sauces proliferating in the seventeenth century, the aesthetic shifted from the artificiality of Mannerism to the sensuality of the Baroque. Rubens was the painter who best personified this later age, his free brushwork and palpable naturalism transforming his oversized canvases into feasts for the eye.

By 1500, oil had replaced eggs as artists' binder of choice, whereas cooks continued to choose from an array of possibilities. Whichever method they adopted, it derived from somewhere else—oil paint from Flanders, cooking oil from Arabia, and butter from northern Europe. Collectively, these ingredients became essential to the creation of Italian Renaissance tastes; indeed, many of the visual and gustatory refinements of the period could not have taken place without them.

Eating and Erudition

Few frills attended the typical medieval meal. Bowls and platters were used for serving, and goblets and cups for drinking, but diners made do with little else. Food was plated on trenchers of dried bread, and fingers did the work of forks and spoons. As the need arose, diners wiped their fingers and mouth on the tablecloth. Although long-handled spoons and two-tined forks were available for taking food from cauldrons or serving bowls, the only personal utensils on hand were knives that typically belonged to their users.[1] "Sharing," as Terrence Scully has pointed out, "was the essence of the medieval meal."[2] Indeed, such was the measure of friendship that the word *companion* literally meant the person with whom one shared bread. The world of manners would change in the course of the Renaissance.

The term "trencher" (*tagliere* in Italian) has its origins in *tagliare*, to cut or slice, an appropriate derivation given that early trenchers were sliced from loaves of stale bread. More than one late medieval source recommends that the bread be four days old.[3] In addition to functioning as a plate, trenchers could double as spoons or provide a handy surface on which to clean one's knife. When soaked in gravy, they could then be eaten or tossed to a favorite dog.

With the coming of the Renaissance, trenchers evolved into more durable artifacts, while individual tableware, cutlery, and napkins found their way onto the tables of all social classes. Just as portraiture and biography, not to mention self-portraiture and autobiography, celebrated humanistic ideals all but forgotten in the Middle Ages, so did dining habits come to reflect the growing autonomy of the individual in society. A second Renaissance phenomenon, the "culture of consumption," with

its increased appetite for worldly goods of every kind, in turn expanded the repertory of the serviceware to include many types and sizes of serving pieces and utensils.[4]

Indeed, it was the table settings, not the food, that most impressed Michel de Montaigne at a dinner he attended in Rome in December 1580.[5] In his journal of foreign travels, Montaigne first remarks on the long-winded benediction and multiple graces that preceded and followed the meal—his host was a French cardinal, but the protocol was Italian—and then focuses on the table service. He notes that each guest was provided with his own napkin along with a knife, fork, spoon, and silver or earthenware plates. He reports seeing little if any sharing of food or drink. Montaigne comments that a servant held a silver basin under his chin as he sipped from his own bottle of water and glass of wine. Curiously, he had nothing else to say about the meal, which he otherwise thought unremarkable.

Montaigne's mention of the "silver or earthenware plates" on which he ate is particularly revealing. As *eating* increasingly turned into *dining* after the Middle Ages, trenchers of stale bread were replaced by dishes made of wood, pewter, and ceramic in most homes, and by plates of gold and silver on aristocratic tables.

The Renaissance tendency to privilege well-crafted objects over those merely made from expensive materials was not just a matter of economy—though gold was in short supply during the fifteenth century—but reflected the greater importance attached to skillfulness in all manners of artistic expression.[6] The phenomenon first became apparent in the art of panel painting when the gold-ground technique began to wane in the mid-quattrocento. Leon Battista Alberti preached the new credo in his treatise *On Painting* (1435):

There are painters who use much gold in their pictures because they think it gives them majesty; I do not praise this. Even if you were painting Virgil's Dido—with her gold quiver, her golden hair fastened with a gold clasp, purple dress with a gold girdle, the reins and all her trappings of gold—even then I would not want you to use any gold, because to

represent the glitter of gold with plain colors brings the craftsman more admiration and praise.[7]

Accordingly, earthenware service pieces began to vie with ones of precious metal on the tables of even the highest social classes. Around 1500, the Bolognese humanist Antonio Urceo wrote a humorous epigram to accompany a gift of ceramics in which he specifically contrasted craftsmanship with cost:

> We are called pots, we exist everywhere,
> And we ask a lower price.
> Glassware is more expensive, and so is crystalware,
> And all metalware surpass us for price,
> However, neither King Agatocles was ashamed of dining off us,
> Nor King Numa of making offerings off us,
> We are not manufactured by foreign hands, and yet
> We are not inferior artistically to any of the foreign arts.
> And if it wasn't for the fact that self-praise
> stinks, we would say that we deserve the first prize.[8]

While progressive painters were receiving praise for their creative illusionism, prosperous patrons were being admonished for unnecessary displays of opulence and material wealth. Sumptuary laws restricted extravagance in numerous aspects of public and private life, and although these mandates may have done little to curtail ostentation, we can have little doubt that the "bonfires of the vanities" sparked by Savonarola in Florence in the 1490s resulted from widespread opprobrium for worldly consumption.[9] Together these two factors—one aesthetic, the other ascetic—were at least partially responsible for the flowering of the art of maiolica in the following century. As gold and silver tableware became scarcer, settings fashioned from ceramics became more ambitious, both in style and in content.

Renaissance artisans were hardly the first to embellish earthenware plates and vessels with painted imagery. Bronze Age potters in Crete and

Mycenae decorated their creations with plant and sea creatures drawn from nature, and sixth-century Corinthian and Athenian vase painters expanded the repertory to include narrative compositions adapted from classical mythology. Scenes derived from Homeric poems featuring Achilles, Patroclus, Ajax, and Troilus—or ones celebrating Heracles and Dionysus—were especially popular. With time, the depictions became more sophisticated as the so-called black-figure style eventually gave way to red-figure designs of striking beauty and naturalism. Vase painting, today so highly valued in part because all other forms of Greek painting have vanished, reached its pinnacle in fifth-century Athens just as Pericles was building the Parthenon and Phidias was carving its sculpture. In the spirit of celebrating individual genius, ancient Greeks recognized the leading vase painters by name.

Greek artisans produced a remarkable number of distinctively shaped pots. Scholars have identified more than thirty types—from enormous calyx and volute kraters to small skyphoi and pyxides.[10] The smallest pieces, like jewelry boxes and perfume jars, sought to enhance the rituals of daily life, whereas the largest were often made as "grave gifts" for the dead. Most, however, found use in eating and drinking. Even modest-size cups and bowls were decorated with figural imagery, whether of fish, fowl, or the heads of women. Larger pots depicted satyrs and maenads dancing, playing music, or otherwise entertaining themselves. Dionysus naturally appeared on vessels for storing, pouring, or drinking wine. And wine, more than food, lay at the heart of Greek social life.[11]

Roman artists emulated Greek architecture and sculpture without hesitation, yet they were surprisingly indifferent to Greek narrative pottery. Their indifference was all the more remarkable given the additional legacy of painted ceramics they inherited from the Etruscans, but Roman tastes clearly leaned more toward metalware and glassware than to anything made of clay. The finest tableware was made of silver—with perhaps the most famous examples being the Hildesheim Treasure or the Mildenhall Dish—whereas more common pieces were cast in bronze, like those discovered at Pompeii. Interestingly, when Pliny speaks of terra cotta in

his *Natural History,* he thinks of it primarily as a building material and only in unadorned form as a container for water or wine.[12] Clearly, in setting the table, the Romans preferred glitter to erudite illustrations to whet the appetite.

Maiolica

Medieval diners forswore such luxuries during the next millennium, but in the thirteenth century, painted earthenware began to reappear on Italian tables, particularly in Umbrian towns like Deruta, Orvieto, and Pesaro, where the Etruscan heritage was strong and the clay plentiful. The new ceramics looked nothing like Greek or Etruscan ware, however. Born of a desire to imitate Chinese porcelain and to incorporate the revolutionary techniques of Middle Eastern potters who had earlier sought the same lustrous effects, late medieval ceramics had a character all their own. They differed from ancient examples primarily in the application of a white tin glaze over the tan or red clay as a base for a color design. Initially, the colors were limited to copper green and manganese purple, and the level of painting was fairly crude. A bowl now in Detroit (figure 62) is a good example of these early pieces. The prevalence of Islamic interlace and floral patterns points to the Moorish origin of the decoration, although how this hybridization occurred remains a mystery, as the confused etymology of the word *maiolica* suggests. Whether the term derives from the name of the Balearic island of Majorca, which was the intermediate center of transport for Moresque lusterware destined for the Italian market, or from *obra de malequa,* the name of lustered pottery made in Málaga and the Moorish south of Spain, it plainly was associated with iridescent Islamic ceramics.[13] Until the sixteenth century, *maiolica* referred exclusively to lusterware of Spanish or Islamic origin, only later applying to unlustered pottery as well.

The antiquarian and secular ideals of the Renaissance inevitably led to the Westernization of Middle Eastern prototypes of every kind. Painters were especially susceptible to non-Western influence because, unlike architects and sculptors, they had few classical models to follow. With

FIGURE 62. Anonymous, maiolica bowl.

the exception of the frescoed *grotteschi* discovered in the Domus Aurea in 1480, Roman wall painting was largely unknown before the eighteenth century, and Greek and Etruscan pottery had yet to attract the interest that attended Greco-Roman sculpture.

Accounts of Greek vases in Renaissance collections are sketchy at best. The earliest appears in a letter to Lorenzo de' Medici in 1491 in which the author, Angelo Poliziano, offers to send from Venice "a most beautiful, very ancient clay vase . . . along with two other little vases of clay. . . . I do not think you have one as beautiful as this."[14] Obviously Lorenzo had others, and by then, at least two quattrocento artists, Andrea Mantegna and Antonio Pollaiuolo, had already depicted Greek vases, or figures taken from vases, in their works.[15] Beyond these examples, the extent of their impact is debatable. Since Michael Vickers wrote in 1977 that "the appreciation of Greek vases in Renaissance Italy has been largely overlooked by both Classical archaeologists and by art historians," few new links have been established between the two.[16]

Nevertheless, toward the end of the late fifteenth century, maiolica painters began to expand their imagery beyond the stylized animal and vegetal patterns favored by ceramists of previous generations. Portraits, usually of anonymous figures, family coats of arms, and, less frequently, iconic religious representations increasingly adorned dishes, wine jugs, and pharmacy jars. A Faentine plate (figure 63), c. 1470–80, gives a hint of the ambitious scenes that would soon find their way onto maiolica.[17] Although crudely drawn and still highly stylized, a narrative scene fills the center of the field on the plate. A seated emperor, attended by two courtiers, receives a man who bears a book in his hands. The emperor is Charles IV, the visitor is Petrarch, and the plate commemorates their meeting more than a century earlier. The historical subject was radical for a work of maiolica, but the artisan was less adventurous when it came to matters of style: the stiffly seated Charles IV is derived from one of the *Tarocchi,* or tarot-card prints, that were produced around 1465–67 by a Ferrarese engraver known as the Master of the E-Series.[18] Relying on graphic sources would become a constant as *maiolicari* (pottery painters) increasingly followed the lead of fine-art painters by turning to narrative.

Again Alberti set the tone in *On Painting,* this time by recommending *istoriato,* or history painting, above all other forms of visual expression.[19] The related doctrine of *ut pictura poesis* (as is painting, so is poetry) favored narrative painting as well.[20] If painters embraced this notion as a way of asserting their intellectual superiority over mere craftsmen, the *maiolicari* who walked in their footsteps presumably sought greater social and professional recognition of their own. As a result, the art of ceramics rose higher in the aesthetic hierarchy, at least among patrons and collectors, than it had at any time since the Greeks.

Sixteenth-century historiated maiolica was as complex and as differentiated as anything produced in classical Greece. Although its richly colored pigments could hardly be more different from the terra cotta and black tones of Attic ware, the erudite imagery and specialized shapes of later Renaissance serviceware were more akin to that of ancient Aegean

FIGURE 63. Anonymous, maiolica dish with Petrarch
and the Emperor Charles IV.

vessels than to that of the Islamic pottery that technically inspired them.
Despite little evidence of conscious emulation, the parallels, neverthe-
less, are striking.

Although Greek vases and the imagery on them were generally tied to
the consumption of wine in ritual events like funerals and symposia,
Renaissance maiolica was mainly used to serve food or to embellish rooms
where food was consumed. Not surprisingly, perhaps, cuisine underwent
as many changes during this period as did tableware. The gastronomic
literature of the fifteenth and sixteenth centuries documents the history
of the phenomenon with some precision. Beginning with the texts of
Maestro Martino da Como, Platina (Bartolomeo Sacchi), and later, Cris-
toforo Messisbugo and Bartolomeo Scappi, we find menus and recipes of
increasing complexity and differentiation. Messisbugo describes a meal for
fifty-four guests that included twelve courses consisting of 140 different

foods served on more than 2,500 plates.[21] Scappi, in turn, devotes hundreds of pages to reciting the menus and itemizing the number of plates required for numerous luncheons and dinners. The lists are staggering: for a typical *collatione* in the garden of an unnamed Roman host, the three-course meal featured nearly one hundred dishes—some of them sculpted from butter or sugar—served on 436 plates and 88 cups.[22] As menus themselves became more colorful, polychromed ceramic serviceware can only have complemented the visual appeal of the food. Indeed, even the plainest tin-glaze plates would have provided a striking background for the virtuoso displays of contemporary cuisine.

The maiolica industry grew significantly in the sixteenth century. Although some of its energy went into the production of tiles, pharmacy jars, birth sets, and the like, most of the output was destined for the dining room, either to be used on the table or to adorn a sideboard or credenza.[23] By 1515, manufacturers in Emilia-Romagna, the Marches, Umbria, and Tuscany, among other places, were making *istoriato* pottery. For the first time in nearly two thousand years, painted ceramics were taken seriously. Novelty may have had something to do with the pieces' popularity. Lorenzo de' Medici said as much when he thanked Roberto Malatesta for a gift of pottery circa 1490, years before the medium attained full maturity.

> Two days ago I received with a letter from your honor those pottery vessels that you have graciously sent me . . . as they are perfect and much to my taste, they gave me great pleasure. I cannot adequately thank you, because if rare things are to be valued more, I appreciate and value these vessels more than if they had been made of silver, because they are very excellent and rare, and new to us here.[24]

As with their forebears in ancient Greece, the most famous painters and their workshops were renowned and remembered: Nicola da Urbino, Francesco Xanto Avelli, Guido Durantino, and Maestro Giorgio Andreoli were among those who stood out in the profession. Nevertheless, Giorgio Vasari, the famous biographer and arbiter of sixteenth-century taste,

praised the finished products ("They would not have been better if they had been executed in oils by the most excellent masters") while all but ignoring the individual *maiolicari* who made them. His ambivalence is apparent in his life of Battista Franco, a Venetian painter who occasionally designed maiolica for the Duke of Urbino. Such efforts, Vasari says, "produced a rare result," albeit one qualified by frequent borrowings from "the prints of Raphael and other able masters."[25] The essentially derivative nature of maiolica compositions continues to constrain art-historical enthusiasm even today, but it seems to have had just the opposite effect on patrons and collectors during the Renaissance.[26]

By the 1520s and 1530s, households were commissioning whole services of tableware, mostly in the area around Urbino, to meet the expanding needs of meals like those later described by Messisbugo and Scappi, or the one attended by Montaigne in Rome. Given the fragility and relatively low survival rate of tin-glazed earthenware, the number of pieces that were originally in the set that Nicola da Urbino made for Isabella d'Este (of which twenty-one survive) or in Xanto's famed Pucci service (of which thirty-seven remain) must have been considerable. Perhaps the tableware changed from one course to the other as diners worked their way through the meal. Scappi's multicourse menus document the custom of alternating *servitio di cocina*, service from the kitchen, with *servitio di credenza*, service from the credenza or dining cabinet. Because contemporary depictions of upscale banquets like Giulio Romano's famous *Feast of the Gods* in Palazzo del Tè, Mantua, invariably show only metalwork on display in princely dining chambers, earthenware may have come more commonly from the kitchen.[27] Indeed, maiolica dishes are sometimes seen on kitchen sideboards in sixteenth-century paintings of everyday scenes, like the *Supper at Emmaus.*[28]

Personalized ceramics were especially common during the early Renaissance. Familial coats of arms and individual emblems known as *imprese* attested to the nobility of the owner, and armorial plates also made popular gifts, whether given or received by the person whose *stemma* they featured.[29] "Portrait" dishes depicting idealized men and women were

popular as well.[30] *Bella donna* plates, such as the one in figure 64, refined the ideal of feminine beauty that had inspired potters more than two millennia earlier. Like many such dishes, this one is embellished with an inscription set within a banderole. Typically, the inscriptions proclaim the woman to be *diva* (divine), *unica* (unique), *graziosa* (charming), or, more commonly, *bella* (beautiful), but here the words read:

LA • VITA • EL • FINE • ELDI • LO • DA • LASE • RA • X
(*Life by its end, day by the evening, is praised.*)

The provocative inscription effectively transforms the plate into an object of meditation, which was clearly the direction in which maiolica was headed in the later Renaissance.

Istoriato serviceware occasionally depicted current events, but most pieces took their subjects from classical sources. These themes reveal the learning, not to mention the pretensions, of maker and owner alike. Ovid's *Metamorphoses* was the favored text, but *maiolicari* also mined printed editions of Virgil, Valerius Maximus, and Livy, among others, for their pictorial possibilities. The popularity of Ovid probably stemmed as much from the availability of an edition illustrated with woodcuts (Venice, 1497) as from the tales themselves. In truth, "maiolica painters," as Timothy Wilson has remarked, "were decidedly not at the cutting edge of humanist scholarship; their knowledge of classical literature and myth was mostly indirect, partial, and unreliable."[31]

Of all the *maiolicari*, Xanto was the most intellectually ambitious. Even his name, a corruption of Santo, or Santini, self-consciously evoked the name of the Homeric river god Xanthus, whose waters flowed on the Trojan plain and who fought on behalf of the Trojans against Achilles and Hephaestus.[32] Xanto could not only read and illustrate classical texts but also wrote verse. After moving from his native Rovigo to Urbino around 1530, he penned a volume of forty-four sonnets for the duke, Francesco Maria della Rovere. The poems, which were never published, are courtly, extolling the virtues of his patron, his country, and, in the end, himself.[33]

One of the finest sets of historiated maiolica to survive is Xanto's Pucci

FIGURE 64. Anonymous, *bella donna* plate.

service, dated 1532–33. Thirty-seven pieces of it are now dispersed among more than two dozen museums and private collections throughout the world. Fortunately, the coherence of the group is evident from the presence on each plate of the Pucci arms—the profile of a moor's head with a white headband on a silver field. Thanks to Julia Triolo's catalogue of the pieces, we can again appreciate the splendor of this service.[34] The patron was Piero Maria Pucci, a nouveau riche Florentine whose family loyalty to

the Medici had been rewarded with numerous political and ecclesiastical appointments. Like most private patrons of the Renaissance, he likely commissioned works of art as part of his overall strategy of self-presentation.

The Pucci dishes, to judge from those that survive, came in three sizes. On average, the largest plates measure forty-four centimeters; the midsize ones, twenty-seven centimeters; and the smallest, nineteen centimeters—almost exactly the dimensions of today's serving platters, dinner plates, and side dishes. Triolo's catalogue of the individual pieces reveals the diversity of Xanto's iconographical preferences. Nearly half the subjects came from Ovid, but a fair number also draw on Virgil, Petrarch, Pliny, and Ariosto; this mixture of literary sources suggests that the potter had access to the ducal library in his native Urbino. For those diners puzzled by what still lay before them after the completion of the meal, all they had to do was turn over the plate, for Xanto provided an explanatory inscription on the underside of each, along with his name and the date.

A typical plate from the Pucci service is *King Anius' Daughters Turned into Doves* (figure 65), now in New York.[35] Given the relative rarity of the depiction, one may be grateful for the inscription:

<div align="center">

• 1532 •

Dil Re Anio Figlie

i[n] più Colombe

Nel • XIII • L: d[e] Ovidio Met:

fra[ncesco]: xanto • A •

da Rovigo, I[n]

Urbino

</div>

Set against a background of architecture and landscape, the scene shows three young women to whom Bacchus has given the capacity to change anything into wine, seeds, and oil. When Agamemnon subsequently demands that they furnish the Greek army with food, they object, and to avoid being abducted, turn again to Bacchus, who transforms them into doves.

Xanto's inscriptions proudly acknowledge his literary sources but ne-

FIGURE 65. Francesco Xanto, maiolica plate with
King Anius' Daughters Turned into Doves.

glect to mention his visual ones. Triolo has collected this information as
well, identifying no fewer than thirty prototypes for figures in the Pucci
service alone.[36] Many plates appropriate material from four, five, and even
six prints, but *King Anius' Daughters* borrows from just two: Giovanni
Giacomo Caraglio's *Contest between the Muses and Pierides* (figure 66),
after Rosso Fiorentino, and Marcantonio Raimondi's *Silenus Supported
by a Young Bacchus* (figure 67), after Raphael or Giulio Romano. Curiously,
Xanto included the musical instruments that the muses hold in the print

FIGURE 66. (Top) Giovanni Giacomo Caraglio, *Contest between the Muses and Pierides.*

FIGURE 67. (Bottom) Marcantonio Raimondi, *Silenus Supported by a Young Bacchus.*

but that have no place in the Ovidian tale. Xanto was not alone in adapting prints to his ceramic compositions, which is why Vasari declared maiolica to be lacking in *invenzione*. Yet if not for the availability of reproductive engravings—a corollary benefit of the printing press—historiated maiolica might never have come about.

Table Talk

Renaissance banquets, like feasts of any period, satisfied cultural as well as nutritional needs.[37] Since the beginning of Greek history, communal meals were occasions for discussing high-minded ideas amid bountiful food and drink and making alliances between entertainments; delectation and didacticism were all but inseparable. Ancient authors embraced the topic of dining with enthusiasm. Plutarch, for example, wrote an entire volume entitled *Table Talk* (*Symposiaka*) exploring the nature of convivial dinner conversation, whereas Atheneus's *Sophists at Dinner* (*Deipnosophistarum*) offered a compendium of extravagance that highlighted the settings and spectacles accompanying the most lavish gastronomic feasts of the ancient world.[38] Renaissance humanists marveled at such texts, which were readily available in modern printed editions from publishers throughout Europe. Indeed, more than a dozen imprints of the *Deipnosophistarum* were available before 1600, one an Italian translation from 1556.[39]

Renaissance authors offered their own advice on improving conversation at the dinner table. Leon Battista Alberti began the trend with his *Intercenales*, or *Dinner Pieces*, a collection of short essays to be read "over dinner or drinks."[40] Other popular titles were Erasmus's *Colloquia* (1519), Giovanni della Casa's *Galateo* (1558), and Stefano Guazzo's *La civile conversazione* (1574). These books were typically prescriptive, but Guazzo devoted some one hundred pages to a transcription of a conversation at an actual dinner party in Casale Monferrato in honor of Vespasiano Gonzaga, duke of Sabbonieta. Although the meal was undoubtedly a cornucopian feast like those Scappi described in his *Opera* (published four years earlier), Guazzo says nothing about the menu or the quality of the food. The rea-

son, as one guest remarked, was that "all the delights of this supper shall not depend on the sweet taste of meats, but of the pleasant discourse of those present."[41] In truth, the dinner seemed but a pretext for the guests to show off their good manners and eloquence.

At the beginning of the evening, the diners played a silly game based on a volume of Petrarchan sonnets "which lay across the table," then moved on to one that called for them to recite proverbs or ditties on the virtues of the solitary life. Among the offerings were "It is better to be alone than in ill company," "If the eye does not see, the heart cannot rule," and the perennial favorite, "Out of sight, out of mind." Of course, few of these contributions were spontaneous or original, with most presumably borrowed from one of the many anthologies of literary maxims and popular *motti* published in the period.[42] A catalogue of such dinner games was compiled by Girolamo Bargagli in his *Dialogo de'giocchi che nelle vegghie sanesi si usano di fare* (*Dialogue of the Games Played in the Evening Companies of Siena*), published in 1572. Bargagli contrasted "games of jest" with "games of knowledge and invention," and for the latter, advised readers to "become familiar with Petrarch, Ariosto, and Dante's verses, of which it is convenient to learn many by heart, not just to play the game of verse-making but also for many other games that may occur."[43] One can easily imagine pieces of historiated maiolica—of which no two were identical—prompting some of the conversations and games.

Bargagli adds that misinterpretation (*aequivocatio*) of texts like Petrarch's was another aspect of dinner-table gamesmanship. For example, the scenes on Xanto's Pucci service are full of narrative conflations and errors of citation, and by all accounts, he was the most learned of the maiolica painters. Were his mistakes intentional, or was his intellect, in the words of Timothy Wilson, merely "unreliable"? The latter inference is probably accurate, but pity the diner who had forgotten or never read the text in question. Having to turn over one's plate to read an explanatory inscription would have been an admission of ignorance.

Stefano Guazzo mentions only one piece of tableware, a boat-shaped wine goblet, in his long-winded description of the dinner for Vespasiano

FIGURE 68. Anonymous, maiolica plate with
Allegory Relating to Vespasiano Gonzaga.

Gonzaga. The author fails to say whether this virtuoso object was made of
metal, glass, or ceramic, but he spares no detail in repeating the repartee it
provoked at the table.[44] Although historiated maiolica did not come up in
the conversation, the guest of honor seems to have taken a special interest
in the medium. We know of Vespasiano's interest not from a dinner service
but from a highly sophisticated plate featuring his *impresa* (lightning
striking a mountain) that has recently come to light (figure 68).[45]

This large (37.1-centimeter) plate is unique, perhaps even uniquely
puzzling, and it offers proof of the pictorial intelligence of the potter
and patron alike. The subject is not from the usual narrative sources, and

no explanatory inscription appears on the highly decorated reverse to explicate its meaning—only the date 1555 within a cartouche. In Wendy Watson's view, the imagery is allegorical, with a border of mythic and emblematic allusions to Vespasiano's personal life and a main scene that seems to conflate his civic aspirations with a tale told by Virgil. The figures of Jupiter, Juno, and Chronos on the rim allude to love, marriage, and time. Opposite Vespasiano's *impresa* is a second emblem that may be that of his first wife, Diana de Cardona, whom he had married six years earlier. Perhaps she or another member of the family commissioned the plate to commemorate the duke's recent return from a series of successful military campaigns and his concomitant decision to rebuild Sabbioneta as an ideal Renaissance city. The center of the plate almost certainly refers to the work at Sabbioneta, although the city in the background is not a literal depiction of the place. More prominently, the foreground figures illustrate a scene in the *Aeneid* in which Aeneas, sleeping by the Tiber, has a dream in which the river god foretells Aeneas's role in the founding of Rome. Awakening, Aeneas forms an alliance with King Evander and with the help of celestial intervention, goes on to realize his destiny. For Vespasiano Gonzaga, like the first-century Roman emperor who was his namesake, the association with the building of Rome was propitious. In time, Sabbioneta became one of the few "ideal" cities to actually be built, and contemporaries viewed it as a "new Rome" and saw the duke as its new Aeneas.

The Gonzaga plate would have made an exceptional conversation piece, if only for the duke, his family, and his court. Unfortunately, scholars have been unable to trace its provenance before the nineteenth century, and we have no way of knowing how its owner originally used it or displayed it. Dinner services like the one Xanto made for Piero Maria Pucci were certainly more typical of the ceramic arts throughout the century. As both literary texts and reproductive engravings proliferated after the invention of the printing press, and dining and its attendant conversations became more complicated and more ritualized, historiated maiolica at once became the ideal vehicle for eating and for erudition.

Edible Art

Trionfi da Tavola

Renaissance feasts in many respects belong as much to the history of showmanship as to the history of gastronomy. Indeed, the tableware and table decorations at courtly dinners were frequently more ostentatious than the meal itself. Chapter 7 explored one aspect of this phenomenon, the intellectual pretensions of table service. This chapter examines its more fanciful side: the centerpieces, or *trionfi da tavola* ("triumphs of the table"), that appealed to the sixteenth- and seventeenth-century taste for deceptive illusions. Although *trionfi* primarily served as feasts for the eye, they were often fashioned from edible substances like meats and cheeses or sugar and marzipan. These virtuosic displays were rife with ironies: their manufacture from inexpensive materials, their almost complete lack of practical utility, the brevity of their existence, and, finally, the possibility of consuming them after they served their decorative purpose. None, of course, survive to the present day, although we can reconstruct a few notable examples from visual and textual sources.

The offering of edible *trionfi* to dinner guests satisfied the taste for ambitious visual iconographies as well as for the embellishment of trifling objects. The preciousness, even the perversity, of such seemingly contrary impulses is evident in Benvenuto Cellini's famous *Saltcellar* (figure 69), which the artist created in the early 1540s for the court of Francis I at Fontainebleau. Made of gold and enamel, and measuring a little more than ten by thirteen inches, this luxury table item showcases two recumbent

FIGURE 69. Benvenuto Cellini, *Saltcellar.*

deities, the Roman sea god Neptune and the earthly Venus. The figures
could hardly appear more languid or graceful as they appraise one another,
accompanied by symbols of their domains, a ship and a classical building,
which hold the salt and pepper. The saltcellar also contains a variety of
marine and terrestrial creatures as well as personifications of Day, Night,
Twilight, Dawn, and the Four Winds. "When I first showed this to his
Majesty," Cellini relates in his autobiography, "he uttered a loud outcry of
astonishment, and could not satiate his eyes with gazing at it."[1]

Cellini was not the first artist to embellish a service piece so extrava-
gantly. Earlier, Giulio Romano (1492–1546) designed a full array of equally
ornamental table decorations for his principal patrons, the Gonzaga of

Mantua. None of these precious metalwork objects seems to have survived, but fortunately hundreds of drawings—both originals and copies—along with numerous reproductive engravings, preserve his designs.[2] Candlesticks, basins, sauceboats, tureens, and urns were part of his repertory, but saltcellars seem to have held a special fascination for the sixteenth-century imagination. Possibly this originated with the intrinsic value of salt, a substance historically known as "white gold," whose trade and taxation played an important role in the Renaissance economy.[3] Yet salt had a mythic side as well. Homer called it "a divine substance," Plato described it as especially dear to the gods, and the twentieth-century Jungian psychologist Ernest Jones has even suggested that the historical obsession with it was not just irrational but subconsciously sexual.[4]

Giulio Romano's saltcellars typically took the shape of a large seashell carried on the back of an imaginary marine creature that floats atop a churning sea. Sometimes the creatures were mythically human—mermen with fish tails like Glaucus or Triton—or took the form of fabulous sea monsters resembling snakes or giant lizards. The distinctions between fable and zoology often blurred, however, as the late-Renaissance imagination was complemented by a keen interest in taxonomy. Indeed, the sixteenth century was as well-known for its specimen collections as for its flights of fancy. All manner of exotic mammals and reptiles were kept in zoos or were stuffed and displayed in "cabinets of curiosities" or "wonder rooms."[5] One avid collector, Ulisse Aldrovandi, even wrote a treatise entitled *Dracologia* that was inspired by the capture outside Bologna on May 13, 1572, of a particularly fearsome serpent with "a bird's feet and a fish's head." A rendering of this *dragone mostroficato*, or "monstrous dragon," preserves its extraordinary appearance.[6]

Trionfi da tavola made of silver or other precious metals could be breathtakingly expensive. Cellini boasts that he was given three hundred pounds of silver and paid five hundred crowns of gold to make twelve figurative candelabra for the king's table.[7] Because few private patrons could match that extravagance, artisans sought ways to fashion the decorations from less expensive materials. What could be more economical, or more witty,

than to use ingredients that were themselves consumable? Bartolomeo Scappi (1570) and Giovanni Battista Rossetti (1584) both describe banquets that sported edible table decorations made of sugar or assorted meats, but an even earlier account describes such decorations at a dinner in Rome in 1519.[8] The host, Lorenzo Strozzi, entertained the Venetian ambassador and four cardinals—along with a few friends and three prostitutes—at a feast marking the beginning of Lent. Carnival festivities have always been occasions for macabre displays, but this one was particularly bizarre. In his diary, the envoy, Marino Sanuto, described the feast as a "death banquet" held in a black-draped chamber with skeletons in the corners and votive tapers providing the only illumination.[9] The pièces de résistance, however, were *trionfi da tavola* made of skulls that opened to reveal roast pheasant and bones that contained sausages. The guests were not amused, however, and several found the affair so frightful that they fled before the meal was over. "Nevertheless," Sanuto had to admit, "it had been one of the most beautiful dinners ever given in Rome."

Vasari describes more palatable offerings in his *Lives* (1568). His biography of the minor Florentine sculptor Giovan Francesco Rustici (1474–1554) contains detailed accounts of several dinners arranged by artists in two local confraternities, the Company of the Cauldron and the Company of the Trowel. Rustici was a member of both, and his "fanciful" tastes—Vasari says he tamed a porcupine to behave like a dog, taught an eagle and a raven to speak like humans, and studied necromancy— found their perfect medium in the many banquets he helped organize. Vasari names the individuals who attended these affairs, and none were aristocrats or people of means. Andrea del Sarto, Domenico Puligo, and Piero di Cosimo took part, but their companions on the whole were artists of lesser distinction. The presumed modesty of their budget may have been the spark that ignited their brightest creative fires.

Vasari admits that his description of these banquets constitutes a "lengthy digression" in his life of Rustici. Not only does he provide the menus, but he also gives detailed descriptions of the costumes, settings,

and entertainments the artists contrived for such gatherings. At banquets sponsored by the Company of the Cauldron, each person customarily brought something to eat that had been "made with clever invention" and that members could share (if two people brought the same dish, they were fined). The clear favorite at one of these dinners, according to Vasari, was a confection designed by Andrea del Sarto (1486–1531) in the shape of the Florence Baptistery.

> The pavement was made of jelly and resembled a variously colored mosaic; the columns, which looked like porphyry, were large sausages; the bases and capitals parmesan cheese; the cornices were made of pastry and sugar, and the tribune of marzipan. In the center was a choir-stall made of cold veal, with a book made of pastry, the letters and notes formed by peppercorns. The singers were roast thrushes with open beaks, wearing surplices of pig's caul, and behind these were two large pigeons for basses, with six larks for the sopranos.[10]

The Company of the Trowel, named for the antics that followed the discovery of a builder's trowel at a Florentine garden party, gave "countless" feasts of their own. A particularly memorable one called for guests to come dressed as builders or laborers and then use trowels and hammers to construct an edible building from plans provided by the company. The materials included:

> Cream cheese for mortar, pastry sugared over, spices and pepper mixed with cheese for sand, and coarse sugar, plums and slices of cake for gravel. The bricks and tiles were made of cake. A plinth that was brought in was judged unsatisfactory by the masons and they decided to break it into pieces whereupon its interior was found to be full of tarts and such things. They then brought a great column wound with calf's tripe. Pulling this apart, they ate the boiled veal, capons and other things of which it was composed. Next they attacked the base of parmesan cheese, and its marvelous capital of roast capon and slices of veal with mouldings of

FIGURE 70. Arch of Vigilance. Page from Francesco Orilia,
Il zodiaco, over, idea di perfettione di prencipi.

tongue. A very ingenious architrave then arrived on a cart, with frieze and cornice composed of too many viands to mention.[11]

Vasari, writing in 1568, notes that such feasts "have now practically died out." They may indeed have died out in Florence, but later publications like G.B. Rossetti's *Dello scalco* (1584) indicate that similar banquets were still occurring in the author's native Ferrara. A remarkable piece of graphic evidence from the seventeenth century attests to the continuance of this fanciful tradition: a woodcut from 1629 depicts an edible triumphal arch erected that year in Naples to celebrate the reign of the popular Spanish viceroy, Antonio Alvarez di Toledo, duke of Alba (figure 70).[12] Designated the "Arch of Vigilance," this construction was the last of twelve temporary zodiacal arches erected to celebrate his benevolent rule. Unlike the other eleven structures, which followed the manner of Cosimo Fanzago, the mastermind of Baroque Naples, this design evidently came from illustrations in Sebastiano Serlio's sixteenth-century treatise on architecture.[13] But where Serlio's architecture was built of rusticated stone and banded columns, Alba's arch was cleverly assembled from cheeses, hams, sausages, and roast piglets. Placed next to it, at the end of the processional way, was a more typically Fanzagoesque "fountain of wine." Both monuments, the author reports, were especially popular with the Neapolitans, who presumably consumed the tribute after the festivities had ended.

Dessert

Ritual feasts of all eras traditionally end with dessert; diners are never more relaxed or primed for a sweet surprise than when already satiated with food and drink. In Europe, the notion of transforming sugary confections into works of art first arose in the fifteenth century. Dessert sculpture, often conceived with artful iconography, then became enormously popular. The epitome of accomplishment in this arena occurred much later when, in the

Regency period, the so-called architect of French cuisine, Antonin Carême (1783–1833), pronounced "architecture the most noble of all the arts with its greatest manifestation being the art of the pastry chef."[14]

The history of sugar sculpture is part of the history of sugar itself. Historians seem to agree that sugar cane was first domesticated in ancient New Guinea but probably not refined until Greco-Roman times.[15] The earliest written evidence of the process is from around 500 A.D., but not until after the eighth century did Europeans begin consuming sugar. Thus, Roman banquets, however extravagant, did not include the kind of table decorations that concern us here. The earliest known use of sugar as an artistic medium is from medieval times in the Middle East. The eleventh-century caliph al-Zahir reportedly celebrated the Islamic holy days with "art works from the sugar bakers," including 157 figures and seven table-sized palaces. In the same century, Nasir-I-Chosrau, a Persian visitor to Egypt, reported that the sultan used 73,300 kilos of sugar in sculpting a tree and other large displays for his table at Ramadan. Several hundred years later, Al-Guzuli (d. 1412) described a dinner for which a caliph had ordered an entire mosque molded from sugar, which he then offered as sustenance to beggars after the festivities.[16]

Soon the idea spread to western Europe, probably along Venetian trade routes. Marco Polo wrote that Venice was already importing sugar in the thirteenth century, and other sources inform us that marzipan pastes adorned royal feasts in France at about the same time and somewhat later in England. The confections combined sugar with oil, crushed nuts, and vegetable gums, and the resulting claylike substance could then be sculpted or molded and baked until hard. The English called such displays "subtleties" and served them between the main courses of banquets. Initially, these pieces were merely whimsical, but as they evolved, they could also carry a political message. "Not only compliments," wrote one commentator, "but even sly rebukes to heretics and politicians were conveyed in these sugared emblems."[17] At the wedding of Henry IV and Joan of Navarre in 1403, the decorations took the shape of animals, buildings, and an assortment of common forms, but at the coronation of

his grandson Henry VI in 1429, the subtleties bore admonitory inscriptions aimed at dissenters of every kind. By the end of the sixteenth century, the taste for this sugary medium had expanded beyond the courts, with one popular English cookbook offering detailed instructions for making "conceits in sugar-works," including "Buttons, Charms, Snakes, Snailes, Frogs, Roses, Shooes, Slippers, Keyes, Knives, Gloves, Letters, Knots, or any other Iumball [sic] for a banquet quicklie."[18]

In Italy, the first discussion of sugar appears in Platina's *De honesta voluptate* in 1470:

> Sugar comes not only from Arabia and India but also from Crete and Sicily.... It is really fine when ground up, or even ground by the teeth. Surely the whiter it is, the better, which it becomes through a long purification, whence to say it needs probably three or more days uncooked. Its force is warm and damp so that it is of good nourishment, is good for the stomach, and soothes whatever discomforts there are, if any. In persons who are choleric, however, it is easily converted into the dominant humor.

Platina, to his credit, does not linger over the humoral side effects of sugar but goes on to describe its appeal to those with a sweet tooth:

> I think the ancients used sugar merely for medicinal purposes, and for that reason no mention is made of it among their foods. They were surely missing a great pleasure, for nothing given us to eat is so flavorless that sugar does not season it. Hence arose that proverb of frequent use: no kind of food is made more tasteless by adding sugar. By melting it, we make almonds, pine nuts, hazelnuts, coriander, anise, cinnamon, and many other things into sweets. The quality of sugar then almost crosses over into the qualities of those things to which it clings in the preparation.[19]

If Platina was indifferent to the artistic and decorative possibilities of melted sugar, he did in an earlier chapter recommend table settings of flowers and fruit to "arouse even sluggish appetites" and inspire overall

enjoyment of the meal.[20] Eventually the penchant for sugar and the predilection for felicitous table settings led Italian banquet planners to combine the two on especially festive occasions. The emergence of Italian *trionfi* was doubtlessly slowed, however, by the passage of sumptuary laws that banned "foolish things" from weddings and banquets that might lead to political disruption.[21] Aristocratic weddings were a special target for regulation because they brought together prominent families with all their simmering ambitions, alliances, and grievances. Thus, as late as 1472, even the libertine city of Venice enacted a law limiting the number of courses hosts could serve at banquets, as well as the size of the dessert *confetti*. Amazingly, the law also banned pheasants, partridges, peacocks, and doves, along with torches or candles weighing more than four pounds.[22]

Three years later, in 1475, the first detailed descriptions of sugar sculptures were made.[23] Not surprisingly, this occurred in the culinary capitals of Emilia-Romagna and the Marche, the occasions being weddings that joined members of the hereditary nobility, not ambitious parvenus. We have court chronicles of a feast in Rimini for the marriage of Roberto Malatesta and Isabella di Montefeltro, daughter of the duke of Urbino, and of one in Pesaro for the union of Costanzo Sforza and Camilla d'Aragona. The Malatesta nuptials cost thirty thousand ducats and required the services of thirty-three cooks. The menu consisted of four "services," each of which offered a variety of hot and cold dishes that altogether consumed 8,680 chickens, 45,000 eggs, 180 hams, 40 blocks of parmesan cheese, 578 Bolognese sausages, and 13,000 oranges.[24] At the end of the feast and just before the dancing began, the sugar sculptures were presented. These confections depicted an assortment of cupids, horses, and, naturally, the Malatesta's heraldic elephants. Even more impressive must have been the *trionfi* that reproduced the architectural masterpieces of Rimini: the ancient Arch of Augustus, the fountain in the town's main square, the Castello, and the so-called Tempio Malatestiano.

The latter two monuments had been commissioned by the groom's late father, Sigismondo Malatesta (d. 1468), one of the more notorious despots of the Renaissance. The "Tempio" was, in fact, a preexisting Gothic church

that Sigismondo began to renovate in 1450 as a monument to himself. His architect was Leon Battista Alberti, the preeminent talent of his generation. By the time of Roberto's wedding in 1475, Alberti, like Sigismondo, had died (in 1472), and the project remained incomplete. The partly remodeled church still stands, and only Matteo de' Pasti's crude foundation medal gives us an idea of its intended appearance. More revealingly, the sugar sculpture was described in the court chronicle as *"nel modo che doveva esser compita,"* or "as it should have been finished." This ephemeral table decoration therefore preserved Alberti's final thoughts on the completion of the church. As such, it would have constituted—if only briefly—an important and unique bit of visual evidence for one of the most innovative buildings of the quattrocento.[25]

The wedding the Sforzas hosted in Pesaro the same summer was just as extravagant. A codex in the Vatican Library, illustrated with thirty-two miniatures, provides both a verbal and visual account of the three-day event. The main banquet adopted a mythological theme, with Latin verses accompanying each of the twelve courses. The final course, or *vivande*, was dedicated to Bacchus and ended with confections such as "a triumphal carriage made of sugar, on which was seated the figure of Justice with a sword and scales in her hands" and "a beautiful antique vase full of carnations, all of gilded sugar."[26] Even more elaborate sugar sculptures graced the table at a "grand luncheon" the next day. There, among "a great number of castles with towers, merlons, weapons, trees, flowers, animals and other things all made of gilded and finely-colored sugar, large enough to hold a man," was the first sugar sculpture ever depicted in a work of art. According to the text and inscriptions on the miniature, it represented "Mount Helicon crowned with a castle accompanied by personifications of Grammar, Rhetoric, and Astrology, along with the nine muses dancing to the music of Apollo."[27] Even allowing for the shortcomings of the copyist, the compositional weakness of the design clearly marks the work as the handiwork of a confectioner rather than a professional artist. Eventually, the quality and sophistication of sugar sculpture would rival the fine arts of painting and sculpture, but that moment lay well in the future.

By the early sixteenth century, sugar sculptures became more common, not just at nuptial feasts but also at banquets celebrating a variety of other occasions. By their nature, these decorations were the perfect paradigm of Mannerist taste, taking special delight in the precious, the virtuosic, and unexpected inversions of form and function. The subject matter expanded to include mythological and religious narratives, portraits of notable individuals, garden ornaments, and even naval vessels at sea. Cristoforo Messisbugo, author of the widely read *Banchetti* (1549), describes a family dinner in 1529 that Alfonso I, duke of Ferrara, held in honor of his sister, Isabella d'Este, marchesa of Mantua. One hundred and four guests attended the eight-service banquet, in which a musical performance accompanied each course. The pièce de résistance was a table of desserts that included twenty-five sugar sculptures representing the labors of Hercules. Each, Messisbugo relates, was "more than two and [a] half *palmi* [about two feet] high, gilded and painted, with complexions that seemed alive, remaining on the table until the end of the meal."[28]

Two aspects of this brief description are noteworthy. The first touches on one of the true paradoxes of Renaissance art: its enthusiasm for classical forms but reluctance to adopt classical subject matter.[29] In the case of the labors of Hercules, *The Oxford Guide to Classical Mythology in the Arts* lists only six representations in painting and sculpture and one set of six engravings made prior to the duke's dinner in 1529. The creator of the sugar sculptures may have based them either on the engravings—all made in 1524 after designs by Rosso Fiorentino—or on the cycle of frescoes that Giulio Romano painted in 1527–28 in the Palazzo del Tè in Mantua, which had been commissioned by Isabella's son, Federico. Given that the marchesa was, in her own words, an "insatiable" art enthusiast, she must have been familiar with Giulio's paintings, if not the prints after Rosso. Whatever the derivation of the sculptures, she could only have taken delight in seeing the compositions translated into *trionfi da tavola*.

The Hercules sculptures were remarkable for a second reason: they were gilded and painted with lifelike colors. Conventional practice in contemporary Italian sculpture was not to polychrome marble as the ancients had done

but to preserve the whiteness of the stone for its intrinsic beauty while reminding viewers of the artfulness of even the most naturalistic effects. Sugar was not stone, however, and the intense whiteness we are accustomed to today—so like Carrara marble in color and granular structure—was all but impossible to achieve using preindustrial refining techniques.[30] Most sugars were brownish like today's unprocessed or "raw" sugars. Sculptors of sugar, like sculptors of wood, occasionally remedied the natural deficiencies of their materials by painting or gilding them. Donatello's famous statue *Mary Magdalen,* carved about seventy-five years earlier, exemplifies this style, with the gilded hair and painted flesh seeming to show the effects of the desert sun. The artisans who created the Hercules series for Isabella d'Este's table evidently shared this aesthetic for they fashioned figures with "complexions that seemed alive." Unfortunately, the gilding and coloring may have rendered the decorations inedible.

Just as maiolica painters turned to Raphael for ideas, confectioners—or their patrons—looked to the work of major sculptors for inspiration. Either directly or indirectly, the names of Jacopo Sansovino, Danese Cattaneo, Giambologna, Pietro Tacca, and eventually even members of Bernini's studio had a connection to this ephemeral medium. The earliest link to an identifiable artist was in 1574, on the occasion of the French king Henry III's weeklong visit to Venice, an extravaganza that led to the temporary suspension of the sumptuary laws. The festivities began with the king's entrance through a temporary triumphal arch designed by Palladio and culminated with a banquet in the Doges' Palace. Unfortunately, none of the visual sources that commemorate the visit depict the table decorations, but various chronicles describe them in detail.[31] At a reception at the Arsenal, the commentator was astonished to discover that "the table linens, plates, knives, forks and bread were [also made] of sugar," an "extraordinary and unique" circumstance that "deceived even his majesty and gave him a good laugh."[32] The chronicle may have exaggerated the uniqueness of the tableware, however, for years earlier, Girolamo Ruscelli had published the "secret" of making "platters, glasses, cups and such things, wherewith you may furnish a table, and when you have done, eat them up."[33]

At the main banquet for Henry in the Doges' Palace, another chronicler was amazed to see "more than 300 figures made of sugar on various tables, all made from drawings and models of the most outstanding artists, directed by the master Nicolò della Pigna."[34] The author identifies the artists as Jacopo Sansovino and Danese Cattaneo, but because these men died in 1570 and 1572, respectively, their involvement can only have been indirect. Accordingly, the "models" in the account were not true *bozzetti*, or preparatory studies, but finished sculptures—probably small bronzes— that were either copied or had molds taken from them.[35]

The first living artist to be associated with molded sugar sculpture was Italy's preeminent sculptor at the time, Giambologna (1529–1608). He created the dessert *trionfi* for two Medici weddings in Florence—that of Marie de' Medici (by proxy) and Henry IV of France in 1600, and that of her cousin Cosimo and Maria Maddalena of Austria in 1608.[36] Michelangelo Buonarotti the Younger recorded a meticulous account of Marie's banquet, noting that the principal feast and entertainment took place in the Salone del Cinquecento of Palazzo Vecchio. Along with mounting a display of gold, silver, and *pietre dure* objects on a giant credenza, attendants set out a "constantly changing" array of sugar sculptures on three banquet tables that spanned the length of the room. The sculptures depicted the labors of Hercules, several versions of the story of Nessus and Deianira, and Henry IV on horseback. Some reportedly measured two *braccia*, or more than four feet, high. At the royal table were life-size statues of the king and queen, the work of the same "sublime inventor" elsewhere identified as "il famoso Gio. Bologna."

Documents in the Medici Archives suggest that Pietro Tacca (1577–1640), Giambologna's most gifted assistant, actually carried out the commission.[37] In 1600, the master was not in good health, and Tacca gradually took over the workshop. Months before the wedding day, Giambologna had already begun reimbursing Tacca for supplies for the sugar sculptures, an indication the grand duke had indeed commissioned Giambologna to do the work. The documents further reveal that the sculptures were cast

from molds in Giambologna's studio. The sugar was probably melted to the consistency of thick paste before being poured into molds and baked. The final step in the process, as with any type of casting, was finishing or chasing the surface with chisels. One payment in the account books is for gilding and painting the *trionfi*; another is to a confectioner for supplying "white and colored sugar paste."

The most fascinating aspect of Marie's table decorations is their reliance on works by Giambologna and Tacca. Buonarotti tells us that *Nessus and Deianira* was two *braccia* high, virtually the same size as a bronze attributed to Tacca in the Louvre. Scholars have dated the bronze to around 1600, the same year as the wedding, so the two were surely related. More intriguing still is the sugar sculpture of Henry IV on horseback. In this case, the bronze, also two *braccia* high, is dated 1604, four years *after* the wedding decoration. Thus, the sugar sculpture may actually have been a *bozzetto* for the final work. More commonly, sugar sculptures were cast from the mold of a bronze, a process anticipating Tacca's posthumous casts of Giambologna's most famous works.

In 1608, the year of Giambologna's death, Tacca was asked to furnish another set of sugar sculptures, this time for the wedding of the young Cosimo and Maria Maddalena. In his reply to this request, Tacca complained that the work was time-consuming and said "it was not enough to choose men and supervise them, but to achieve clean and beautiful results it was also necessary to work with his own hands with not a little diligence." Despite his reservations, Tacca transformed into "sugar fantasies" forty of the most beautiful sculptures in Tuscany, including Giambologna's equestrian portrait of the grand duke in Piazza della Santissima Annunziata and several treatments of Hercules, the public personification of Florentine heroism. Most of the sugar sculptures named in the chronicles correspond to bronzes by Giambologna, but others seem to have drawn on Tacca's original designs. Tacca probably deployed some of the *trionfi* more than once: his earliest biographer, Filippo Baldinucci, tells us that he retained the sculptures he designed for the weddings of numerous Medici princes

and princesses.[38] Baldinucci also reports that during the plague of 1630, Tacca melted down the sugar sculptures and turned the residue into wine to mollify and nourish members of his workshop and keep them from fleeing with his professional secrets. If Baldinucci was telling the truth, his is the first account of people actually consuming the confections.

The appetite for sugar sculpture only increased as the seventeenth century went on. By 1662, Bartolomeo Stefani, author of *L'arte di ben cucinare* (*The Art of Cooking Well*) advised his readers how to prepare a "simple" banquet:

> Let the table be well set, in the richest way possible.... At one end let there be a *trionfo* representing Pluto's palace. At the other end, Proserpina's palace; she should be coming out, with the serpent at her feet; Pluto likewise, with his dog Cerberus, and a trident in his hand. In the center of the table a garden of sugar, its gates made of candied citrus, a fountain in the middle, of good design with various figures, set off by two mountains of green gelatin, with wild beasts and hunters....[39]

The first accurate visual representations of Italian dessert *trionfi* date from the seventeenth century. A handful of surviving preparatory drawings along with a number of documentary prints and drawings give an idea of what these short-lived confections looked like. However, none of the banquets they adorned were "simple" in the sense that Stefani seems to have intended. The first feast for which we have ample graphic evidence was in honor of Queen Christina of Sweden. In 1654, Christina abdicated the Swedish crown she had worn for ten years and converted to Catholicism. After spending a year in Catholic Flanders while negotiating with the papacy, she disguised herself as a man and traveled to Rome. The newly elected pope, Alexander VII, was ecstatic because her conversion signaled a propaganda victory of the greatest magnitude. It confirmed the rhetoric of *Ecclesia triumphans* while effectively ending a century of Counter-Reform militancy and pessimism. Although her disregard for social convention would later be an embarrassment for the papacy, her arrival in Rome dur-

ing Christmas week of 1655 set off unprecedented fanfare and festivity. Alexander VII considered the event the premier accomplishment of his first year in office and commemorated it on the reverse of his *medaglia annuale* (annual papal medal) of 1656.[40]

Before Christina's arrival, Bernini hurriedly designed the Porta del Popolo through which she would enter the city, and he also designed a special coach with a silver chassis and embroidered velvet upholstery adorned with sculpture and her new coat of arms. Documents show that key members of his studio helped conceive and cast the *trionfi* that graced the table at the banquet Alexander gave for her on December 26. Passing over the cooks in the pope's kitchen, the Bernini team fashioned an array of sugar sculptures that included a cornucopia-bearing Allegory of Abundance crowned with ears of corn (an obvious allusion to the sheaf of corn on the queen's heraldry) and surrounded by *putti* holding more ears of corn; a statue of Pallas Athena surrounded by personifications of the Liberal Arts; and a triumphal car of crystallized citron carrying other mythological figures. Marzipan trees and various other natural forms molded in aspic, jelly, and *blancmange* completed the ensemble.

Although no visual records of the December 26 dinner survive, we have several drawings and watercolors depicting a second banquet in Christina's honor thirteen years later. The host of this dinner was Alexander's newly elected successor, Clement IX, who held the event both to welcome the queen back to the city after a short absence and to express the pope's gratitude for her influence on the outcome of the papal election. The most informative graphic sources are a set of drawings by Pierre Paul Sevin (1650–1710), a *pensionnaire* at the French Academy from 1666 to 1671. One of these drawings (figure 71) shows the banqueting room in the Quirinal Palace—then the principal papal residence—with the feast under way. The pope and the queen sit at adjoining tables, hers somewhat lower than his; her chair is also lower and has less elaborate embellishment and upholstery. Their physical separation, along with the choral music that was performed throughout the meal, would have made conversation difficult.

In another drawing, a papal courtier stands between them to facilitate the exchange of compliments.

Gracing the two tables are a few small plates of food and nearly twenty *trionfi*. The crudeness of the drawing precludes precise analysis, but many of the sculptures appear to represent oak trees, an allusion to the family crest of the pope's predecessor, which could suggest reuse of the sculptures. Other drawings, by Sevin, show more elaborate table settings that feature Clement's coat of arms. In one (figure 72), a table set for twenty people is adorned with trumpeting Fames and other allegorical devices. Among the allegorical images is a phoenix, a favorite emblem of Christina that she interpreted as a symbol of her rebirth after converting to Catholicism. The drawing may thus have been for a piece destined for one of the papal banquets or perhaps for another affair held in her honor. Interestingly, a page of preparatory studies of *trionfi* attributed to Bernini's assistant Johann Paul Schor also depicts a phoenix about to take flight. Schor specialized in temporary decorations of all kinds, and the bravura and delicacy of his drawing suggests the ephemerality of sugar sculpture itself.[41]

In two other drawings by Sevin, we see tables laid for Maundy Thursday banquets.[42] Naturally, the theme is the Passion of Christ, with one drawing representing the narrative directly (figure 73) and the other doing so emblematically (figure 74). Although neither drawing is dated, the *trionfi* in both clearly relate to well-known works of art designed by Bernini or his chief rival, Alessandro Algardi. In the emblematic version, the resemblance between the confectionary angels who bear the instruments of the passion and the marble ones who grace Bernini's Ponte Sant'Angelo (1667–71) could hardly be more striking. At the other banquet, the table sculptures of *Christ Falling under the Cross* and the *Flagellation* are just as obviously related to small bronzes from the workshop of Algardi. Because Algardi died in 1654 and the centerpiece on this table features the coat of arms of Clement IX (reigned 1667–69), the chronological sequence is self-evident. Thus just as Pietro Tacca reused the molds of Giambologna to fashion sugar

FIGURES 71 & 72. (Opposite) Pierre Paul Sevin, drawings from *Banquet in Honor of Queen Christina.*

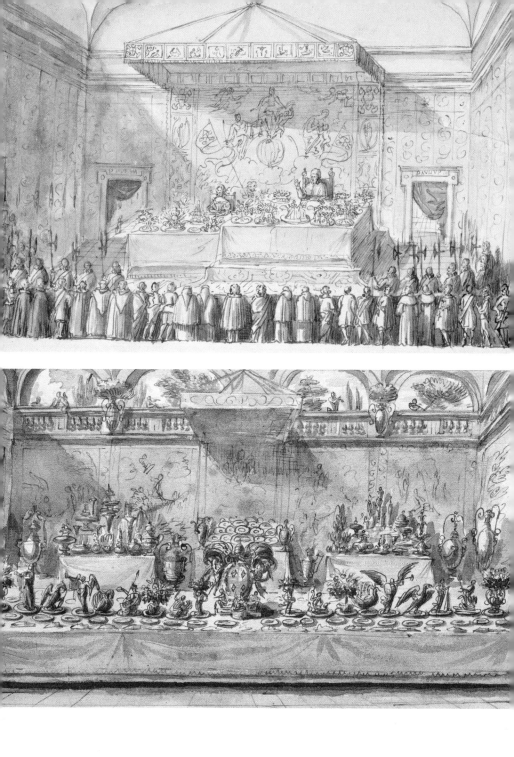

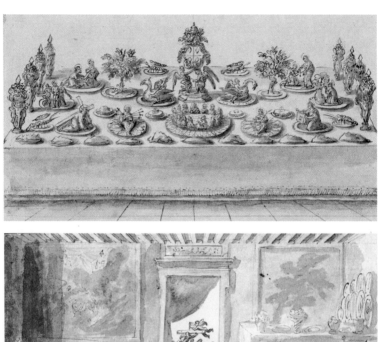

FIGURES 73 & 74. Pierre Paul Sevin, drawings from *Banquet for Maundy Thursday.*

sculptures half a century earlier, heirs to Algardi's studio presumably did the same. Indeed, as Jennifer Montagu has observed, "The arts of casting in bronze and casting in sugar were not far apart, and it could well be that the same models, or even molds, were used for both media."[43]

Montagu discusses another way in which the Baroque sugar sculptures like the ones depicted in Sevin's drawings are noteworthy.

What makes [them] so particularly interesting is how they differ from the sculptural forms traditional in bronze or marble. Looking at the little figures enacting the *Washing of Peter's Feet*, or what may be *Christ Taking Leave of His Mother*, one must remember that, apart from groups of the *Baptism* or the *Giving of the Keys*, or various closely entwined scenes of rape or attempted rape, free-standing sculptures of more than one figure are rare in Roman baroque art.[44]

Better than marble, or even bronze, in its ability to bear its own weight, sugar allowed artists to capture the demonstrative gestures and fleeting effects of which the Baroque period was so fond. Indeed, for the sculptural expression of figural movement, wind-swept drapery, and the delicacy of clouds and foliage, this perishable material was perhaps the most compliant medium of all.

The most graphic depictions of sugar sculptures displayed on a banqueting table appear in a suite of engravings that record a dinner hosted in Rome in 1687 by Lord Castlemaine, English ambassador to the Holy See.[45] The dinner, which took place in the grand *salone* of the envoy's residence in Palazzo Pamphili, followed a formal audience with Pope Innocent XI and included among the guests numerous prelates and the entire College of Cardinals. Although Castlemaine's unsuccessful efforts to reconcile England and Rome proved to be costly to him personally—he was recalled a year later for bringing unseemly pressure on the pope and subsequently imprisoned—his Roman banquet was among the grandest of its kind. Ironically, the only enduring legacy of his diplomacy is the prints, published with an accompanying text by his majordomo, John Michael Wright.[46] One sheet (figure 75), nearly four feet wide, depicts the fully laid table beneath Pietro da Cortona's grandiloquent ceiling fresco the *Apotheosis of Aeneas*. According to Wright, the table was arranged and open to visiting admirers two days before the banquet took place and "afterwards [the *trionfi*] were sent as Presents to the greatest Ladies [in Rome]."[47]

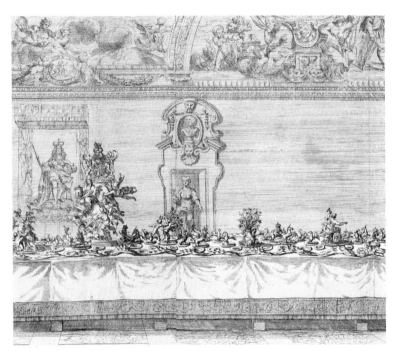

FIGURE 75. Arnold van Westerhout, detail from *Dinner Hosted in Rome by Lord Castlemaine.*

Nestled among the gilt plates and elaborately folded napkins were some eighty sugar sculptures, the largest "almost half as big as life." According to Wright, these sculptures embodied a broad range of allegorical themes in highlighting the accomplishments of King James II: Juno, Cybele, Vulcan, and Neptune stood for the Four Elements; two pairs represented the royal attributes of Justice and Peace, and Valor and Victory; and two others showed Moral Virtues seated under palm trees, evoking the witty armorial device of Lord Castlemaine, whose given name was Roger Palmer. Finally, two mythological groups, Apollo and Daphne, and Myrrha and Adonis, "intimated that His Majesty, whose Victories had planted him Laurels in

His own time, wanted not the Myrrhe of His Virtues to embalm him to posterity."[48]

In addition to the panoramic rendering of the *salone*, each of the table sculptures is illustrated and, with the possible exception of the centerpiece, all were "made of a kind of Sugar-Paste, but modelled to the utmost skill of a statuary." Each of the engraving plates is also signed by the engraver, Arnold van Westerhout, and the designer, Giovanni Battista Leinardi. The term *delin*[*eavit*], which appears after Leinardi's name, does not necessarily mean that he invented these complicated compositions himself. Yet Leinardi, like Ciro Ferri—the only other artist to whom the "erudite orna-ments" have been attributed—had been a student of Pietro da Cortona (1596–1669), and Cortona's influence on the energetic handling of the sculptures is unmistakable to anyone looking up from the table to the ceil-ing. Whoever was responsible for the designs was responsive to the work of Bernini as well, for the *Apollo and Daphne* was freely derived from one of the sculptor's most famous statues in Galleria Borghese.

By the end of the seventeenth century, the stylistic and qualitative distinctions between the permanent and the ephemeral were becoming increasingly vague. The notion that works in sugar typically imitated ones of stone or bronze—never the other way around—was also subject to reversal. When an outspoken critic of Bernini's statue of Constantine noted at its unveiling in the Vatican in 1670 that "the whole horse seems like a *trionfo* of marzipan and meringue," he was only stating the obvious.[49]

By the eighteenth century, biscuit porcelain largely replaced sugar as a more durable medium for banquet sculpture.[50] Time would pass before edible—or potentially edible—works of art came back in fashion, and only now, in the modern era, have the eye and palate embraced this form of creative expression with the enthusiasm of the past. The multitiered wedding cake remains an icon of popular culture, while numerous con-temporary artists have gone on to raise "edible art" to the highest levels of aesthetic recognition.[51] Indeed, like so many modern appetites born of the Renaissance imagination, the pairing of food and art has proved to be more than a flash in the historical pan.

Postscript

Scholars have found fertile ground in comparing different creative genres since classical times. According to Plutarch, the Greek lyric poet Simonides of Ceos (556–468 B.C.) was the first to suggest that painting was mute poetry, and poetry a speaking picture. Centuries later, Horace (65–8 B.C.) coined the phrase *ut pictura poesis* (as is painting, so is poetry), a concept Renaissance artists and patrons later found so irresistible that they made it central to the aesthetic theory of their time.

Verbal analogies between art and cuisine also carry an ancient pedigree. In Plato's *Gorgias,* when Socrates is asked "What sort of an art is cookery?" he replies that cookery is part of the same profession as rhetoric, for both are arts of deceit.[1] Elsewhere, he states, "Style is a spice for the senses," offering a metaphor that would resonate in many sixteenth- and seventeenth-century discourses. Indeed, in 1633, one of Caravaggio's many critics labeled his robust naturalism "a new food seasoned with such a rich and succulent sauce that it has made gluttons of some painters." Another critic went so far as to suggest what paintings might taste like.[2]

The most literal example of the intersection of art and cookery in antiquity is the Baker's Tomb in Rome, a curious structure from the first century B.C. that is shaped like the bread oven at which the deceased, Marcus Vergilius Eursaces, toiled during his life. To the modern eye, this enormous monument—it stands thirty-three feet high—looks more like an early icon of kitsch and popular culture than a paradigm of timeless classicism. It may have appeared equally unseemly to people in the Renaissance, but artisans of the era did not hesitate to reverse the exercise by miniaturizing real buildings as edible decorations for the banquet table.

Architecture has historically been linked with food through metaphor. In his seventh-century work *Etymologiarum sive originum*, Isidore of Seville gives the etymological origins of "architecture": "The ancients used the word *aedes* in reference to any edifice. Some think that this was derived from a form of the word for eating, *edendo*, citing by way of example a line from Plautus: 'If I had invited you home (*in aedum*) for lunch.' Hence we also have the word 'edifice' because originally a building was made for eating (*ad edendum factum*)."[3]

Isidore's logic may be a little shaky, but his association of gastronomy with architecture has since been repeated many times over. Ben Jonson, the English playwright, invoked this connection in one of his masques, ridiculing Inigo Jones, the architect and set designer, as a preposterous master cook.[4] Alternatively, not through metaphor alone is Antonin Carême (1783–1833) known as "the architect of French cuisine." Carême's architectonic table decorations were legendary, and he explained the aesthetic underlying them in his famous remark comparing the noble art of architecture to that of the pastry chef.[5] The distinctions between the culinary and fine arts have only grown blurrier in recent years, evidenced by the publication of two books—*Eating Architecture* and *Eating Culture*— devoted to the theme.

Renaissance authors of books on cookery, if not cooks themselves, clearly understood that the preparation of food was a form of artistic expression. Although the word *arte* could be defined as "an art, a trade, an occupation, a science, a craft," Maestro Martino was, nevertheless, the first to upgrade the pedestrian title *Libro di cucina*, so common in the fourteenth century, to *Libro de arte coquinaria* in his influential book of the following century.[6] Martino's subsequent renown as the "first celebrity chef" began when a contemporary disciple, Bartolomeo Sacchi, compared him with Carneades, the illustrious Greek philosopher. Similar claims were common in the visual arts, where encomiums likening painters to ancient predecessors such as Apelles or Zeuxis were standard rhetorical practice.

Fine cuisine, however, only partially fulfilled the Renaissance criteria for art. Although cookery required *invenzione* (originality) along with

well-crafted execution, it could hardly lay claim to *istoria* (Alberti's term for narration), the prerequisite for serious painting or sculpture. The same deficiency beleaguered painters of genre scenes, but the remedial overlays of allegory and symbolism they turned to were seldom available in the kitchen. The exceptions, of course, were the edible *trionfi*, which typically took inspiration from representational works of art.

Aestheticians struggle to attach the proper significance to food and drink within the realm of art. The lack of symmetry between the qualities of painting and cuisine has vexed even those who seek to raise the status of the latter. As Carolyn Korsmeyer points out in *Making Sense of Taste: Food and Philosophy*, "Either food is denied the status [of art] altogether, while being granted aesthetic value . . . or foods are recognized as permitting a certain degree of artistic achievement but are relegated to a minor art form." Conceding the ceremonial and ritual aspects of dining, Korsmeyer concludes, "Certainly food does not qualify as a fine art; it does not have the right history . . . [although] culinary art can still be considered a minor or decorative art, or perhaps a functional or applied art."[7] By this definition, Renaissance cuisine had its equal not in the pictorial arts but in more functional artistic forms like ceramics or textiles. The affinity was most pronounced in the mid-sixteenth century, when the cultural outlook was perhaps uniquely unified, thanks to the period's special convergence of historical and developmental factors. Sitting at a banqueting table, savoring the textures and flavors of one of Scappi's multicourse menus as colorful figures on the dishes slowly emerged from below one's minestrone or macaroni, would have provided a perfectly synesthetic experience.

Vocational crossovers between practitioners of the culinary and pictorial arts were relatively rare, but we know of a few "Renaissance men" who practiced both professions. Andrea del Sarto, as we have seen, moved from his studio to the kitchen to fabricate an edible replica of the Florentine Baptistery. More intriguing, perhaps, is the example of Cesare Ripa (1555–1622). Although not himself a painter, Ripa was the author of *Iconologia*, the "painter's bible" and the most influential iconographical index of all time.[8] When it was first published in Rome in 1593, the *Iconologia* relied on

text alone to catalogue an array of allegories and personifications, but the book only achieved its full impact ten years later when an expanded edition was printed with woodcut illustrations. Proceeding systematically through more than one thousand images and nearly seven hundred abstract concepts, it prescribed ways to represent everything from "Abundance" to "Zeal." More than two dozen illustrated reprintings—and translations into every European language—appeared in the following centuries, pointing to Ripa's success in linking images with abstract ideas.

Ripa, one may be surprised to learn, was not a professional scholar but a man of the kitchen and pantry. In 1602, nine years after the publication of the *Iconologia*—the only book he wrote—one of his patrons, a Roman cardinal, named him in his testamentary "Lista della Famiglia" as his *trinciante*, or carver.[9] Elsewhere described as a majordomo or chief butler, Ripa remained devoted to domestic life even after his book of emblems had won wide acclaim.

Ripa and del Sarto were not alone in combining an interest in gastronomy with an interest in images. The Frenchman Claude Lorrain is even better known for abandoning his training as a pastry chef to become one of the premier painters of seventeenth-century Rome. Interestingly, he specialized not in kitchen or tavern scenes but in Arcadian landscapes of breathtaking beauty and refinement.

The wavering career choices of these men may not have been common in their day, yet they affirm the conceptual bonds between making and appreciating both food and art in early modern Europe. The dynamic field of exchanges and displacements that occurred between the two vocations—technical, stylistic, and thematic—links them in ways that suggest a shared sense of purpose, if not quite a true relationship of equals. To rephrase Horace's pronouncement on the interplay between art and literature, we might say *ut pictura coquina,* "as is painting, so is cooking."

NOTES

INTRODUCTION

1. See Paul Oskar Kristeller, *Renaissance Thought and the Arts*, for a basic introduction to the ideals of Renaissance humanism.

2. Phyllis Bober, *Art, Culture, and Cuisine: Ancient and Medieval Gastronomy*, is the landmark study of ancient and medieval gastronomy, and Ken Albala makes a number of thoughtful observations comparing Renaissance art and cuisine in the first chapter of *The Banquet: Dining in the Great Courts of Late Renaissance Europe*.

3. Paul Frankl discusses the practical application of this theory in late medieval architecture in *Gothic Architecture*, 220–25.

4. Peter Burke, *The Italian Renaissance: Culture and Society in Italy*, 162.

5. Allen G. Debus, *Man and Nature in the Renaissance*, provides a useful introduction to the new epistemology.

6. For the history of a sensory hierarchy, see ch. 1 of Carolyn Korsmeyer, *Making Sense of Taste: Food and Philosophy*.

7. See Elizabeth Eisenstein, *The Printing Press as an Agent of Change: Communications and Social Transformation in Early Modern Europe*, on the dissemination of antiquarian, scientific, and religious ideals at the time.

8. C. Lévi-Strauss, *The Raw and the Cooked, Introduction to the Science of Mythology*. See also Robert Deliège, *Lévi-Strauss Today: An Introduction to Structural Anthropology*.

9. I discuss Andrea del Sarto's creation in chapter 8. Elizabeth David, *Harvest of the Cold Months: The Social History of Ice and Ices*, 3–40, convincingly dismisses the legend of Buontalenti's invention of *gelato*.

10. Alfred North Whitehead, *Adventures of Ideas*, 13–14. I discovered this passage (originally published in 1933) in Bober, *Art, Culture, and Cuisine*, 4. Michel Foucault extends the enquiry into synchronic but seemingly unrelated streams of thought (what he calls *discursive formations*) in both *The Order of Things* (1966) and *The Archaeology of Knowledge* (1971).

ONE. ARTISTS AND COOKS

1. Michael Baxandall, *Painting and Experience in Fifteenth Century Italy*, 15–16, was th e first to emphasize this point.

2. The following discussion refers to the edition published by Ludovico Frati as *Libro di cucina del secolo XIV a cura di Ludovico Frati*.

3. Alberto Capatti and Massimo Montanari, *Italian Cuisine: A Cultural History*, 8.

4. Cennino d'Andrea Cennini, *The Craftsman's Handbook: "Il Libro dell'Arte,"* 3.

5. For an exhaustive monographic study of Platina, see Bruno Laurioux, *Gastronomie, humanisme et société à Rome au milieu du XVe siècle: Autour du* De honesta voluptate *de Platina*. Mary Ella Milham's introduction to Platina, *On Right Pleasure and Good Health*, her critical edition and translation of *De honesta voluptate et valetudine*, is the most informative source available in English.

6. Apicius lived in the first century A.D., but apparently his recipe collection was not compiled until the fourth century (see *Apicius: A Critical Edition* and *Apicius, The Roman Cookery Book: A Critical Translation of* The Art of Cooking for Use in the Study and the Kitchen, esp. 12–13).

7. Laurioux, *Gastronomie*, esp. 33–102, discusses Platina's reliance on earlier texts.

8. See Maestro Martino, *The Art of Cooking: The First Modern Cookery Book*. 10. In *On Right Pleasure*, 51, Milham estimates that "his [Platina's] borrowing from Martino is about forty percent of his own work … [and] at least ninety-five percent of Martino's work." For a comparison of the several modern translations of Maestro Martino, see Nancy Jenkins's review, "Two Ways of Looking at Maestro Martino."

9. For a useful introduction to humoral theory in antiquity, see Mark Grant, *Galen on Food and Diet*, esp. chs. 2–5. Ken Albala, *Eating Right in the Renaissance*, esp. ch. 2, provides a fascinating account of the many later modifications to the theory.

10. Platina, *On Right Pleasure*, book 1, ch. 10, 117.

11. Ibid., book 7, ch. 25, 321.

12. Leon Battista Alberti, *On Painting*, 67.

13. Ibid., 72.

14. Platina, *On Right Pleasure*, book 10, ch. 70, 467–69.

15. Alberti, *On Painting*, 98.

16. For recent biographical information about Scappi, see Terence Scully's introduction to his 2008 translation, *The Opera of Bartolomeo Scappi (1570): L'arte et prudenza d'un maestro cuoco/ The Art and Craft of a Master Cook*.

17. Simon Ditchfield, *Liturgy, Sanctity and History in Tridentine Italy*, esp. ch. 11; Paula Findlen, *Possessing Nature: Museums, Collecting, and Scientific Culture in Early Modern Italy*, esp. part 1, ch. 3.

18. Bartolomeo Scappi, *Opera dell'arte del cucinare*, book 4, 192r–194r; Scully edition, 397–400.

19. Ibid., 192v–193r; Scully edition, 397–99.

20. Platina, *On Right Pleasure*, book 5, ch. 1, 243.

21. Scappi, *Opera*, book 2, 60r–61r; Scully edition, 207. Although the practice of serving a bird "redressed" in its own feathers seems so typical of the sixteenth-century love of virtuosity, it actually originated a century or two earlier (Terence Scully, *The Art of Cookery in the Middle Ages*, 106).

22. Giorgio Vasari, *The Lives of the Painters, Sculptors, and Architects*, vol. 2, 158–59.

23. Anthony Blunt offers a classic analysis of Vasari's use of the term in ch. 7 of his *Artistic Theory in Italy, 1450–1600*. Philip Sohm, *Style in the Art Theory of Early Modern Italy*, esp. 109–11, discusses the meaning of *grazia* in the writing of Vasari and others.

24. Scappi, *Opera*, book 1, 1v–2r; Scully edition, 99.

25. See Sohm, *Style*, 194–200, for an extended discussion of the term *vaghezza*.

26. Scappi, *Opera*, book 4, 320r–325r; Scully edition, 412–20. Disguising one food to look like another already had a long history, as Jeremy Parzen recounts in "Please Play with Your Food: An Incomplete Survey of Culinary Wonders in Italian Renaissance Cookery." Phyllis Bober comments on the popularity of culinary disguise in the ancient world in *Art, Culture, and Cuisine: Ancient and Medieval Gastronomy*, esp. 149.

27. Vasari, *Lives*, vol. 1, 336; vol. 2, 11.

28. Baldassari Castiglione, *The Book of the Courtier*, 43.

29. Vasari's stemma belongs to the Medici, while Scappi's is one he seems to have made up for himself. Beneath his portrait Vasari includes a topographical view of his native Arezzo arranged like the predella of a Renaissance altarpiece. Just as aptly, the composition of Scappi's frontispiece has his name inscribed in a scroll beneath the portrait and his stemma to the left, a configuration that suggests a table set with a central platter, a saucer to the side, and a folded napkin below.

30. For an illuminating essay on Vasari's theory of physiognomy, see Sharon Gregory, "The Outer Man Tends to Be a Guide to the Inner: The Woodcut Portraits in Vasari's *Lives* as Parallel Texts."

31. I discuss the circumstances surrounding this work in *Caravaggio: The Art of Realism*, esp. 97–98.

32. From the dust jacket of Martino, *The Art of Cooking*.

33. Annibale Carracci's drawings of eighty tradesmen were posthumously engraved and printed in the seventeenth century in *Le arti di Bologna*. See also Cesare Vecellio's *Renaissance Costume Book*, esp. fig. 189.

34. These characterizations appear in "The Cook's Tale" and "Manciple's Prologue" (see Geoffrey Chaucer, *The Complete Canterbury Tales*, 81–82, 335–37). Cooks, as Phyllis Bober points out in *Art, Culture, and Cuisine*, 79, had already appeared as comic characters on the Greek stage.

35. Mikhail Bakhtin covers this topic rather exhaustively in *Rabelais and His World*, especially ch. 4.

36. Thus, food imagery plays almost no role in Paul Barolsky, *Infinite Jest: Wit and Humor in Italian Renaissance Art*.

37. George W. McClure, *The Culture of Profession in Late Renaissance Italy*, xiii.

38. Ibid., 128.

39. Tomaso Garzoni, *La piazza universale di tutte le professioni del mondo*, discourse 90, 813–21. The account begins with a rehearsal of the history of painting in the ancient world based on Pliny, and ends with a lengthy list of modern artists mainly active in the author's native Venice (not surprisingly, given his origins, Garzoni praises color above all other pictorial elements).

40. See David Chambers and F. Quiviger, eds., *Italian Academies of the Sixteenth Century*, especially the essays by the editors.

41. For a brief survey of the history of artists' societies, see Robert Chirico, "From Cave to Café: Artists' Gatherings."

42. See J. Lynch, "Giovanni Paolo Lomazzo's Self-portrait in the Brera," and M.V. Cardi's "Intorno all'autoritratto in veste di Bacco di Giovan Paolo Lomazzo" for detailed investigations of the picture's iconography.

43. The basic study of this fascinating group of artists is G. J. Hoogewerff, *De Bentvueghels* (with an English summary). See also Peter Schatborn and Judith Verbene, *Drawn to Warmth: 17th-Century Dutch Artists in Italy*.

44. For this subset of northern artists, the principal source is David Levine and Ekkehard Mai, *I Bamboccianti: Niederländische Malerrebellen im Rom des Barock*. Also by these authors, see "The Bentvueghels: 'Bande Academique.'"

TWO. REGIONAL TASTES

1. Teofilo Folengo, *Baldo*, book 2, lines 96–130.

2. Don Mitchell, *Cultural Geography: A Critical Introduction*, illuminates the subcategories of "cultural studies."

3. Thomas DaCosta Kaufmann, *Toward a Geography of Art*, 22.

4. See Clarence Glacken, *Traces on the Rhodian Shore: Nature and Culture in Western Thought from Ancient Times to the End of the Nineteenth Century*, esp. 82–88.

5. *Ancient Medicine*, ch. 3. On humoral theory in ancient and early modern times, see Ken Albala, *Eating Right in the Renaissance*, esp. ch. 2.

6. Hippocrates, *Airs, Waters, Places*, ch. 24.

7. Pliny the Elder, *Natural History*, vol. 9, book 35, 283–99, 383.

8. Ibid., 75.

9. Pollio Vitruvius, *Ten Books on Architecture*, book 4, ch. 1, 102–6.

10. Pliny, *Natural History*, book 11, 42, 97.

11. Apicius, *Apicius: A Critical Edition*. See also the discussion of Apicius in Phyllis Bober, *Art, Culture, and Cuisine: Ancient and Medieval Gastronomy*, 149–59.

12. Cipriano Piccolpasso, *The Three Books of the Potter's Art*, facsimile.

13. Vitruvius, *Ten Books*, book 2, ch. 7, 49–50.

14. Ibid., book 8, ch. 3, 236.

15. Leon Battista Alberti, *On the Art of Building in Ten Books*, book 2, 49–50. In the following century, Vasari further elaborated on the qualities of local stone in Giorgio Vasari, *Vasari on Technique*, part 1, ch. 1.

16. Ibid., book 5, 150.

17. See John Varriano, *Italian Baroque and Rococo Architecture*, 278–94, for a discussion of the architecture of southern Italy.

18. Giovanni Rebora, *Culture of the Fork: A Brief History of Food in Europe*, 40–41.

19. The document is in the Florentine State Archives but may be accessed online at The Medici Archive Project: http://documents.medici.org/document__ details.cfm?entryid=9447. Interestingly, the only fish mentioned among the more than 1,100 items in the "Food and Wine" section are gifts sent to the Medici from outside Tuscany. See also Giuliano Pinto, "Il consumo della carne nella Firenze del Quattrocento," for additional information on the consumption of meat in Renaissance Florence.

20. Gregory Hanlon, *Early Modern Italy, 1550–1800: Three Seasons in European History*, 84. At the time, the workforce was some 60,000 people.

21. See, for example, the standard text for the period, Frederick Hartt and David Wilkins's *Italian Renaissance Art*. For a thoughtful study on the classification of artistic centers in Italian art, see the classic essay by Enrico Castelnuovo and Carlo Ginzburg, "Centro e perferia."

22. Platina, *On Right Pleasure and Good Health*, book 10, ch. 20, 439.

23. I compiled these figures from Scappi's own recipe indexes in the original 1570 edition of the *Opera*. Unfortunately, Terence Scully's new edition of Scappi does not index recipes with regional distinctions in mind (for Scully's 2008

edition, see Scappi, *The Opera of Bartolomeo Scappi* [*1570*]: *L'arte et prudenza d'un maestro cuoco/The Art and Craft of a Master Cook*). See also Ken Albala, *The Banquet: Dining in the Great Courts of Late Renaissance Europe*, especially 123–26, for a discussion of the role of foreign imports in Italian cuisine at the time.

24. Bartolomeo Scappi, *Opera dell'arte del cucinare*, 168v: "Vengo a fare le liste delle cose che si possino servire di mese in mese, lequali generalmente s'usano in Italia, e massime nella Città di Rome." The Scully edition, 381, translates the last phrase as "normally eaten in Italy and particularly in the city of Rome."

25. Giovanni Battista Rossetti, *Dello scalco*, 527–30.

26. Ortensio Lando, *Commentario delle più notabili & monstruose cose d'Italia*, 11, 66–67.

27. Modern editions of del Turco and Stefani were published by Arnoldo Forni Editore in 1992 and 2000.

28. Giovanni Battista Crisci, *Lucerna de Corteggiani;* Antonio Latini, *Lo scalco alla moderna*, 2 vols.

29. See Rudolf Wittkower, *Art and Architecture in Italy, 1600–1750*, 582.

30. Fynes Moryson, *An Itinerary Containing His Ten Yeeres Travell* [1605–17], book 4, 93.

31. Anna Evangelista's introduction to the modern edition of del Turco, *Epulario e segreti vari*, especially xxx–xlviii, provides an informative overview of his range of ingredients and methods of preparation.

32. Bill Buford, *Heat: An Amateur's Adventures as Kitchen Slave, Line Cook, Pasta-Maker, and Apprentice to a Dante-Quoting Butcher in Tuscany*, 243–44.

33. Andrew Dalby, *Dangerous Tastes: The Story of Spices*, 125.

34. The traditional view that spices were mainly used to conceal the poor quality or spoilage of meat and fish has finally been put to rest; on the contrary, because spices were so expensive, they became status symbols in the gastronomy of the rich. Thus, Cristoforo Messisbugo, in *Libro novo*, 39r–v, advises tightfisted hosts to cut back on "sugars and spices" by two-thirds or a half if they wish to save money.

35. The full text of the so-called *Anonimo veneziano* is available online at www.geocities.com/helewyse/libro.html.

36. Cennino d'Andrea Cennini, *The Craftsman's Handbook: "Il Libro dell'Arte,"* 29–30.

37. For humoral theory in the Renaissance, see Albala, *Eating Right*, esp. ch. 2. Massimo Luigi Bianchi, *Signatura Rerum: Segni, magia e consocenza da Parecelsus a Leibniz*, provides an excellent introduction to the "doctrine of the signatures."

38. Marsilio Ficino, *The Book of Life*, 124.

39. Ibid., 33, 26.

40. Baldassare Pisanelli, *Trattato della natura de'cibi et del bere*, 144–45.

41. In modern times, this material has been collected from Giorgio Vasari's *The Lives of the Painters, Sculptors, and Architects* and published in the volume *Vasari on Technique*. The discussion on painting begins on 205.

42. Ibid., 205, 207.

43. Vasari, *The Lives*, vol. 2, 170.

44. The classic cultural interpretation of the period is Jacob Burckhardt's *The Civilization of the Renaissance in Italy*.

45. John Onians, *Neuroarthistory, from Aristotle and Plato to Baxandall and Zeki*.

46. Johann Wolfgang von Goethe, *Italian Journey (1786–88)*, 79.

47. See, for example, Semir Zeki, *Inner Vision: An Exploration of Art and the Brain*.

48. John Onians, "The Biological Basis of Renaissance Aesthetics."

49. Elisabeth de Bièvre, "The Urban Subconscious: The Art of Delft and Leiden."

50. Onians, "The Biological Basis," 15.

51. Michael Baxandall, *Painting and Experience in Fifteenth Century Italy*, 94.

52. Raymond de Roover, *The Rise and Decline of the Medici Bank, 1397–1494*, 96–100.

53. Baxandall, *Painting and Experience*, 101–2.

54. I am most grateful to Dott. Vasco Tacconi for furnishing me with information on the modern Accademia della Fiorentina, founded in 1991 by members of the Association of Florentine Butchers, and for forwarding the organization's impressive set of publications. The name *bistecca*, of course, is not Italian but a corruption of the English word "beefsteak" occasioned by the nostalgia of eighteenth-century Grand Tourists for their beefsteak clubs at home.

55. John Florio's 1598 Italian-English dictionary, *A Worlde of Wordes, or Most Copious and Exact Dictionarie in Italian and English*, defines *carbonata* as "meates broiled upon the coles," whereas del Turco, *Epulario e segreti vari*, 72–73, describes it only as a method of toasting bread in the manner one still does with bruschetta.

56. Pellegrino Artusi, *Science in the Kitchen and the Art of Eating Well*, 386. The author offers the following explanation for beef's lack of popularity: "In many Italian provinces they almost exclusively butcher old work animals rather than the requisite yearlings." Yet even in Florence, he confesses, "butchers call both yearlings and any bovine animal about two years old a 'calf.' But if these animals

could speak, they would tell you not only are they no longer calves, but that they have already had a mate and a few offspring as well."

57. Thomas Coryate, *Coryate's Crudities*, 395.

58. Ibid., 415.

59. M. Margaret Newett, *Canon Pietro Casola's Pilgrimage to Jerusalem in the Year 1494*, esp. chs. 1 and 18.

60. Elizabeth David, *Italian Food*, 169.

61. Ibid., 281.

62. Pliny, *Natural History*, book 20. The individual responsible for cultivating modern radicchio was Francesco van den Borre, a Belgian agronomist who moved to Treviso in 1859 and spent the rest of his life (d. 1910) cultivating new varieties of plants (www.vandenborre.it/azienda.htm).

63. Waverly Root, *The Food of Italy*, 84.

64. Ibid., 146, quoting from an unidentified source.

65. Ibid., 187, quoting the *Chronache* of one Giovanni Schedel.

66. Ibid., 197 and 195, where the writer cites an unnamed seventeenth-century source for the *tortellini* legend.

67. Ludovico Frati, *Libro di cucina del secolo XIV*, 50; Maestro Martino, *The Art of Cooking: The First Modern Cookery Book*, 80; Platina, *On Right Pleasure*, book 8, ch. 27, 365.

68. Platina, *On Right Pleasure*, book 8, ch. 26, 363.

THREE. SIGNIFICANT STILL LIFES

1. My translation is freely based on Vitruvius, *Ten Books on Architecture*, 82–83. The passage is from ch. 7: "Greek Houses."

2. Martial, *Martial: The Twelve Books of Epigrams*, book 13, "The Xenia."

3. Ibid., verse 3, lines 4–6.

4. Pliny the Elder, *Natural History*, book 35, 65.

5. Ibid., 65–66.

6. The theme seems to have been especially common in Roman North Africa, to judge from the number of mosaics depicting *xenia* in the Bardo Museum in Tunis and the Archeological Museum of El Djem. Some of these works appear on the Art Resource website, www.artres.com.

7. Lodovico Dolce, *Dialogue on Painting* (1557), 151.

8. Philostratus the Younger, *Imagines*. On the veracity of the legend about this work, see Karl Lehmann-Hartleben, "The *Imagines* of the Elder Philostratus."

9. Philostratus, *Imagines*, book 1, no. 31.

10. According to the OCLC Online Computer Library Center (WorldCat), the first edition was printed in Venice in 1503, and other Italian editions followed in 1517, 1521, 1522, 1532, 1535, and 1550.

11. Frederick Hartt and David Wilkins, *Italian Renaissance Art*, 589–91. The paintings were based on Philostratus, *Imagines*, book 1, nos. 6 and 25.

12. Leonardo da Vinci, *Leonardo on Painting: An Anthology of Writings*, 202.

13. Ibid., 34.

14. See Martin Kemp, "Leonardo and the Idea of Naturalism: Leonardo's Hypernaturalism," 65–73.

15. Andrea Bayer, *Painters of Reality: The Legacy of Leonardo and Caravaggio in Lombardy*, cat. no. 73, 180.

16. See Giacomo Berra, "Contributo per la datazione della 'natura morta di pesche' di Ambrogio Figino."

17. Pamela Jones, *Federico Borromeo and the Ambrosiana: Art Patronage and Reform in Sixteenth-Century Milan*, gives an exhaustive treatment of the cardinal's interest and collecting habits.

18. Ibid., 82. The following discussion largely draws from ch. 2 of my book *Caravaggio: The Art of Realism*.

19. Ibid., fig. 24, for an illustration of a *Ficus carica* painted by Ligozzi that bears a remarkable resemblance to Caravaggio's *Basket of Fruit*.

20. Charles Sterling, *Still Life Painting from Antiquity to the Present Time*, 59.

21. Hetty Joyce, "Grasping at Shadows: Ancient Paintings in Renaissance and Baroque Rome," gives some idea of what paintings may have been known in this period.

22. Howard Hibbard, *Caravaggio*, 346.

23. Varriano, *Caravaggio*, 64–65.

24. Zygmunt Wázbínski, *Il Cardinale Francesco Maria del Monte, 1549–1626*, vol. 2, 409–32.

25. Helen Langdon has devoted an entire chapter of her book *Caravaggio: A Life* to the poetical context of his art.

26. Howard Hibbard transcribes and translates the verse in his *Caravaggio*, 371.

27. Ibid., appendix 2, 343–87, still remains the most useful source for tracking the early critical fortunes of the artist.

28. See Luigi Salerno, *La natura morta italiana, 1560–1805/Still Life Painting in Italy, 1560–1805*.

29. Although not excavated until much later, a *Still Life with Fruit* from the

House of Julia Felix in Pompeii (see the image at www.artres.com AR146421) is remarkably close in composition.

30. Giovanni Baglione gives the biography of this peripatetic and intellectually curious painter in *Le vite de'pittori, scultori, et architetti,* 335–36.

31. Ann Sutherland Harris, "Giovanna Garzoni."

32. Norman Bryson devotes a rambling chapter to "Still Life and 'Feminine' Space" in *Looking at the Overlooked: Four Essays on Still Life Painting,* 136–78.

33. Peter Cherry "Bodegon."

34. William Jordan and Peter Cherry, *Spanish Still Life: From Velázquez to Goya,* 33, 38–39 n. 22.

35. Ibid., 189 n. 8.

36. James Casey, "Spain: A Failed Transition"; Andrew Cunningham and Ole Grell, *The Four Horsemen of the Apocalypse: Religion, War, Famine and Death in Reformation Europe,* 234–37.

37. Peter N. Dunn, *Spanish Picaresque Fiction: A New Literary History,* 5.

38. The translation from *Guzmán,* I:iii, 108–10, is from Barry Wind, *Velázquez's Bodegónes,* 94–95.

39. Jordan and Cherry, *Spanish Still Life,* 43.

40. Ibid., 29 and 188 n. 18, explains the difference between the two, a *cantarero* being a cooling space in a Spanish house "located in a corridor connecting the front and back doors through which air passes and keeps foodstuffs fresh" and a *despensa* being a "niche in a cellar used for the same purpose."

41. Norman Bryson, *Looking at the Overlooked,* 66.

42. Ibid., 69 and 183 nn. 5–6, where Bryson cites Martin Soria, "Sánchez Cotán's *Quince, Cabbage, Melon, and Cucumber,*" 311–18, as the source for this information.

43. Joan Alcock, "Velázquez' Cooks and Portrayal of Food in Spanish Still Life Art of the Seventeenth Century," 19–20.

44. Pieter Aertsen, Beuckelaer, and Jacob Matham were particularly renowned for inserting such commentary into the background, and their favorite themes were the Supper at Emmaus and Christ in the House of Mary and Martha. I discuss Aertsen's moralizing treatment of such themes in chapter 5.

45. At the time (1701), the work hung in the Buen Retiro palace in Madrid (José López-Rey, *Velázquez: A Catalogue Raisonné of His Oeuvre,* 163–64, cat. no. 124).

46. Alcock, "Velázquez' Cooks," 21.

47. The years 1603 to 1614 experienced especially severe droughts in Spain (Casey, "Spain: A Failed Transition," 214).

48. Wind, *Velázquez's* Bodegónes, 103.

49. Cited by Jordan and Cherry in *Spanish Still Life*, 36.

50. Chapter 5 discusses still lifes that carry social commentary and erotic promise. *Vanitas* still lifes that emphasized the impermanence of earthly things also achieved a certain popularity (Jordan and Cherry, *Spanish Still Life*, 21–24).

51. *Catholic Encyclopedia* at www.newadvent.org/cathen/12608c.htm.

52. Miguel de Molinos, *Guía espiritual*, 9.

53. Peter Cherry, "Alejandro de Loarte"; Jordan and Cherry, *Spanish Still Life*, 56–61.

FOUR. SACRED SUPPERS

1. Gillian Feeley-Harnik, *The Lord's Table: The Meaning of Food in Early Judaism and Christianity*, 126–27.

2. However, according to William Kaufman, in *The Catholic Cook Book: Traditional Feast and Fast Day Recipes*, pork (as well as goose) could also be served during the Holy Days of Advent and Christmas.

3. Simone Prudenzani, "Il Saporetto," cited by Odile Redon, Françoise Sabban, and Silvano Serventi, *The Medieval Kitchen: Recipes from France and Italy*, 6.

4. Maestro Martino, *The Art of Cooking: The First Modern Cookery Book*, 55.

5. Although he does not discuss paintings of the Last Supper, the engagement of the viewer in Renaissance art is the theme of John Shearman's book *Only Connect . . . Art and the Spectator in the Italian Renaissance*.

6. Johann Wolfgang von Goethe, *Goethe on Art*, 170–71. His account of the fresco dates from 1788.

7. Burton Anderson, *The Wine Atlas of Italy and Traveller's Guide to the Vineyards*, 133.

8. The discussion that follows first appeared in my article "At Supper with Leonardo" in *Gastronomica*.

9. Giorgio Vasari, *The Lives of the Painters, Sculptors, and Architects*, vol. 1, 262.

10. Luigi Ballerini, introduction to Martino, *The Art of Cooking*, 14. Vasari corroborates this statement, adding, "When passing places where birds were sold, Leonardo would pay the vendor only to release them from their cages" (*Lives*, vol. 2, 157).

11. Leonardo da Vinci, *The Notebooks of Leonardo da Vinci*, edited by Edward MacCurdy, 89–90.

12. Leonardo da Vinci, *The Notebooks of Leonardo da Vinci*, edited by Jean Paul Richter, no. 1534. The other notations are in nos. 1519, 1520, 1521, 1535, 1544, 1545, 1548, and 1549.

13. Carlo Pedretti, *"Eccetera: perche la minestra si fredda": codice Arundel, fol. 245 recto.*

14. Massimo Montanari, *La fama e l'abbondanza, storia dell'alimentazione in Europa*, 101 (cited by Alberto Capatti and M. Montanari, *Italian Cuisine: A Cultural History*, 71).

15. G. B. Rossetti, *Dello scalco* (1584), 199–204 (cited by Capatti and Montanari, *Italian Cuisine*, 136).

16. Platina, *On Right Pleasure and Good Health*, book 10, ch. 4, 425.

17. Leonardo, *The Notebooks of Leonardo da Vinci*, edited by Jean Paul Richter, no. 1469.

18. From Arnaldo della Torre, *Paolo Marsi da Pescina*, 124 (cited in Martino, *Art of Cooking*, 39).

19. Interestingly, the fad seems to have died out in the second half of the century, for none of the eel recipes given by Scappi (1570) or Rossetti (1584) call for orange slices on the side.

20. Cristoforo di Messisbugo, *Libro novo, nel qual s'insegna a' far d'ogni sorte di vivanda*, 9r–14v. Elsewhere in the book, the author gives simpler fish recipes that also call for orange slices. John McPhee, *Oranges*, chs. 3 and 4, and Pierre Laszlo, *Citrus: A History*, chs. 9–12, cite other examples of the Renaissance fascination with this fruit.

21. Vasari, *Lives*, vol. 3, 246.

22. Jacopo Carucci Pontormo, *Pontormo's Diary*, 97.

23. Kenneth Bendiner, *Food in Painting: From the Renaissance to the Present*, 146–47. The concept of "public privacy" originated with Rebecca L. Spang, in *The Invention of the Restaurant: Paris and Modern Gastronomic Culture*, 34.

24. I have discussed the tableware at greater length in "Caravaggio and the Decorative Arts in the Two *Suppers at Emmaus*," 222–24.

25. Bartolomeo Scappi, *Opera dell'arte del cucinare*, book 2, chs. 117ff; see 194–213 in the translation by Terence Scully: *The Opera of Bartolomeo Scappi (1570): L'arte et prudenza d'un maestro cuoco/The Art and Craft of a Master Cook*.

26. Gillian Riley, *A Feast for the Eyes: The National Gallery Cookbook*, 56.

27. Howard Hibbard, *Caravaggio*, 367.

28. Comune di Roma, *La natura morta al tempo di Caravaggio*, cat. no. 52.

29. Platina, *On Right Pleasure*, book 7, ch. 69, 343.

30. Ibid., ch. 25, 321, discusses cabbage more generally. As one can see in chapter 2, Platina's understanding of nutrition was heavily dependent on his belief in humoral theory.

31. The transcript of the trial is available in David Chambers and Brian Pullan, *Venice: A Documentary History, 1450–1630*, 232–36. For a discussion of the

painting's iconography, see Philipp Fehl, "Veronese and the Inquisition: A Study of the Subject Matter of the So-Called Feast in the House of Levi," 325–54.

32. Although she focuses solely on the paintings of Caravaggio, Pamela Askew explores the role of secondary figures in paintings of conversion in "Caravaggio: Outward Action, Inward Vision."

FIVE. EROTIC APPETITES

1. David O. Frantz discusses the difference between learned and popular erotica during the Renaissance in *Festum Voluptatis: A Study of Renaissance Erotica,* especially chapter 1. Barbara C. Bowen, *One Hundred Renaissance Jokes: An Anthology,* translates witticisms from twenty-seven authors, the majority of whom were Italian.

2. Bette Talvacchia, *Taking Positions: On the Erotic in Renaissance Culture,* especially 88, and Paul Barolsky, *Infinite Jest: Wit and Humor in Italian Renaissance Art.*

3. Massimo Luigi Bianchi, *Signatura Rerum: Segni, magia e consoscenza da Parecelsus a Leibniz,* provides an excellent introduction to the doctrine of signatures, which was definitively set forth in the seventeenth century by Jakob Boehme in *Signatura Rerum* [1621].

4. Giambattista della Porta, *Phytognomonica,* book 3. Several plates from this treatise are illustrated in Giulia Caneva, *Il mondo di Cerere nella Loggia di Psiche: Villa la Farnesina, sede dell'Accademia Nazionale dei Lincei,* figs. 2.4–2.11. Among the "signature" relationships were plants with flowers shaped like butterflies as a cure for insect bites, maidenhair ferns as a remedy for baldness, and pomegranate seeds as an aid to dental health.

5. Barolsky, *Infinite Jest,* 84, credits Ulrich Middeldorf and Konrad Oberhuber for suggesting that "in the sumptuously painted festoons the figs and cucumbers, traditional sexual symbols, may have been intended as playful sexual illusions, appropriate to the iconography [of the Loggia]." Nora Galli de' Paratesi, *Le brutte parole, semantica dell'eufemismo,* esp. part 2, ch. 1, provides a glossary of sexual euphemisms. For a detailed study of Giovanni da Udine's conceits, see Philippe Morel, "Priape à la Renaissance: Les ghirlandes de Giovanni da Udine a la Farnesine," 13–28.

6. Giorgio Vasari, *Le vite de' più eccellenti pittori scultori e architetti nelle redazioni del 1550 e 1568,* vol. 5, 452–53. The translation is more or less my own.

7. Perino del Vaga, another student of Raphael, trimmed an allegory of *Theology* in the Sala Paolina of the Castel Sant'Angelo in this fashion (illustrated by Morel, "Priape à la Renaissance," fig. 19). Giovanni Paolo Lomazzo, author

of the Counter-Reform *Trattato dell'arte della pittura* (1584), 402, laments the presence of such imagery in sacred settings.

8. For the career of Frangipane, see Bert Meijer, "Niccolo Frangipane."

9. Adrienne von Lates, "Caravaggio's Peaches and Academic Puns," discusses the cultural context in which much of the bawdy verse was written.

10. John Florio, *A Worlde of Wordes, or Most Copious and Exact Dictionarie in Italian and English,* 96, 271.

11. Von Lates, "Caravaggio's Peaches," 57. The poem about peaches was written before 1522 (Francesco Berni, *Poesie e prose,* 53–56), although it was not published until early in the seventeenth century, in *Opere burlesche del Berni* (1603).

12. Unpublished inventories of Roman trial records indicate relatively few prosecutions for sodomy during the sixteenth century; Archivio di Stato di Roma, vol. 280, *Processi (1505–1599).* See also John K. Brackett, *Criminal Justice and Crime in Late Renaissance Florence, 1537–1609.*

13. Deborah Parker, *Bronzino, Renaissance Painter as Poet,* 18–19.

14. Ibid., 31. The last lines of the poem parody Dante's opening of *Paradiso* 25.

15. Charles McCorquodale, *Bronzino,* colorplate 11.

16. Jules Janick, "Caravaggio's Fruit: A Mirror of Baroque Horticulture."

17. The basic study of these pictures remains Donald Posner's "Caravaggio's Homo-Erotic Early Works."

18. John T. Spike, "Caravaggio erotico." Although the authorship of this privately owned picture has not been universally accepted, the painting has never been attributed to another artist.

19. For Caravaggio's career in general, see John T. Spike, *Caravaggio,* and for the artist's realism, see my *Caravaggio: The Art of Realism.*

20. Howard Hibbard, *Caravaggio,* 354, transcribes and translates Baglione's remarks.

21. The trial testimony is available in Walter Friedlaender, *Caravaggio Studies,* 270–79. Sandro Corradini, *Caravaggio, materiali per un processo,* publishes a vast array of documents—mainly from police archives—that attest to the artist's antisocial and unruly behavior.

22. See Robert Palter, *The Duchess of Malfi's Apricots and Other Literary Fruits,* 160–65, for the history of "the fig gesture."

23. Charlotte Houghton, "This Was Tomorrow: Pieter Aertsen's Meat Stall as Contemporary Art."

24. Much of my discussion of Aertsen's work comes from Günter Irmscher, "*Ministrae voluptatum:* Stoicizing Ethics in the Market and Kitchen Scenes of Pieter Aertsen and Joachim Beuckelaer."

25. Terence, *The Woman of Andros, the Self-Tormentor, the Eunuch,* line 732 in

The Eunuch. The theme was frequently illustrated in sixteenth-century northern art (Jane D. Reid, *The Oxford Guide to Classical Mythology in the Arts, 1300s–1900s,* vol. 1, 156–58).

26. Irmscher, *"Ministrae voluptatum,"* 222, gives the exact citation from Erasmus.

27. Ibid., 220.

28. Augustine, *Confessions,* 1, 7, 11.

29. The degree to which artists intended these "inverted" narratives to put forth serious moral lessons is a matter of debate. Keith P. F. Moxey, *Pieter Aertsen, Joachim Beuckelaer, and the Rise of Secular Painting in the Context of the Reformation,* 106, argues that such scenes "certainly possess a moralizing element that depends upon the contrast of foreground and background; however, this is far from constituting the whole meaning of the compositions."

30. The print by Hans Vogtherr the Younger was published around 1545 (Keith Moxey, *Peasants, Warriors, and Wives: Popular Imagery in the Reformation,* 82, 84). It is illustrated in Max Geisberg, *The German Single-Leaf Woodcut, 1500–1550,* vol. 4, cat. no. 1471.

31. Bert Meijer, "Cremona e i paesi bassi," 25–30.

32. See Barry Wind, *"Pitture ridicole:* Some Late Cinquecento Comic Genre Paintings," 25–35. Paleotti's text (ch. 27) is reproduced in *Trattati d'arte del Cinquecento, fra manierismo e Controriforma,* edited by Paola Barocchi, 370–74.

33. Sheila McTighe, "Foods and the Body in Italian Genre Painting, about 1580: Campi, Passarotti, Carracci." Much of the following discussion is taken from this illuminating study.

34. Ibid., 305.

35. WorldCat (OCLC) lists twelve editions and printings of this title between 1585 and 1600, indicating that it was a well-read book. McTighe cites the 1589 edition of Pisanelli's *Trattato della natura de'cibi et del bere.* A 1980 reprint of the 1611 edition is available from Arnaldo Forni Editore.

36. The four humors begin with the natural elements blood, water, yellow bile, and black bile, which were associated with the sanguine, phlegmatic, choleric, and melancholic temperaments, respectively.

37. Ken Albala, *Eating Right in the Renaissance,* esp. ch. 2.

38. Such a claim, as McTighe points out in "Foods and the Body," 308, was part of a larger discussion of the biological basis of social differences, a topic that Piero Camporesi explores in more detail in *Bread of Dreams.*

39. McTighe, "Foods and the Body," 310.

40. Pisanelli, *Trattato,* 27, as quoted in McTighe, "Foods and the Body," 310–11.

41. Berni, *Poesie e prose,* 42–44, 47–50.

42. Lomazzo, *Trattato,* 459.

43. Wind, *"Pitture ridicole,"* 109. Wind's article "Vincenzo Campi and Hans Fugger, a Peep at Late Cinquecento Bawdy Humor," 109, transcribes verses with this theme.

44. Cesare Ripa, *Iconologia*, first published unillustrated in 1593 and later in an illustrated edition of 1603.

45. Wind, "Vincenzo Campi," 112.

46. G. Lill, *Hans Fugger*, as cited by Wind in "Vincenzo Campi," 114. For other pictures by Campi in this genre, see Franco Paliaga and Bram de Klerck, *Vincenzo Campi*. A recently discovered contract drawn up in Cremona in 1587 reveals that one of Campi's followers, Giulio Calvi, was commissioned to paint a series of pictures of equally comic character (Robert S. Miller, *"Diversi personagii molto ridiculosi:* A Contract for Cremonese Market Scenes," 156–59).

47. Giuseppe Olmi and Paolo Prodi, "Art, Science, and Nature in Bologna," esp. 232.

48. For more on Aldrovandi and the emerging discipline of natural history, see Paula Findlen, *Possessing Nature: Museums, Collecting, and Scientific Culture in Early Modern Italy*.

49. Angela Ghirardi, *Bartolomeo Passarotti, pittore (1529–1592): Catalogo generale*, 228.

50. Claudio Strinati et. al., *Caravaggio e la collezione Mattei*, 138–43.

51. Ghirardi, *Bartolomeo Passarotti*, 67.

52. Wind, *"Pitture ridicole,"* 31.

53. Marvin T. Herrick, *Italian Comedy in the Renaissance*, 109, 121.

54. Wind, *"Pitture ridicole,"* 31.

55. The vignette pictured on the right of the composition shows Zan Tripuando's friend, the gluttonous and stupid Zan Zacagni, making advances to the cook (Vito Pandolfi, *La Commedia dell'Arte*, vol. 1, 231–39). The engraving reproduced here is from Pierre Louis Duchartre, *The Italian Comedy*, 68.

56. Guy de Tervarent, *Attributs et symboles dans l'art profane*, 335.

57. McTighe, "Foods and the Body," 313–14.

58. The fresco is *The Sacrifice of Noah* in the Vatican Logge, after which Marco Dente made a print that helped to disseminate the image. John Rupert Martin was the first to note Carracci's derivation from the print, which is illustrated by McTighe in "Foods and the Body," fig. 18.

59. Leo Steinberg, *Other Criteria: Confrontations with Twentieth-Century Art*, 72–74.

60. McTighe, "Foods and the Body," 316, 323 n. 42.

61. Ibid., 317.

62. Ibid.

63. Ibid., 318. The full title of the treatise is *Microcosmo nel quale si tratta breve-mente dell'anima vegetabile sensibile rationale dell' huomo sua complessione fisionomia delle infirmità che nascono in tutte le parti del corpo e loro curo*, Florence, 1600.

64. For a modern translation of this title, see San Juan de Huarte, *Examen de ingenios, The Examination of Mens Wits.*

SIX. EGGS, BUTTER, LARD, AND OIL

1. Cennini was born around 1370 and died in 1440. Scholars have dated his treatise anywhere from 1390 to 1437.

2. Cennino d'Andrea Cennini, *The Craftsman's Handbook: "Il Libro dell'Arte,"* 91.

3. Ibid., 66, 68. Centuries earlier, Theophilus gave instructions for making cheese glue in his treatise *On Divers Arts*, 26.

4. Cennini, *The Craftsman's Handbook*, 5, 79. Later in the book (109), when describing how to model crests or helmets, he recommends mixing gesso, size, and beaten tow "like a batter."

5. From Theophilus, *On Divers Arts*, and Daniel V. Thompson, *The Materials of Medieval Painting*.

6. David Bomford et al., *Art in the Making: Italian Painting before 1400*, 28.

7. Ralph Mayer, *The Artist's Handbook of Materials and Techniques*, 214.

8. Ibid., 215.

9. Giorgio Vasari, *Vasari on Technique*, 225.

10. Ibid., 226; Cennini, *The Craftsman's Handbook*, 89–90.

11. The precise nature of the relationship between Antonello and Bellini is not clear. In a recent essay, Keith Christiansen asks, "How, given the scarcity of evidence, do we trace the obviously enriching effects of the give-and-take between Antonello and Bellini?" ("The Exalted Art of Antonello da Messina," 14).

12. *Vasari on Technique*, 230.

13. Ibid., 230; Mayer, *The Artist's Handbook*, 126–27.

14. Alberto Capatti and Massimo Montanari, *Italian Cuisine: A Cultural History*, 100. Apicius lived in the first century A.D. around the time of Tiberius, but the recipes that bear his name seem not to have been compiled before the late fourth or early fifth century. *Apicius: A Critical Edition*, translated by Christopher Grocock and Sally Grainger, is the most thorough critical translation of his book.

15. Massimo Montanari, *La fame e l'abbondanza, storia dell'alimentazione in Europa*, 12–13.

16. Felipe Fernàndez-Armesto, *Near a Thousand Tables: A History of Food*, 139; Ken Albala, *Eating Right in the Renaissance*, 168.

17. Fernàndez-Armesto, *Near a Thousand Tables*, 139. On the use of oil in cooking throughout the Islamic world, see Maxime Rodinson, A. J. Arberry, and Charles Perry, *Medieval Arab Cookery;* Lilia Zaouali, *Medieval Cuisine of the Islamic World;* and Charles Perry, "Medieval Arab Oils."

18. Capatti and Montanari, *Italian Cuisine*, 101. Anthimus's *De observatione ciborum* was written in the sixth century. I have used Mark Grant's modern English translation (1996), 55–57, for the discourse on lard.

19. See Gillian Riley, *The Oxford Companion to Italian Food*, 270–72, for distinctions between true lard (*strutto*), lardo (cured back fat), and pancetta (bacon). In a private communication, Ms. Riley has further distinguished between *sugno* (fat from dripping roasts) and *grasso* (fresh hard fat), adding that "sadly, historic recipes are inconsistent in their use of these terms."

20. Comparing the south Italian, Tuscan, and Venetian versions of the *Liber de coquina*, Capatti and Montanari, *Italian Cuisine*, 102, observe that the percentage of recipes calling for lard varied by region, the ones from Tuscany and Venice calling for its use in 36 percent and 42 percent of the dishes, respectively.

21. Odile Redon, Françoise Sabban, and Silvano Serventi, *The Medieval Kitchen: Recipes from France and Italy*, 24, 98–99, 134–35. See also Terrence Scully, *The Art of Cookery in the Middle Ages*, as indexed.

22. Platina, *On Right Pleasure and Good Health*, book 2, ch. 22, 164–65.

23. Ibid., ch. 13, 150–53. Platina suggests that olives "are difficult to digest, of little nutriment, and generate crass and sticky humors. Eaten outside the regular meal, they repress vapors to the head." For superstitions about worms, see Pietro Camporesi, *Bread of Dreams*, esp. chs. 16 and 17.

24. According to *La Cucina Italiana* (www.globalgourmet.com), extra-virgin olive oil is the most digestible of the edible fats. In addition to aiding bile, liver, and intestinal functions, it reportedly assists in the assimilation of vitamins A, D, and K, and slows down the aging process.

25. A new edition of Apicius (*Apicius: A Critical Edition*) with critical commentary by Christopher Grocock and Sally Grainger was published by Prospect Books in 2006.

26. Riley, *The Oxford Companion to Italian Food*, 333.

27. Fernàndez-Armesto, *Near a Thousand Tables*, 139.

28. This observation and much of the discussion that follows in this paragraph draws on Giovanni Rebora, *Culture of the Fork: A Brief History of Food in Europe*, 97–98.

29. See R. J. Forbes, "Food and Drink," 112–18, for the early history of this device.

30. Bartolomeo Scappi, *Opera dell'arte del cucinare*.

31. Scappi, *Opera*, 4v. The translations that follow are my own, made with the assistance of John Florio's Italian-English dictionary of 1598, *A Worlde of Wordes, or Most Copious and Exact Dictionarie in Italian and English*.

32. Scappi, *Opera*, 433v, 434r; see Terence Scully's edition, *The Opera of Bartolomeo Scappi (1570): L'arte et prudenza d'un maestro cuoco/The Art and Craft of a Master Cook*, 612.

33. Pliny the Elder, *Natural History*, book 28, 133.

34. Jean-Louis Flandrin, *Il gusto e la necessità*, 59, 79 n. 108, as cited by Capatti and Montanari, *Italian Cuisine*, 102.

35. Capatti and Montanari, *Italian Cuisine*, 104–5.

36. The theory of the four humors originated in antiquity, formulated primarily by Hippocrates and Galen. On the ancient beliefs, see Mark Grant, trans., *Galen on Food and Diet*, esp. ch. 2. On Renaissance attitudes, see Albala, *Eating Right*, 48–52, 78–82.

37. Flandrin in Jean-Louis Flandrin and Massimo Montanari, *Food: A Culinary History, from Antiquity to the Present*, 418–32. Nevertheless, a few sixteenth-century authors continued to link cuisine and medicine.

38. Anthony Blunt, *Artistic Theory in Italy, 1450–1600*, 154–55.

39. Gillian Riley, *Renaissance Recipes*, 37–38, rightly questions the traditional view that the artist took little pleasure at the table.

40. Charles de Tolnay, "Le Menu de Michelange"; and Leo Steinberg, *Michelangelo's Last Paintings: The* Conversion of St. Paul *and the* Crucifixion of St. Peter, 7.

41. Scappi, *Opera*, book 2, ch. 163, 67v. Alan Davidson, *The Oxford Companion to Food*, 147.

42. Ken Albala, "Ovophilia in Renaissance Cuisine," 11–19.

43. Cristoforo Messisbugo, *Libro novo, nel qual s'insegna a' far d'ogni sorte di vivanda*, 53v–54r, 108r–v. Ken Albala discusses the colorful nature of sixteenth-century garnishes in *The Banquet: Dining in the Great Courts of Late Renaissance Europe*, 68–72.

44. Albala quotes the recipe in *The Banquet*, 71.

SEVEN. EATING AND ERUDITION

1. As Sarah Coffin has written, "Generally speaking, up until the late seventeenth century and, in some cases, later, hosts did not provide cutlery to their guests; people travelled with their own sets" (Coffin et al., *Feeding Desire: Design and Tools of the Table, 1500–2005*, 28).

2. Terence Scully, *The Art of Cookery in the Middle Ages*, 172.

3. Gerard Brett, "Trenchers," 23.

4. See Richard Goldthwaite, *Wealth and the Demand for Art in Italy, 1300–1600;* Lisa Jardine, *Worldly Goods: A New History of the Renaissance;* and Evelyn Welch, *Shopping in the Renaissance: Consumer Cultures in Italy, 1400–1600.*

5. Michel de Montaigne, *The Journal of Montaigne's Travels in Italy,* vol. 2, 85–87.

6. Michael Baxandall, *Painting and Experience in Fifteenth-Century Italy*, 16.

7. Leon Battista Alberti, *On Painting*, 85.

8. Marta Ajmar, "Talking Pots: Strategies for Producing Novelty on the Consumption of Printed Pottery in Renaissance Italy," 56–57.

9. See Catherine Killerby, *Sumptuary Law in Italy, 1200–1500,* for the history of this phenomenon.

10. See Maxwell G. Kanowski, *Containers of Classical Greece: A Handbook of Shapes.*

11. My forthcoming book, *Wine: A Cultural History,* devotes a chapter to the role of wine in Greek society.

12. Pliny the Elder, *Natural History*, book 35, 158–61.

13. Catherine Hess, *Italian Ceramics: Catalogue of the J. Paul Getty Museum Collection*, 1.

14. Laurie Fusco and Gino Corti, *Lorenzo de' Medici, Collector and Antiquarian*, 73 and doc. 153.

15. Mantegna painted a Greek *oenochoe* in his fresco cycle in the Ovetari Chapel, Padua (1455–56), whereas Pollaiuolo appropriated figures from a lost work of the Niobid Painter in his famous engraving the *Battle of the Nudes* (Cornelius Vermeule, *European Art and the Classical Past*, 45; Michael Vickers, "A Greek Source for Antonio Pollaiuolo's *Battle of the Nudes and Hercules and the Twelve Giants,*" 187).

16. Vickers, "A Greek Source," 187.

17. Wendy Watson, *Italian Renaissance Maiolica from the William A. Clark Collection*, 32–34.

18. Ibid.

19. Alberti, *On Painting*, 72.

20. Rensselaer Lee, *Ut Pictura Poesis: The Humanistic Theory of Painting;* see also Francis Ames-Lewis, *The Intellectual Life of the Early Renaissance Artist,* esp. ch. 7.

21. Cristoforo Messisbugo, *Libro novo, nel qual s'insegna a far d'ogni sorte di vivanda*, 31–99.

22. Bartolomeo Scappi, *Opera dell'arte del cucinare*, 192r–194r; see Terence

Scully's edition, *The Opera of Bartolomeo Scappi (1570): L'arte et prudenza d'un maestro cuoco/The Art and Craft of a Master Cook*, 397–401.

23. Richard Goldthwaite, "The Economic and Social World of Italian Renaissance Maiolica," esp. 17. See also Timothy Wilson, *Italian Maiolica of the Renaissance*, xv–xvi.

24. Ajmar, "Talking Pots," 58.

25. Giorgio Vasari, *The Lives of the Painters, Sculptors, and Architects*, vol. 4, 20. The most exhaustive treatment of the influence of prints on sixteenth-century maiolica is the Vatican exhibition catalogue *L'istoriato: Libri a stampa e maioliche italiane del cinquecento*.

26. Only in the sixth edition of the standard textbook on Italian Renaissance art does maiolica appear (Frederick Hartt and David Wilkins, *Italian Renaissance Art*, 547, 680).

27. The painting is reproduced in Hartt and Wilkins, *Italian Renaissance Art*, fig. 18.66.

28. A maiolica-laden sideboard is visible in a painting of the Supper at Emmaus attributed to the circle of Francesco da Ponte Bassano that was sold at Sotheby's, Milan, on October 28, 1999, lot 82.

29. Wilson, *Ceramic Art of the Italian Renaissance*, 131.

30. See Marta Ajmar and D. Thornton, "When Is a Portrait Not a Portrait?: *Belle Donne* on Maiolica and the Renaissance Praise of Local Beauties."

31. Wilson, *Ceramic Art*, 137.

32. Bette Talvacchia, "Professional Advancement and the Use of the Erotic in the Art of Francesco Xanto," 122.

33. The volume is known from a single manuscript in the Vatican Library. It was published for the first time in Francesco Cioci, *Xanto e il Duca di Urbino*.

34. Julia Triolo, "The Armorial Maiolica of Francesco Xanto Avelli."

35. Jörg Rasmussen, *Italian Maiolica in the Lehman Collection*, cat. no. 77, 132–33.

36. The total number of graphic sources that Xanto used during his career was fifty-nine (Triolo, "The Armorial Maiolica," appendix B).

37. The most recent study of the subject is Ken Albala, *The Banquet: Dining in the Great Courts of Late Renaissance Europe*.

38. Michel Jeanneret, *A Feast of Words: Banquets and Table Talk in the Renaissance*, 68–69.

39. As catalogued by WorldCat (OCLC).

40. Leon Battista Alberti, *Dinner Pieces*, 5.

41. Stefano Guazzo, *The Civile Conversation*, vol. 2, 134.

42. Marta Ajmar, "Talking Pots," 61. Among the texts were Antonfrancesco Doni's *La zucca* (1552) and Lodovico Guicciardini's *L'ore di ricreazione* (1565).

43. Ajmar, "Talking Pots," 61.

44. Guazzo, *The Civile Conversation*, vol. 2, 138–39.

45. I owe the discussion that follows to Wendy Watson's brilliant exposition of the piece in *Italian Painted Ceramics from the Howard I. and Janet H. Stein Collection and the Philadelphia Museum of Art*, 126–29.

EIGHT. EDIBLE ART

1. Benvenuto Cellini, *The Life of Benvenuto Cellini*, 302.

2. See Beth Holman, *Disegno: Italian Renaissance Designs for the Decorative Arts*, 94–112.

3. Already in Roman times, Roman soldiers were sometimes paid in salt, a practice that gave rise to the word *salary* and the expressions "worth his salt" or "earning his salt." For the various cultural meanings of salt, the only edible stone, see Mark Kurlansky, *Salt: A World History*, with full bibliography.

4. Ernest Jones, "The Symbolic Significance of Salt."

5. See Paula Findlen, *Possessing Nature: Museums, Collecting, and Scientific Culture in Early Modern Italy*, 17–47.

6. Ibid., 19, fig. 1.

7. Cellini, *Life of Benvenuto Cellini*, 264.

8. Marino Sanuto describes the 1519 dinner in *I diarii*, vol. 27, 74–75. See also Bartolomeo Scappi, *Opera dell'arte del cucinare*, 192v–193v; Terence Scully's translation, *The Opera of Bartolomeo Scappi (1570): L'arte et prudenza d'un maestro cuoco/The Art and Craft of a Master Cook*, 397–401; and Giovanni Battista Rossetti, *Dello scalco*.

9. For background on the phenomenon of death banquets, see Phyllis Bober, "The Black or Hell Banquet," 68; and Guendalina Ajello Mahler, "Ut pictura convivia: Heavenly Banquets and Infernal Feasts in Renaissance Italy."

10. Giorgio Vasari, *The Lives of the Painters, Sculptors, and Architects*, vol. 4, 33.

11. Ibid., 35.

12. Francesco Orilia, *Il zodiaco, over, idea di perfettione di prencipi*, 456. To my knowledge, Phyllis Pray Bober was the first to discover and publish the print in her "Prologue: Cuisine as Architectural Invention," 3.

13. The designs for the arches borrowed especially from Serlio's doorways (Sebastiano Serlio, *Tutte l'opere d'architettura et prospettiva*, book 4, 23v).

14. Ian Kelly, *Cooking for Kings: The Life of Antonin Carême, the First Celebrity Chef*, 38.

15. Sidney W. Mintz, *Sweetness and Power: The Place of Sugar in Modern History*, ch. 2, is the source for all that follows in this paragraph.

16. Ibid., 88, citing an earlier study by E. von Lippmann, *Geschichte des Zuckers*.

17. Ibid., 89, citing *Our English Home*, 70.

18. Ibid., p. 92, citing Sir Hugh Platt, *Delightes for Ladies*, nos. 73–79.

19. Platina, *On Right Pleasure and Good Health*, book 2, ch. 15, 157.

20. Ibid., book 1, ch. 12, 119.

21. Catherine K. Killerby, *Sumptuary Law in Italy, 1200–1500*, 66–80.

22. Ibid., 67, citing documents from the Archivio di Stato di Venezia.

23. Katherine J. Watson, "Sugar Sculptures for Grand Ducal Weddings from the Giambologna Workshop," remains the most important study of Italian Renaissance sugar sculpture. See also June di Schino, "The Triumph of Sugar Sculpture in Italy, 1500–1700"; and Daniela Ambrosini, "Les honneurs sucrés de Venise."

24. Watson, "Sugar Sculptures," 26 n. 1, cites an obscure nineteenth-century publication on the wedding, but the chronicle has since been reprinted in Claudio Benporat, *Feste e banchetti: Convivialità italiana fra tre e quattrocento*, 224–36.

25. Interestingly, the idea of ceremonially consuming local architecture has reappeared in recent times, namely in the work of Alicia Rios, who labels the phenomenon "urbanophagy." To view some of her work, see www.alicia -rios.com.

26. *Le nozze di Costanzo Sforza e Camilla d'Aragona celebrate a Pesaro nel maggio*. The text is reprinted without the illustrations by Benporat, *Feste e banchetti*, 176–23.

27. *Le nozze*, pl. 29.

28. Cristoforo Messisbugo's account of the banquet is from his *Libro novo* (1557), 15r–19v.

29. Based on his statistical analysis of the iconography of Italian paintings between 1420 and 1539, Peter Burke estimates that 87 percent of the pictures had religious subjects, and, not counting portraits, only a little over 4 percent were "secular" (*The Italian Renaissance: Culture and Society in Italy*, 162–63).

30. Mintz, *Sweetness and Power*, 87.

31. Bianca Tamassia Mazzarotto, *Le feste veneziane: I giochi popolari, le cerimonie religiose e di governo*, 303–13.

32. Ibid., 311.

33. Girolamo Ruscelli, *De secreti del reverendo Donno Alessio Piemonte sei libri*, Venice, 1555. The quotation is from an English translation printed in London in 1558, 62v–63r (Peter Brown, *Pleasures of the Table*, 56).

34. Mazzarotto, *Le feste*, 311.

35. On confectionary molds, see "Culinary Moulds" at www.historicfood .com, the website of Ivan Day.

36. What follows is mainly from Watson, "Sugar Sculptures."

37. Ibid., 26 nn. 14 and 15.

38. Filippo Baldinucci, *Notizie de'professori del disegno da Cimabue in qua*, vol. 4, 99–100.

39. Translated by Berengario delle Cinqueterre, *The Renaissance Cookbook: Historical Perspectives through Cookery*, 105.

40. John Varriano and Nathan Whitman, Roma resurgens: *Papal Medals from the Age of the Baroque*, 96.

41. The drawing is reproduced in Stefanie Walker and Frederick Hammond, *Life and Arts in the Baroque Palaces of Rome*, cat. no. 83.

42. Georgina Masson, "Food as a Fine Art," 339, associates the drawings with Christina's banquet, but Jennifer Montagu, *Roman Baroque Sculpture: The Industry of Art*, 220 nn. 98 and 99, more plausibly relates them to the Maundy Thursday celebrations of 1667 and 1668. Per Bjurstrom, *Feast and Theatre in Queen Christina's Rome*, 58–59, does not offer an opinion on the matter.

43. Montagu, *Roman Baroque Sculpture*, 196.

44. Ibid., 196–97.

45. See Alain Gruber, "Le festin offert par Roger Earl of Castlemaine"; and Barberini et al., *Life and the Arts*, cat. nos. 81 and 82.

46. John Michael Wright, *An Account of His Excellence, Roger Earl Castlemaine's Embassy from His Sacred Majesty James IId, King of England, Scotland, France, and Ireland &c. to His Holiness Innocent XI*, London, 1688. The complete volume is available online from EEBO (Early English Books Online) at http://eebo .chadwyck.com.

47. Ibid., 55.

48. Ibid., 63.

49. George Bauer, *Bernini in Perspective*, 48.

50. See Alvar González-Palacios, *Fasto Romano: Dipinti, sculture, arredi dai Palazzi di Rome*, cat. no. 187 and pl. 70, for an illustration of a biscuit table piece from the late eighteenth century that looks as if it were made of sugar.

51. For example, see the work of Alicia Rios at www.alicia-rios.com. A recent internet search for "edible art" and "eat art" disclosed more than a quarter of a million sites for each.

POSTSCRIPT

1. Plato, *Gorgias*, lines 462–63.

2. Philip Sohm, *Style in the Art Theory of Early Modern Italy*, 6–7, quotes

Vincenzo Carducho's *Diálogos de la pintura* on Caravaggio and Marco Boschini's *La carta del navegar pitoresco* (1660) on the sensations evoked by paintings (spices, spongy bread, marzipan, and pasta). Boschini also comments on the sound and smell of paintings.

3. Marco Frascari, "*Semiotica ab edendo*, Taste in Architecture," 194.

4. Ibid.

5. Ian Kelly, *Cooking for Kings: The Life of Antonin Carême, the First Celebrity Chef*, 38.

6. The definition is from the 1598 edition of John Florio, *A Worlde of Wordes*, 18. Interestingly, the only ancient cookbook title to come down to us—Apicius's *De re coquinaria*—literally translates as *On the Matter of Cooking*.

7. Carolyn Korsmeyer, *Making Sense of Taste: Food and Philosophy*, 140–45.

8. Elizabeth McGrath, "Cesare Ripa," in *The Dictionary of Art*, vol. 26, 425–26.

9. Chiara Stefani, "Cesare Ripa: New Biographical Evidence," 307–12. During Ripa's lifetime, Vincenzo Cervio published an entire volume, *Il trinciante*, explicating the many household responsibilities of a carver.

BIBLIOGRAPHY

Ackerman, Diane. *A Natural History of the Senses*. New York: Vintage Books, 1995.

Adamson, Melitta W., ed. *Food in the Middle Ages: A Book of Essays*. New York: Garland Publishing, 1995.

Ajello Mahler, Guendalina. "Ut pictura convivia: Heavenly Banquets and Infernal Feasts in Renaissance Italy." *Viator* 38, no. 2 (2007): 235–64.

Ajmar, Marta. "Talking Pots: Strategies for Producing Novelty on the Consumption of Printed Pottery in Renaissance Italy." In *The Art Market in Italy: 15th–17th Centuries*, edited by M. Fantoni, L. C. Matthew, and S. F. Matthews-Brieco, 55–64. Modena: Franco Cosimo Panini, 2003.

Ajmar, Marta, and D. Thornton. "When Is a Portrait Not a Portrait?: *Belle Donne* on Maiolica and the Renaissance Praise of Local Beauties." In *Image of the Individual: Portraits in the Renaissance*, edited by N. Mann and L. Syson, 138–53. London: British Museum Press, 1998.

Albala, Ken. *The Banquet: Dining in the Great Courts of Late Renaissance Europe*. Urbana: University of Illinois Press, 2007.

———. *Eating Right in the Renaissance*. Berkeley: University of California Press, 2002.

———. "Ovophilia in Renaissance Cuisine." In *Eggs: Proceedings of the Oxford Symposium on Food and Cookery, 2006*, edited by R. Hosking, 11–19. Devon, UK: Prospect Books, 2007.

Alberti, Leon Battista. *Dinner Pieces*. Translated by D. Marsh. Binghamton: State University of New York, Medieval and Renaissance Texts & Studies, 1987.

———. *On Painting*. Translated by J. R. Spencer. New Haven, CT: Yale University Press, 1966.

———. *On the Art of Building in Ten Books*. Translated by J. Rykwert, N. Leach, and R. Tavernor. Cambridge, MA: MIT Press, 1988.

Alcock, Joan P. "Velázquez' Cooks and the Portrayal of Food in Spanish Still Life Art of the Seventeenth Century." In *Cooks and Other People: Proceedings of the Oxford Symposium on Food and Cookery, 1995*, edited by H. Walker, 15–24. Devon, UK: Prospect Books, 1996.

Ambrosini, Daniela. "Les honneurs sucrés de Venise." In *Le boire et le manger au XVIe siècle: Actes du XIe colloque du Puy-en-Velay*, edited by M. Viallon-Schoneveld, 267–84. Saint-Etienne: Publications de l'université de Saint-Etienne, 2004.

Ames-Lewis, Francis. *The Intellectual Life of the Early Renaissance Artist.* New Haven, CT: Yale University Press, 2000.

Anderson, Burton. *Treasures of the Italian Table: Italy's Celebrated Foods and the Artisans Who Made Them.* New York: William Morrow, 1994.

———. *The Wine Atlas of Italy and Traveller's Guide to the Vineyards.* New York: Simon and Schuster, 1990.

Anthimus. *De observatione ciborum* [On the Observance of Foods]. Edited and translated by Mark Grant. Devon, UK: Prospect Books, 1996.

Apicius. *Apicius: A Critical Edition.* Edited and translated by Christopher Grocock and Sally Grainger. Devon, UK: Prospect Books, 2006.

———. *The Roman Cookery Book: A Critical Translation of* The Art of Cooking *for Use in the Study and the Kitchen.* Translated by B. Flower and E. Rosenbaum. London: George G. Harrap, 1958.

Archivio di Stato di Roma, Tribunale Criminale del Governo. Vol. 280, *Processi (1505–1599).*

Art Resource website: www.artres.com.

Artusi, Pellegrino. *Science in the Kitchen and the Art of Eating Well.* Translated by M. Baca and S. Sartarelli. Toronto: University of Toronto Press, 2003.

Askew, Pamela. "Caravaggio: Outward Action, Inward Vision." In *Michelangelo Merisi da Caravaggio, la vita e le opere attraverso I documenti, Atti del Convegno Internazionale di Studi,* edited by S. Macioce, 148–69. Rome: Logart Press, 1995.

Augustine. *Confessions.* Translated by W. Watts. Cambridge, MA: Harvard University Press, 1968–70.

Baglione, Giovanni. *Le vite de'pittori, scultori, et architetti* [1642]. Reprint, Bologna: Arnaldo Forni Editore, 1975.

Bakhtin, Mikhail. *Rabelais and His World.* Translated by H. Iswolsky. Bloomington: Indiana University Press, 1984.

Baldinucci, Filippo. *Notizie de'professori del disegno da Cimabue in qua.* Vol. 4 of *Opere di Filippo Baldinucci.* Milan: Società tipografica de'Classici italiani, 1808–12.

Barolsky, Paul. *Infinite Jest: Wit and Humor in Italian Renaissance Art.* Columbia: University of Missouri Press, 1978.

Bauer, George, ed. *Bernini in Perspective.* Englewood Cliffs, NJ: Prentice-Hall, 1976.

Baxandall, Michael. *Painting and Experience in Fifteenth-Century Italy.* Oxford: Clarendon Press, 1972.

Bayer, Andrea, ed. *Painters of Reality: The Legacy of Leonardo and Caravaggio in Lombardy.* New York: Metropolitan Museum of Art, 2004.

Bendiner, Kenneth. *Food in Painting: From the Renaissance to the Present.* London: Reaktion Books, 2004.

Benporat, Claudio. *Feste e banchetti: Convivialità italiana fra tre e quattrocento.* Florence: Leo S. Olschki, 2001.

Berni, Francesco. *Poesie e prose.* Florence: Leo S. Olschki, 1934.

Berra, Giacomo. "Contributo per la datazione della 'natura morta di pesche' di Ambrogio Figino." *Paragone*, no. 469 (1989): 3–13.

Bianchi, Massimo Luigi. *Signatura rerum: Segni, magia e consoscenza da Parecelsus a Leibniz.* Florence: Leo S. Olschki, 1987.

Biblioteca Apostolica Vaticana. *L'istoriato: Libri a stampa e maioliche italiane del cinquecento.* Faenza: Gruppo Editoriale Faenza Editrice, 1993.

Bièvre, Elisabeth de. "The Urban Subconscious: The Art of Delft and Leiden." *Art History* 18 (1995): 222–52.

Bjurstrom, Per. *Feast and Theatre in Queen Christina's Rome.* Stockholm: Nationalmuseum, 1966.

Blunt, Anthony. *Artistic Theory in Italy, 1450–1600.* Oxford: Clarendon Press, 1962.

Bober, Phyllis. *Art, Culture, and Cuisine: Ancient and Medieval Gastronomy.* Chicago: University of Chicago Press, 1999.

———. "The Black or Hell Banquet." In *Feasting and Fasting: Proceedings of the Oxford Symposium on Food and Cookery, 1998,* edited by H. Walker, 55–57. London: Prospect Books, 1990.

———. "Prologue: Cuisine as Architectural Invention." In *Eating Architecture,* edited by J. Horwitz and P. Singley. Cambridge, MA: MIT Press, 2004.

Bomford, David, Jill Dunkerton, Dillian Gordon, Ashok Roy, and Jo Kirby. *Art in the Making: Italian Painting before 1400.* London: National Gallery, 1989.

Bowen, Barbara C. *One Hundred Renaissance Jokes: An Anthology.* Birmingham, AL: Summa Publications, 1988.

Brackett, John K. *Criminal Justice and Crime in Late Renaissance Florence, 1537–1609.* Cambridge: Cambridge University Press, 1992.

Brett, Gerard. "Trenchers." In *Annual, Art and Archaeology Division,* 23–27. Toronto: Royal Ontario Museum, 1962.

Brown, Peter. *Pleasures of the Table.* York, UK: Fairfax House, 1997.

Bryson, Norman. *Looking at the Overlooked: Four Essays on Still Life Painting.* Cambridge, MA: Harvard University Press, 1990.

Buford, Bill. *Heat: An Amateur's Adventures as Kitchen Slave, Line Cook, Pasta-Maker, and Apprentice to a Dante-Quoting Butcher in Tuscany*. New York: Alfred A. Knopf, 2006.

Burckhardt, Jacob. *The Civilization of the Renaissance in Italy*. New York: Harper & Row, 1958.

Burke, Peter. *The Italian Renaissance: Culture and Society in Italy*. Princeton, NJ: Princeton University Press, 1999.

Camporesi, Piero. *Bread of Dreams*. Translated by D. Gentilcore. Chicago: University of Chicago Press, 1996.

Caneva, Giulia. *Il mondo di Cerere nella Loggia di Psiche: Villa La Farnesina, sede dell' Accademia Nazionale dei Lincei*. Rome: Fratelli Palombi Editori, 1992.

Capatti, Alberto, and Massimo Montanari. *Italian Cuisine: A Cultural History*. Translated by A. O'Healy. New York: Columbia University Press, 2003.

Cardi, Maria V. "Intorno all'autoritratto in veste di Bacco di Giovan Paolo Lomazzo." *Storia dell'arte* 81 (1994): 182–93.

Carracci, Annibale. *Le arti di Bologna* [1646]. Reprint, Rome: Edizioni del Elefante, 1966.

Casey, James. "Spain: A Failed Transition." In *The European Crisis of the 1590s: Essays in Comparative History*, edited by P. Clark, 209–28. London: George Allen and Unwin, 1985.

Castelnuovo, Enrico, and C. Ginzburg, "Centro e perferia." In *Storia dell'arte Italiana*, part 1, vol. 1, 285–352. Milan: U. Hoepli, 1901.

Castelvetro, Giacomo. *The Fruit, Herbs, and Vegetables of Italy*. Translated by G. Riley. London: Viking Penguin, 1989.

Castiglione, Baldassari. *The Book of the Courtier*. Translated by C. S. Singleton. New York: Doubleday, 1959.

Cellini, Benvenuto. *The Life of Benvenuto Cellini*. Translated by J. A. Symonds. London: Phaidon Press, 1995.

Cennini, Cennino d'Andrea. *The Craftsman's Handbook: "Il Libro dell'Arte."* Translated by D. V. Thompson. New York: Dover Publications, 1954.

Chambers, David, and Brian Pullan. *Venice: A Documentary History, 1450–1630*. Toronto: University of Toronto Press, 2001.

Chambers, David, and F. Quiviger, eds. *Italian Academies of the Sixteenth Century*. London: Warburg Institute, 1995.

Chaucer, Geoffrey. *The Complete Canterbury Tales*. Edited by J. H. Fisher and M. Allen. Boston: Thomson Higher Education, 2006.

Cherry, Peter. "Alejandro de Loarte." In *The Dictionary of Art*, vol. 19, 521. New York: Grove's Dictionaries, 1996.

———— "Bodegón." In *The Dictionary of Art*, vol. 4, 209–12. New York: Grove's Dictionaries, 1996.

Chirico, Robert. "From Cave to Café: Artists' Gatherings." *Gastronomica, The Journal of Food and Culture* 2, no. 4 (2002): 33–41.

Christiansen, Keith. "The Exalted Art of Antonello da Messina." In *Antonello da Messina: Sicily's Renaissance Master*, edited by G. Barbera, with contributions by K. Christiansen and A. Bayer. New Haven, CT: Yale University Press, 2005.

Cinqueterre, Berengario delle (Barringer Fifield). *The Renaissance Cookbook: Historical Perspectives through Cookery.* Crown Point, IN: Dunes Press, 1975.

Cioci, Francesco. *Xanto e il Duca di Urbino.* Milan: Fabbri Editori, 1987.

Coffin, Sarah D., Ellen Lupton, Darra Goldstein, and Barbara Bloemink. *Feeding Desire: Design and the Tools of the Table, 1500–2005.* New York: Assouline, 2006.

Comune di Roma. *La natura morta al tempo di Caravaggio.* Naples: Electa, 1995.

Corradini, Sandro. *Caravaggio, materiali per un processo.* Rome: Alma Roma, 1993.

Coryate, Thomas. *Coryate's Crudities.* New York: Macmillan, 1905.

Crisci, Giovanni Battista. *Lucerna de Corteggiani.* Naples: Roncagliolus, 1634.

Cunningham, Andrew, and Ole P. Grell. *The Four Horsemen of the Apocalypse: Religion, War, Famine and Death in Reformation Europe.* New York: Cambridge University Press, 2000.

Dacos, Nicole, and Catherine Furlan. *Giovanni da Udine, 1487–1561.* Udine: Cassamassima, 1987.

Dalby, Andrew. *Dangerous Tastes: The Story of Spices.* Berkeley: University of California Press, 2000.

David, Elizabeth. *Harvest of the Cold Months: The Social History of Ice and Ices.* New York: Viking, 1998.

————. *Italian Food.* Baltimore: Penguin Books, 1969.

Davidson, Alan. *The Oxford Companion to Food.* New York: Oxford University Press, 1999.

Day, Ivan. "Culinary Moulds," www.historicfood.com.

Debus, Allen G. *Man and Nature in the Renaissance.* Cambridge: Cambridge University Press, 1978.

Deliège, Robert. *Lévi-Strauss Today: An Introduction to Structural Anthropology.* Translated by N. Scott. Oxford: Berg, 2004.

Ditchfield, Simon. *Liturgy, Sanctity and History in Tridentine Italy.* Cambridge: Cambridge University Press, 1995.

Dolce, Lodovico. *Dialogue on Painting* [1557]. Reprinted in *Dolce's "Aretino" and Venetian Theory of the Cinquecento,* by Mark W. Roskill. New York: New York University Press, 1968.

Duchartre, Pierre Louis. *The Italian Comedy*. Translated by R. Weaver. New York: Dover Publications, 1966.

Dunn, Peter N. *Spanish Picaresque Fiction: A New Literary History*. Ithaca, NY: Cornell University Press, 1993.

Eisenstein, Elizabeth. *The Printing Press as Agent of Change: Communications and Social Transformation in Early Modern Europe*. Cambridge: Cambridge University Press, 1979.

Feeley-Harnik, Gillian. *The Lord's Table: The Meaning of Food in Early Judaism and Christianity*. Washington, DC: Smithsonian Institution Press, 1994.

Fehl, Philipp. "Veronese and the Inquisition: A Study of the Subject Matter of the So-Called Feast in the House of Levi." *Gazette des beaux-arts* 58 (1961): 325–54.

Fernàndez-Armesto, Felipe. *Near a Thousand Tables: A History of Food*. New York: Simon and Schuster, 2002.

Ficino, Marsilio. *The Book of Life*. Translated by C. Boer. Irving, TX: Spring Publications, 1980.

Findlen, Paula. *Possessing Nature: Museums, Collecting, and Scientific Culture in Early Modern Italy*. Berkeley: University of California Press, 1994.

Flandrin, Jean-Louis. *Il gusto e la necessità*. Translated by L. Saetti. Milan: Il Saggiatore, 1994.

Flandrin, Jean-Louis, and Massimo Montanari, eds. *Food: A Culinary History*. Translated by C. Botsford, A. Goldhammer, C. Lambert, F. M. López, and S. Stevens. New York: Penguin Books, 2000.

Florio, John. *A Worlde of Wordes, or Most Copious and Exact Dictionarie in Italian and English*. London: Arnold Hatfield, 1598; http://eebo.chadwyck.com.

Folengo, Teofilo. *Baldo*. Translated by A. E. Mullaney. Cambridge, MA: Harvard University Press, 2007.

Forbes, R.J. "Food and Drink." In vol. 2 of *A History of Technology*, edited by C. Singer, E.J. Holmyard, A.R. Hall, and T. Williams, 112–18. Oxford: Clarendon Press, 1956.

Foucault, Michel. *The Archaeology of Knowledge and the Discourse on Language*. Translated by A. M. Sheridan Smith. New York: Pantheon Books, 1972.

———. *The Order of Things: An Archaeology of the Human Sciences*. New York: Vintage Books, 1994.

Frankl, Paul. *Gothic Architecture*. Baltimore: Penguin Books, 1962.

Frantz, David O. *Festum Voluptatis: A Study of Renaissance Erotica*. Columbus: Ohio State University Press, 1989.

Frascari, Marco. "*Semiotica ab edendo*, Taste in Architecture." In *Eating Architecture*, edited by J. Horwitz; P. Stingley, 197–203. Cambridge, MA: MIT Press, 2004.

Frati, Ludovico. *Libro di cucina del secolo XIV a cura di Ludovico Frati.* Livorno: R. Giusti, 1899. Reprint, Bologna: Arnaldo Forni Editore, 1986.

Freedman, Paul, ed. *Food: The History of Taste.* Berkeley: University of California Press, 2007.

Friedlaender, Walter. *Caravaggio Studies.* New York: Schocken Books, 1969.

Fusco, Laurie, and Gino Corti. *Lorenzo de' Medici, Collector and Antiquarian.* Cambridge: Cambridge University Press, 2006.

Galli de' Paratesi, Nora. *Le brutte parole, semantica dell'eufemismo.* Milan: A. Mondadori, 1969.

Garzoni, Tomaso. *La piazza universale di tutte le professioni del mondo.* Florence: Leo S. Olschki, 1996.

Geisberg, Max. *The German Single-leaf Woodcut, 1500–1550,* vol. 4. Revised and edited by W. L. Strauss. New York: Hacker Art Books, 1974.

Ghirardi, Angela. *Bartolomeo Passarotti, pittore (1529–1592): Catalogo generale.* Rimini: Luisi, 1990.

Giacosa, Ilaria Gozzini. *A Taste of Ancient Rome.* Chicago: University of Chicago Press, 1994.

Glacken, Clarence. *Traces on the Rhodian Shore: Nature and Culture in Western Thought from Ancient Times to the End of the Nineteenth Century.* Berkeley: University of California Press, 1967.

Goethe, Johann Wolfgang von. *Goethe on Art.* Edited and translated by J. Gage. Berkeley: University of California Press, 1980.

———. *Italian Journey (1786–88).* Translated by W. H. Auden and E. Mayer. New York: Schocken Books, 1968.

Goldthwaite, Richard. "The Economic and Social World of Italian Renaissance Maiolica." *Renaissance Quarterly* 42 (1989): 1–32.

———. *Wealth and the Demand for Art, 1300–1600.* Baltimore: Johns Hopkins University Press, 1993.

González-Palacios, Alvar, ed. *Fasto Romano: Dipinti, sculture, arredi dai Palazzi di Rome.* Rome: Leonardo-De Luca Editori, 1991.

Grant, Mark, trans. and ed. *Galen on Food and Diet.* London: Routledge, 2000.

Gregory, Sharon. "The Outer Man Tends to Be a Guide to the Inner: The Woodcut Portraits in Vasari's *Lives* as Parallel Texts." In *The Rise of the Image, Essays on the History of the Illustrated Book,* edited by R. Palmer and T. Frangenberg, 51–85. Aldershot, UK: Ashgate, 2003.

Gruber, Alain. "Le festin offert par Roger Earl of Castlemaine." *Gazette des beaux-arts* 126 (1995): 99–110.

Guazzo, Stefano. *The Civile Conversation.* Translated by G. Pettie and B. Young. New York: Alfred A. Knopf, 1925.

Hanlon, Gregory. *Early Modern Italy, 1550–1800: Three Seasons in European History.* New York: St. Martin's Press, 2000.

Harris, Ann Sutherland. "Giovanna Garzoni." In *The Dictionary of Art,* vol. 12, 169–70. New York: Grove's Dictionaries, 1996.

Hartt, Frederick, and David Wilkins. *Italian Renaissance Art.* 6th ed. Upper Saddle River, NJ: Pearson Prentice Hall, 2007.

Henisch, Bridget Ann. *Fast and Feast: Food in Medieval Society.* University Park: Pennsylvania State University Press, 1976.

Herrick, Marvin T. *Italian Comedy in the Renaissance.* Freeport, ME: Books for Libraries Press, 1970.

Hess, Catherine. *Italian Ceramics: Catalogue of the J. Paul Getty Museum Collection.* Los Angeles: J. Paul Getty Museum, 2002.

Hibbard, Howard. *Caravaggio.* New York: Harper and Row, 1983.

Hippocrates. *Ancient Medicine and Airs, Waters, Places.* Translated by W. H. S. Jones. Vol. 1 of *Hippocrates* (Loeb Classical Library). New York: Putnam, 1923.

Holman, Beth. *Disegno: Italian Renaissance Designs for the Decorative Arts.* Dubuque, IA: Kendall/Hunt Publishing, 1997.

Hoogewerff, Godefridus. *De Bentvueghels.* The Hague: M. Nijhoff, 1952.

Höper, Corinna. *Bartolomeo Passarotti (1529–1592).* Worms: Wernerische Verlagsgellschaft, 1987.

Horwitz, Jamie, and Paulette Singley, eds. *Eating Architecture.* Cambridge, MA: Harvard University Press, 2004.

Houghton, Charlotte. "This Was Tomorrow: Pieter Aertsen's Meat Stall as Contemporary Art." *Art Bulletin* 86 (2004): 277–300.

Huarte, San Juan de. *Examen de ingenios, The Examination of Mens Wits* [1594]. Translated by M.C. Camilli and R. Carew. Gainesville, FL: Scholar's Facsimiles and Reprints, 1959.

Huntington, Ellsworth. *Civilization and Climate.* New Haven, CT: Yale University Press, 1915.

Irmscher, Günter. "*Ministrae voluptatum:* Stoicizing Ethics in the Market and Kitchen Scenes of Pieter Aertsen and Joachim Beuckelaer." *Simiolus* 16 (1986): 219–32.

Janick, Jules. "Caravaggio's Fruit: A Mirror of Baroque Horticulture," www.hort .purdue.edu/newcrop/caravaggio/caravaggio__l.html.

Jardine, Lisa. *Worldly Goods: A New History of the Renaissance.* New York: Nan A. Talese, 1996.

Jeanneret, Michel. *A Feast of Words: Banquets and Table Talk in the Renaissance.* Chicago: University of Chicago Press, 1991.

Jenkins, Nancy. "Two Ways of Looking at Maestro Martino." *Gastronomica, The Journal of Food and Culture* 7, no. 2 (Spring 2007): 97–103.

Jones, Ernest. "The Symbolic Significance of Salt." In *Salt and the Alchemical Soul.* Woodstock, NY: Spring Publications, 1995.

Jones, Pamela. *Federico Borromeo and the Ambrosiana: Art Patronage and Reform in Sixteenth-Century Milan.* New York: Cambridge University Press, 1993.

Jordan, William, and Peter Cherry. *Spanish Still Life: From Velázquez to Goya.* London: National Gallery Publications, 1995.

Joyce, Hetty. "Grasping at Shadows: Ancient Paintings in Renaissance and Baroque Rome." *Art Bulletin* 74 (1992): 219–46.

Kanowski, Maxwell G. *Containers of Classical Greece: A Handbook of Shapes.* Saint Lucia: University of Queensland Press, 1984.

Kaufman, William. *The Catholic Cook Book: Traditional Feast and Fast Day Recipes.* New York: Citadel Press, 1965.

Kaufmann, Thomas DaCosta. *Toward a Geography of Art.* Chicago: University of Chicago Press, 2004.

Kelly, Ian. *Cooking for Kings: The Life of Antonin Carême, the First Celebrity Chef.* London: Short Books, 2003.

Kemp, Martin. "Leonardo and the Idea of Naturalism: Leonardo's Hypernaturalism." In *Painters of Reality, The Legacy of Leonardo and Caravaggio in Lombardy,* edited by A. Bayer, 65–73. New Haven, CT: Yale University Press, 2004.

———. *Seen/Unseen: Art, Science, and Intuition from Leonardo to the Hubble Telescope.* Oxford: Oxford University Press, 2006.

Killerby, Catherine. *Sumptuary Law in Italy, 1200–1500.* New York: Oxford University Press, 2002.

Korsmeyer, Carolyn. *Making Sense of Taste: Food and Philosophy.* Ithaca, NY: Cornell University Press, 1999.

Kristeller, Paul Oskar. *Renaissance Thought and the Arts.* Princeton, NJ: Princeton University Press, 1990.

Kurlansky, Mark. *Salt: A World History.* New York: Penguin Books, 2003.

Lando, Ortensio. *Commentario delle più notabili & monstruose cose d'Italia.* Venice: Bartolomeo Cesano, 1553. Reprint, Bologna: Pendragon, 1994.

Langdon, Helen. *Caravaggio: A Life.* London: Chatto and Windus, 1998.

Laszlo, Pierre. *Citrus: A History.* Chicago: University of Chicago Press, 2007.

Lates, Adrienne von. "Caravaggio's Peaches and Academic Puns." *Words & Image* 11 (1995): 55–60.

Latini, Antonio. *Lo scalco alla moderna.* Naples: Parrino e Mutii, 1692–94.

Laurioux, Bruno. *Gastronomie, humanisme et société à Rome au milieu du XVe siècle: Autour du De honesta voluptate de Platina*. Florence: Edizioni del Galluzzo, 2006.

Lee, Rensselaer. *Ut Pictura Poesis: The Humanistic Theory of Painting*. New York: W.W. Norton, 1967.

Lehmann, Gilly. "The Cook as Artist?" In *Food and the Arts: Proceedings of the Oxford Symposium on Food and Cookery, 1998*, edited by H. Walker, 125–33. Devon, UK: Prospect Books, 1999.

Lehmann-Hartleben, Karl. "The *Imagines* of the Elder Philostratus." *Art Bulletin* 23 (1941): 16–44.

Leonardo da Vinci. *Leonardo on Painting: An Anthology of Writings*. Edited and translated by M. Kemp and M. Walker. New Haven, CT: Yale University Press, 2001.

———. *The Literary Works of Leonardo da Vinci*. Compiled and edited from the original manuscripts by J. P. Richter; commentary by C. Pedretti. 2 vols. Berkeley: University of California Press, 1977.

———. *The Notebooks of Leonardo da Vinci*. Arranged, rendered into English, and introduced by E. MacCurdy. New York: Reynal and Hitchcock, 1938.

———. *The Notebooks of Leonardo da Vinci*. Compiled and edited from the original manuscripts by J.P. Richter. 2 vols. New York: Dover Publications, 1970.

Levine, David. "The Bentvueghels: 'Bande Academique.'" In *IL60: Essays Honoring Irving Lavin on His Sixtieth Birthday*, edited by M.A. Lavin, 207–26. New York: Italica Press, 1990.

Levine, David, and Ekkehard Mai. *I Bamboccianti: Niederländische Malerrebellen im Rom des Barock*. Milan: Electa, 1991.

Lévi-Strauss, Claude. *The Raw and the Cooked*. Translated by J. and D. Weightman. Chicago: University of Chicago Press, 1983.

Lomazzo, Giovanni Paolo. *Trattato dell'arte della pittura*. Milan: Ponte, 1584. Reprint, Ann Arbor, MI: University Microfilms, 1989.

Lopez-Rey, José. *Velázquez: A Catalogue Raisonné of His Oeuvre*. London: Faber and Faber, 1963.

Lynch, James. "Giovanni Paolo Lomazzo's Self-Portrait in the Brera." *Gazette des beaux-arts* 64 (1964): 189–97.

———. "Lomazzo and the Accademia della Valle di Bregno." *Art Bulletin* 48 (1966): 210–11.

Martial. *Martial: The Twelve Books of Epigrams*. Translated by J.A. Pott and F.A. Wright. New York: E. P. Dutton, 1924.

Martino, Maestro. *The Art of Cooking: The First Modern Cookery Book.* Translated by J. Parzen. Berkeley: University of California Press, 2004.

Masson, Georgina. "Food as a Fine Art." *Apollo* 83 (1966): 338–41.

Mayer, Ralph. *The Artist's Handbook of Materials and Techniques.* New York: Viking Press, 1982.

Mazzarotto, Bianca Tamassia. *Le feste veneziane: I giochi popolari, le cerimonie religiose e di governo.* Florence: Sansoni, 1961.

McClure, George W. *The Culture of Profession in Late Renaissance Italy.* Toronto: University of Toronto Press, 2004.

McCorquodale, Charles. *Bronzino.* New York: Harper and Row, 1981.

McGrath, Elizabeth. "Cesare Ripa." In *The Dictionary of Art,* vol. 26, 425–26. New York: Grove's Dictionaries, 1996.

McPhee, John. *Oranges.* New York: Farrar, Straus and Giroux, 2000.

McTighe, Sheila. "Foods and the Body in Italian Genre Painting, about 1580: Campi, Passarotti, Carracci." *Art Bulletin* 86 (2004): 301–23.

Medici Archive Project: www.medici.org.

Meijer, Bert. "Cremona e i paesi bassi." In *I Campi e la cultura artistica Cremonese del Cinquecento,* edited by M. Gregori, 25–30. Milan: Electa, 1985.

———. "Niccolo Frangipane." *Saggi e memorie* 8 (1972): 151–91.

Messisbugo, Cristoforo di. *Libro novo, nel qual s'insegna a' far d'ogni sorte di vivanda.* Venice: Heredi di Giovanni Padouano, 1557. Reprint, Bologna: Arnaldo Forni Editore, 2001.

Miller, Robert S. "*Diversi personagii molto ridiculosi:* A Contract for Cremonese Market Scenes." In *Painters of Reality: The Legacy of Leonardo and Caravaggio in Lombardy,* ed. A. Bayer, 156–59. New Haven, CT: Yale University Press, 2004.

Mintz, Sidney W. *Sweetness and Power: The Place of Sugar in Modern History.* New York: Penguin Books, 1986.

Mitchell, Don. *Cultural Geography: A Critical Introduction.* Oxford: Blackwell Publishers, 2000.

Molinos, Miguel de. *Guía espiritual.* Madrid: Editorial Espasa-Calpe, 1935.

Montagu, Jennifer. *Roman Baroque Sculpture: The Industry of Art.* New Haven, CT: Yale University Press, 1989.

Montaigne, Michel de. *The Journal of Montaigne's Travels in Italy.* Translated by W. G. Waters. 3 vols. London: John Murray, 1903.

Montanari, Massimo. *La fame e l'abbondanza, storia dell'alimentazione in Europa.* Rome/Bari: Laterza, 1988.

———. *Food Is Culture.* Translated by A. Sonnenfeld. New York: Columbia University Press, 2004.

Morel, Philippe. "Priape à la Renaissance: Les ghirlandes de Giovanni da Udine a la Farnesine." *Revue de l'art* 69 (1985): 13–28.

Moryson, Fynes. *An Itinerary Containing His Ten Yeeres Travell*. NY: Macmillan, 1907.

Moxey, Keith. *Peasants, Warriors, and Wives: Popular Imagery in the Reformation*. Chicago: University of Chicago Press, 2004.

——. *Pieter Aertsen, Joachim Beuckelaer, and the Rise of Secular Painting in the Context of the Reformation*. New York: Garland Publications, 1977.

Newett, M. Margaret. *Canon Pietro Casola's Pilgrimage to Jerusalem in the Year 1494*. Manchester, UK: Manchester University Press, 1907.

Le nozze di Costanzo Sforza e Camilla d'Aragona celebrate a Pesaro nel maggio 1475. Rome: Tammaro de Marinis, 1946.

Olmi, Giuseppe, and Paolo Prodi. "Art, Science, and Nature in Bologna." In *The Age of Correggio and the Carracci*. Washington, DC: National Gallery of Art, 1986.

Onians, John. "Architecture and Painting: The Biological Connection." In *Architecture and the Pictorial Arts from Antiquity to the Enlightenment*, edited by C. Anderson, 1–14. Aldershot, UK: Ashgate, 2002.

——. "The Biological Basis of Renaissance Aesthetics." In *Concepts of Beauty in Renaissance Art*, edited by F. Ames-Lewis and M. Rogers, 12–27. Aldershot, UK: Ashgate, 1998.

——. *Neuroarthistory: From Aristotle and Plato to Baxandall and Zeki*. New Haven, CT: Yale University Press, 2007.

Orilia, Francesco. *Il zodiaco, over, idea di perfettione di prencipi*. Naples: Ottavio Beltrano, 1630.

Paleotti, Gabriele. *Discorso intorno alle immagini sacre e profane* [1582]. In *Trattati d'arte del Cinquecento, fra manierismo e Controriforma*, edited by P. Barocchi. Bari: G. Laterza, 1960–62.

Paliaga, Franco, and Bram de Klerck. *Vincenzo Campi*. Soncino: Edizioni dei Soncino, 1997.

Palter, Robert. *The Duchess of Malfi's Apricots and Other Literary Fruits*. Columbia: University of South Carolina Press, 2002.

Pandolfi, Vito. *La Commedia dell'Arte*. Florence: Le Lettere, 1988.

Parker, Deborah. *Bronzino: Renaissance Painter as Poet*. Cambridge: Cambridge University Press, 2000.

Parzen, Jeremy. "Please Play with Your Food: An Incomplete Survey of Culinary Wonders in Italian Renaissance Cookery." *Gastronomica, The Journal of Food and Culture* 4, no. 4 (Fall 2004): 25–33.

Pedretti, Carlo. *"Eccetera: Perché la minestra si fredda": Codice Arundel, fol. 245 recto.* Florence: Giunta Barbera, 1975.

Perry, Charles. "Medieval Arab Oils." In *The Fat of the Land: Proceedings of the Oxford Symposium on Food and Cookery, 2002,* edited by H. Walker, 237–42. Devon, UK: Prospect Books, 2003.

Philostratus the Younger. *Imagines.* Translated by A. Fairbanks. Cambridge, MA: Harvard University Press, 1979.

Piccolpasso, Cipriano. *The Three Books of the Potter's Art, A Facsimile of the Manuscript in the Victoria and Albert Museum, London.* Translated with intro by R. Lightbown and A. Caiger-Smith. London: Scholar Press, 1980.

Pinto, Giuliano. "Il consumo della carne nella Firenze del Quattrocento." In *Della carne e del vino,* 25–39. Florence: Accademia della Fiorentina, 1992.

Pisanelli, Baldassare. *Trattato della natura de'cibi et del bere* [1583]. Venice: Domenico Imbetti, 1611. Reprint, Bologna: Arnaldo Forni Editore, 1980.

Platina. *On Right Pleasure and Good Health (De honesta voluptate et valetudine).* Translated by M. E. Milham. Tempe, AZ: Medieval and Renaissance Texts and Studies, vol. 168, 1998.

Pliny the Elder. *Natural History.* Translated by H. Rackham. Cambridge, MA: Harvard University Press, 1952.

Pontormo, Jacopo Carucci. *Pontormo's Diary.* Edited and translated by R. Mayer. New York: Out of London Press, 1982.

Porta, Giambattista della. *Phytognomonica.* Naples: H. Salvianum, 1588.

Posner, Donald. "Caravaggio's Homo-Erotic Early Works." *Art Quarterly* 34 (1971): 301–24.

Rasmussen, Jörg. *Italian Maiolica in the Lehman Collection.* New York: Metropolitan Museum of Art, 1989.

Rebora, Giovanni. *Culture of the Fork: A Brief History of Food in Europe.* Translated by A. Sonnenfeld. New York: Columbia University Press, 2001.

Redon, Odile, Françoise Sabban, and Silvano Serventi. *The Medieval Kitchen: Recipes from France and Italy.* Chicago: University of Chicago Press, 1988.

Reid, Jane. *The Oxford Guide to Classical Mythology in the Arts, 1300–1990s.* New York: Oxford University Press, 1993.

Riley, Gillian. *A Feast for the Eyes: The National Gallery Cookbook.* London: National Gallery Publications, 1997.

———. *The Oxford Companion to Italian Food.* Oxford: Oxford University Press, 2007.

———. *Renaissance Recipes.* San Francisco: Pomegranate Books, 1993.

Rios, Alicia. "Urbanophagy," www.alicia-rios.com.

Ripa, Cesare. *Iconologia*. Rome: Heredi di Gio. Giglioti, 1593. First illustrated ed. Rome: Lepido Faeii, 1603.

Rodinson, Maxime, A.J. Arberry, and Charles Perry. *Medieval Arab Cookery*. Devon, UK: Prospect Books, 2001.

Root, Waverly. *The Food of Italy*. New York: Vintage Books, 1992.

Roover, Raymond de. *The Rise and Decline of the Medici Bank, 1397–1494*. New York: W.W. Norton, 1966.

Rosaccio, Gioseppe. *Il microcosmo di Gioseppe Rosaccio, cosmografo*. Bologna: n.p., 1688.

Rossetti, Giovanni Battista. *Dello scalco*. Ferrara: Domenico Mammarello, 1584. Reprint, Bologna: Arnaldo Forni Editore, 1991.

Salerno, Luigi. *La natura morta italiana, 1560–1805/Still Life Painting in Italy, 1560–1805*. Rome: Ugo Bozzi Editore, 1984.

Sanuto, Marino. *I diari di Marino Sanuto*. Venice: E. Visentini, 1879–1903. Reprint, Bologna: Arnaldo Forni Editore, 1969–70.

Scapp, Ron, and Brian Seitz, eds. *Eating Culture*. Albany: State University of New York Press, 1998.

Scappi, Bartolomeo. *Opera dell'arte del cucinare*. Venice: Michele Tramezzini, 1570. Reprint, Bologna: Arnaldo Forni Editore, 1981.

———. *The Opera of Bartolomeo Scappi (1570): L'arte et prudenza d'un maestro cuoco/The Art and Craft of a Master Cook*. Translated with commentary by T. Scully. Toronto: University of Toronto Press, 2008.

Schatborn Peter, and Judith Verbene. *Drawn to Warmth: 17th-Century Dutch Artists in Italy*. Amsterdam: Wanders Publishers, 2001.

Schino, June di. "The Triumph of Sugar Sculpture in Italy, 1500–1700." In *Look and Feel: Studies in Texture, Appearance, and Incidental Characteristics of Food: Proceedings of the Oxford Symposium on Food and Cookery, 1992*, edited by H. Walker, 203–6. Devon, UK: Prospect Books, 1993.

Scully, Terence. *The Art of Cookery in the Middle Ages*. Woodbridge, UK: Boydell Press, 1995.

Serlio, Sebastiano. *Tutte l'opere d'architettura et prospettiva*. Ridgewood, NJ: Gregg Press, 1964.

Shearman, John. *Only Connect . . . Art and the Spectator in the Italian Renaissance*. Princeton, NJ: Princeton University Press, 1992.

Sohm, Philip. *Style in the Art Theory of Early Modern Italy*. Cambridge: Cambridge University Press, 2001.

Spang, Rebecca. *The Invention of the Restaurant: Paris and Modern Gastronomic Culture*. Cambridge, MA: Harvard University Press, 2000.

Spike, John T. *Caravaggio*. New York: Abbeville Press, 2001.

————. "Caravaggio erotico." *FMR* 15 (1975): 14–22.

Stefani, Bartolomeo. *L'arte di ben cucinare*. Mantua: Osanna, 1662. Reprint, Bologna: Arnaldo Forni Editore, 2000.

Stefani, Chiara. "Cesare Ripa: New Biographical Evidence." *Journal of the Warburg and Courtauld Institutes* 53 (1990): 307–12.

Steinberg, Leo. *Michelangelo's Last Paintings:* The Conversion of St. Paul *and* The Crucifixion of St. Peter. London: Phaidon, 1975.

————. *Other Criteria: Confrontations with Twentieth-Century Art*. Oxford: Oxford University Press, 1972.

Sterling, Charles. *Still Life Painting from Antiquity to the Present Time*. Translated by J. Emmons. New York: Universe Books, 1959.

Strauss, Walter L., ed. *The Illustrated Bartsch*. New York: Abaris Books, 1978– 2000.

Strinati, Claudio, et al. *Caravaggio e la collezione Mattei*. Milan: Electa, 1995.

Talvacchia, Bette. "Professional Advancement and the Use of the Erotic in the Art of Francesco Xanto." *Sixteenth Century Journal* 25 (1994): 121–53.

————. *Taking Positions: On the Erotic in Renaissance Culture*. Princeton, NJ: Princeton University Press, 1999.

Terence. *The Woman of Andros, the Self-Tormentor, the Eunuch*. Edited and translated by J. Barsby. Cambridge, MA: Harvard University Press, 2001.

Tervarent, Guy de. *Attributs et symboles dans l'art profane*. Geneva: Librairie Droz, 1997.

Theophilus. *On Divers Arts*. Translated by J.G. Hawthorne and C.S. Smith. Chicago: University of Chicago Press, 1963.

Thompson, Daniel V. *The Materials of Medieval Painting*. New Haven, CT: Yale University Press, 1936.

Tolnay, Charles de. "Le Menu de Michelange." *Art Quarterly* 2 (1940): 240–43.

Triolo, Julia. "The Armorial Maiolica of Francesco Xanto Avelli." Ph.D. thesis, Pennsylvania State University, 1966. Available from UMI Dissertation Services, Ann Arbor, MI.

Turco, Giovanni del. *Epulario e segreti vari: Trattati di cucina toscana nella Firenze Seicentesca, 1602–36*. Translated and with critical notes by A. Evangelista. Bologna: Arnaldo Forni Editore, 1992.

Varriano, John. "At Supper with Leonardo." *Gastronomica, The Journal of Food and Culture* 8, no. 1 (2008): 75–79.

————. "Caravaggio and the Decorative Arts in the Two *Suppers at Emmaus*." *Art Bulletin* 68 (1986): 218–24.

————. *Caravaggio: The Art of Realism*. University Park: Pennsylvania State University Press, 2006.

———. "Fruits and Vegetables as Sexual Metaphor in Late Renaissance Rome." *Gastronomica, The Journal of Food and Culture* 5, no. 4 (2005): 8–14.

———. *Italian Baroque and Rococo Architecture.* New York: Oxford University Press, 1986.

Varriano, John, and Nathan Whitman. Roma resurgens: *Papal Medals from the Age of the Baroque.* Ann Arbor: University of Michigan Museum of Art, 1983.

Vasari, Giorgio. *The Lives of the Painters, Sculptors, and Architects.* Translated by W. Gaunt. 4 vols. New York: Dutton, 1970.

———. *Vasari on Technique.* Translated by L. S. Maclehose with introduction and notes by G. B. Brown. London: J. M. Dent, 1907.

———. *Le vite de'più eccellenti pittori scultori e architetti nelle redazioni del 1550 e 1568.* Edited by R. Bettarini. Florence: Studio per Edizioni Scelte, 1984.

Vecellio, Cesare. *Vecellio's Renaissance Costume Book.* New York: Dover Publications, 1977.

Veneziano, Anonimo. *Libro di cucina,* www.geocities.com/helewyse/libro.html.

Vermeule, Cornelius. *European Art and the Classical Past.* Cambridge, MA: Harvard University Press, 1964.

Vickers, Michael. "A Greek Source for Antonio Pollaiuolo's *Battle of the Nudes* and *Hercules and the Twelve Giants.*" *Art Bulletin* 59 (1977): 182–87.

Villarosi, Paolo. "A History of Olive Oil," www.globalgourmet.com/food/egg/ egg0397/newrecs.html.

Vitruvius, Pollio. *Ten Books on Architecture.* Translated by I. Rowland. Cambridge: Cambridge University Press, 1999.

Walker, Stefanie, and Frederick Hammond, eds. *Life and Arts in the Baroque Palaces of Rome:* Ambiente Barocco. New Haven, CT: Yale University Press, 1999.

Watson, Katherine J. "Sugar Sculpture for Grand Ducal Weddings from the Giambologna Workshop." *Connoisseur* 199 (1978): 20–26.

Watson, Wendy. *Italian Painted Ceramics from the Howard I. and Janet H. Stein Collection and the Philadelphia Museum of Art.* Philadelphia: Philadelphia Museum of Art, 2001.

———. *Italian Renaissance Maiolica from the William A. Clark Collection.* London: Scala Books, 1986.

Wázbínski, Zygmunt. *Il Cardinale Francesco Maria del Monte, 1549–1626.* 2 vols. Florence: Leo S. Olschki, 1994.

Welch, Evelyn. *Shopping in the Renaissance: Consumer Cultures in Italy, 1400–1600.* New Haven, CT: Yale University Press, 2005.

Wilson, Timothy. *Ceramic Art of the Italian Renaissance.* London: British Museum Publications, 1987.

———. *Italian Maiolica of the Renaissance.* Milan: Bocca Editori, 1996.

Wind, Barry. *"Pitture ridicole.* Some Late Cinquecento Comic Genre Paintings."
 Storia dell'arte 20 (1974): 25–35.

———. *Velázquez's* Bodegónes: *A Study in Seventeenth-Century Spanish Genre
 Painting.* Fairfax, VA: George Mason University Press, 1987.

———. "Vincenzo Campi and Hans Fugger, a Peep at Late Cinquecento Bawdy
 Humor." *Arte Lombarda* 47–48 (1977): 108–14.

Wittkower, Rudolf. *Art and Architecture in Italy, 1600–1750.* New York: Penguin
 Books, 1982.

Wright, John M. *An Account of His Excellence, Roger Earl Castlemaine's Embassy from
 His Sacred Majesty James IId, King of England, Scotland, France, and Ireland &c.
 to His Holiness Innocent XI.* London, 1688, http://eebo.chadwyck.com.

Zaouali, Lilia. *Medieval Cuisine of the Islamic World.* Translated by M. B. DeBevoise,
 foreword by C. Perry. Berkeley: University of California Press, 2007.

Zeki, Semir. *Inner Vision: An Exploration of Art and the Brain.* New York: Oxford
 University Press, 1999.

ILLUSTRATIONS AND CREDITS

INDEX

References to illustrations are italicized.

CALIFORNIA STUDIES IN FOOD AND CULTURE

DARRA GOLDSTEIN, EDITOR